THE NIKON HANDBOOK SERIES:

Close-up Photography and Copying

By Joseph D. Cooper and Joseph C. Abbott

AMPHOTO
American Photographic Book Publishing Co., Inc.
Garden City, New York

NOTE FROM THE PUBLISHER

The Nikon Handbook Series was previously published as *The Nikon Nikkormat Handbook*. The series was compiled from *The Nikon Nikkormat Handbook* and the supplements that were used to update it. As the series goes to press, it contains the latest available information on Nikon equipment.

ACKNOWLEDGEMENT

Grateful acknowledgement is hereby made to Mark Iocolano for his assistance in preparing this work for publication.

Library of Congress Cataloging in Publication Data

Cooper, Joseph David, 1917-1975.
 Close-up photography and copying.

 (The Nikon handbook series)
 Includes index.
 1. Photography, Close-up. 2. Photography
—Copying. I. Abbott, Joseph C., joint author.
II. Title. III. Series.
TR683.C66 1979 778.3'24 79-9978

ISBN 0-8174-2489-X (hardbound)
ISBN 0-8174-2161-0 (softbound)

Manufactured in the United States of America

Contents

Introduction

This volume of the Nikon Handbook Series is concerned with close-up photography. The first chapter is an overview of close-up fundamentals. Covered in this chapter are: close-up attachment lenses, extension rings, Nikon bellows attachments, slide-copying adapters, and Nikkor lenses for close-up work. Chapter 2 deals with the copying of films and other single-plane subjects. Discussed in this chapter are procedures for copying both in black and white and in color, slide duplicating, copying by reflected light (such as copying photographic prints and documents), and a guide to copy problems. Chapter 3 covers three-dimensional close-ups, and discusses camera and subject supports, depth of field, and lights and reflectors.

This compact, seven-volume edition of the Nikon Handbook Series constitutes a significant revision of the original two-volume loose-leaf edition by the late Joseph D. Cooper. The present work is not a condensation; all of the material of the original Nikon-Nikkormat Handbook, including loose-leaf supplements volumes one and two, is presented here. Additional material on the latest Nikon equipment has been collected especially for this edition. The original text, containing references to material and techniques, has been thoroughly revised to reflect current developments.

Insofar as possible, material has been organized so as to separate descriptions of equipment from explanations of usage. In the book describing cameras, for example, Chapter 2 is the basic reference source on individual cameras and their features. The handling of cameras is treated in the following chapter.

As a systems reference guide, this Series is also designed to serve photographers (and photographic dealers) in discovering new applications and information about equipment they do not have but may want to procure. It includes historical information: the evolution of the entire Nikon camera line, beginning with the rangefinder models; characteristics of discontinued lenses for the Nikon reflex cameras; and operating information on important discontinued accessories.

In addition to being a technical reference source, the Nikon Handbook Series has been designed as a general guide to photography with the 35mm single-lens reflex camera and its lenses, accessories, films, and other materials. For example, the chapters on exposure, artificial lighting, close-ups, motorized photography, underwater photography, special effects, and other subjects are fairly complete coverages of principles and methods going far beyond the use of Nikon equipment alone.

Close-up Fundamentals

Ever since lenses were invented, man has been fascinated by his ability to render small things large—to see the details of small or distant objects. Close-up photography makes it possible to record the tiny world of the unseen and to display details that most of us rarely perceive. The drama of it all is that even when we do hold small objects in hand for examination, we ordinarily do not take in and remember all of the minute details. Our human visual limitations are barriers in themselves for, unlike the closely extended lens, the eye of the average adult cannot get closer than about 10 inches. Our crowded schedules do not let us take time to look at all the things that cross our paths—to look at them in a way that enables us to perceive their richness of detail.

Nikon lenses and mechanical accessories are available to make possible the photography of extremely small objects at close and extremely close ranges, to make color duplicates and black-and-white negatives and color slides, and to make faithful reproductions of films, documents, and printed materials.

The ability to see the image on the focusing screen while taking the picture, the availability of mechanical and optical accessories and lenses for close-up work, and the making of automatic exposure adjustments without working out complex mathematical formulae all combine to make close-up work relatively simple with any of the F-mount cameras covered in this book.

The fundamental principles of photography which apply to more generalized situations are fully applicable to close-up photography, only more so. In this area of photographic work, just as images are magnified, so are all of the optical and mechanical problems of picture taking. Everything is made much more critical —problems of perspective, depth of field, correction of optical aberrations, lighting, and control of camera movement during exposure, among others. These problems are covered in this and the next two chapters, which deal with different aspects of close-up work and photomacrography. The present chapter covers general principles of close-up photography. It also covers the complete range of Nikon close-up optics and accessories and their operating instructions. The use of ringlights is covered in Chapter 3.

INTRODUCTION TO
CLOSE-UP PHOTOGRAPHY

The scope of close-up photography covers image-to-subject ratios of 1:10 through 50:1 (or 1/10× through 50×). Within this extremely wide range of image reproduction, there are additional subdivisions of terminology covering increasingly more critical applications of close-up technique. The term *closeup* is generally acknowledged to cover the range of 1:10 through 1:1, that is, from one-tenth of the original object size on film through actual life-size reproduction. Within this range, *extreme closeups* are those covered by the range of 1:5 through 1:1. When objects are photographed greater than life size—greater than 1:1—through magnifications as great as 50:1, the body of technique is called *photomacrography*. For greater magnification, the camera is mounted on a compound microscope utilizing both ocular and objective, which brings one into the area of *photomicrography*.

The accompanying schematic diagram shows the overlapping ranges of general photography, close-up photography, photomacrography, and photomicrography.

In earlier days, a photographer had to compute necessary "exposure factors" with the aid of simple algebraic formulae, to compensate for lens extensions that affect nominal f/stop ratings. Behind-the-lens exposure measurement makes mathematical calculations largely unnecessary. Nevertheless, in some situations photographers may prefer to use their cameras without such exposure-measuring aids or might not have them available. Accordingly, this chapter includes the basic formulas used in making exposure computations in addition to determining distances of objects from the lens, the amount of lens extension needed in given situations, and so forth.

RELATION BETWEEN MAGNIFACTION
AND
PHOTOGRAPHIC APPARATUS FOR 35mm

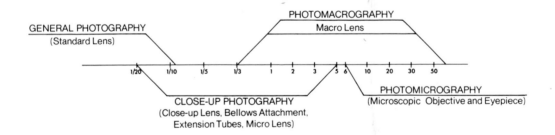

Overlapping ranges of close-up photography, photomacrography, and photomicrography (approximations). 6× is minimum photomicrographic magnification using 1.2× objective and 5× eyepiece.

Summary of Equipment Capabilities

With ordinary lenses of any focal length, the normal focusing range does not make it possible to focus closely enough to achieve desired image magnification. Closer focusing for greater image size is made possible by attaching a supplementary lens system or by inserting a suitable extension between the lens and the camera body.

The following is a brief summary of the uses and working ranges of the different types of close-up lenses and extension devices covered in this chapter:

1. *Simple close-up lenses,* also called supplementary lenses, attach to the front of camera lenses. They alter focal lengths without requiring exposure adjustments for they affect relative lens apertures nominally. They offer a range of magnification of about $1/7 \times$ (1:7) through about $2/3 \times$ (2:3). The greater magnifications are achieved with lenses in the range of 105mm through 200mm. Supplementary close-up lenses offer limited magnification potentials beyond which optical disadvantages are encountered.

2. *Extension rings or tubes* are simple means for lengthening the distance between the lens and film plane in order to project a larger image of the subject on the film. They are available in different lengths, making it possible to achieve slight or substantial extensions.

a. The Auto Extension Ring Set PK consists of three rings—PK-11, PK-12, and PK-13 (for AI lenses only), and PK-1, PK-2, and PK-3 (non-AI)—which increase lens-to-film distance. The rings provide extensions of 8mm, 14mm, and 27.5mm, respectively, and can be used singly or in combination. Seven different extensions are possible in all. The rings couple directly with the automatic diaphragm of Nikkor lenses with a focal length of from 20mm to 300mm and permit full-aperture metering when used with the appropriate camera/lens combination.

b. The Extension Ring Set K offers a magnification maximum of $2 \times$ with indicated wide-angle lenses. Lesser magnifications of about $1/3 \times$ (1:3) are attainable with indicated longer lenses, such as in the 105mm through 200mm group.

c. The E2 Ring affords magnifications ranging from $1/5 \times$ to $1/2 \times$ (1:5 to 1:2) with different lenses. Additional PK, K, or E2 rings can be added for greater magnification and they can also be combined with bellows units.

d. The BR-2 Macro Adapter Ring, used to attach nonsymmetrical lenses in the reverse mode either to the camera body directly or to a bellows extension, makes it possible to achieve high ratios of magnification, such as $9 \times$ with the 28mm lens, $7 \times$ with the 35mm lens, and $4 \times$ with the 50mm lens.

3. *Bellows extensions* offer infinitely variable adjustments in the distance between lens and film plane with further magnification possible by adding rings and supplementary lenses. The thickness of the bellows itself at minimum extension constitutes a substantial increment, particularly when using wide-angle lenses, so that bellows are particularly useful with short-mount 105mm and 135mm. (discontinued) lenses, which then can be focused from infinity to near subjects. Other lenses with regular focusing mounts can be used only for close-up work as they cannot be focused at infinity. According to the bellows model used, the minimum magnification of the 50mm $f/2$ lens in normal mode ranges from $0.6 \times$ to $1 \times$. With lenses in normal mode in the range of 105mm through 200mm, magnifications of about $1 \times$ can be achieved. Wide-angle lenses in normal and reverse mode offer greater magnification.

4. *Special lenses* are available with optical corrections for close focusing.

a. The short-mount 105mm $f/4$ and

135mm $f/4$ lenses (with F mount) have such optical designs and are used as described in paragraph 3.

b. The 55mm $f/3.5$ Micro-Nikkor-P lens offers diaphragm-coupled magnifications up to 1:2 with the lens unit alone, while with the intermediate PK-13 (or PK-3) ring 1:1 magnification can be achieved. Greater magnifications are obtainable in reverse mode. The lens can also be used for ordinary infinity photography.

c. The 105mm $f/4$ Micro-Nikkor is a longer focal length lens for close-up photography. The focal length permits the photographer to maintain a greater working distance between the camera lens and the subject, for reasons of lighting placement, working space, or personal safety. The lens offers diaphragm- and meter-coupled magnifications of 1:2 with the lens alone, or 1:1 with the automatic PN-11 (AI) or PN-1 (non-AI) adapter ring.

d. The 200mm $f/5.6$ Medical-Nikkor Auto lens has been specially designed for close-up work, utilizing special supplementary lenses and a built-in ringlight. All of these special lenses are to be preferred in close-up work because of their close-focus optical corrections.

5. *Other systems and arrangements* can be used in close-up work. For example:

a. El-Nikkor lenses can be adapted for use with bellows and extension rings. They are superbly corrected for close focusing and are of particular advantage in copying flat originals where edge-to-edge or corner-to-corner sharpness is desired. Special adapter rings are needed to attach the Leica-thread mounts to bayonet F mounts.

b. The camera body can be used for photomacrography and photomicrography by attaching it to the Nikon Multiphot and to simple and compound microscopes.

c. Experimentally you can mount two lenses front to front, utilizing a twin-threaded coupling ring. A typical arrangement is to use a "tele" lens in normal mode attached to the camera

MAGNIFICATION RANGES WITH VARIOUS NIKON CLOSE-UP ACCESSORIES IN COMBINATION WITH 50mm $f/2$ LENS

Accessory \ Magnification	5	4	3	2	1	1/2	1/3	1/4	1/5	1/6	1/7	1/8	1/9	1/10	1/11	1/12	1/13	1/14	1/15	1/20	1/25	1/30
Close-Up Lens No. 0											1/7										1/27.3	
No. 1									1/5.5								1/13					
No. 2								1/3.9		1/6.5												
E2 Ring					1/2.7	1/3.7																
K-Ring Set					1								1/8.9									
Bellows Attach PB 4/5	4.3				1																	

NIKON CLOSE-UP SYSTEM

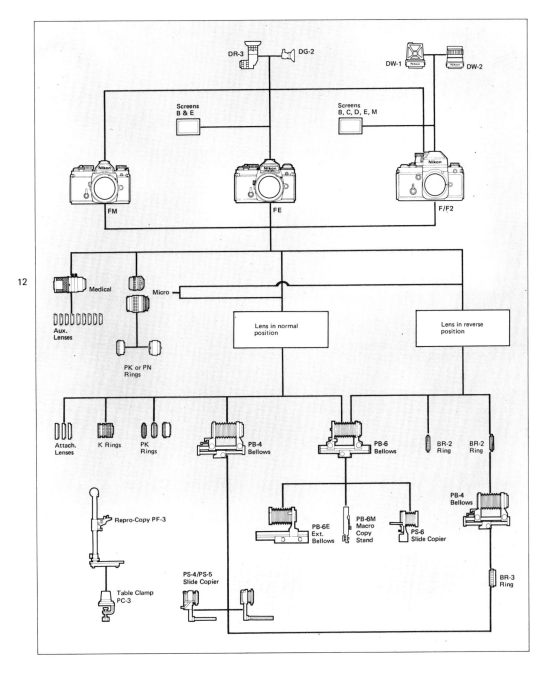

All close-up lenses and attachments can be used with any Nikon or Nikkormat cameras. Viewfinders and focusing screens in diagrams are for use only with Nikon cameras.

MAGNIFICATION RANGES OF THE LENSES BEST SUITED FOR CLOSEUPS

Lens	Close-up Accessories	Lens Mounting	Magnification Range	
50mm f/2	Lens alone	Normal		1/9.6X – ∞
	Close-up Attachments	Normal	No. 0	1/7.1X – 1/27X
			No. 1	1/5.6X – 1/13X
			No. 2	1/3.9X – 1/6.6X
			Nos. 1 & 2	1/3.0X – 1/4.4X
	Extension Ring E2	Normal		1/2.7X – 1/3.7X
	Extension Ring Set K	Normal		1X – 1/1.9X, 1/2X – 1/3.1X, 1/3.2X – 1/8.9X
	Bellows PB–3	Normal		1/1.6X – 2.8X
		Reversed		1.4X – 3.5X
	Bellows PB–4, PB–5	Normal		1/1.2X – 3.6X
		Reversed		1.6X – 4.4X
105mm f/4 Bellows	Bellows PB–3	Normal		1/1.1X – ∞
	Bellows PB–4, PB–5	Normal		1.3X – ∞
55mm f/3.5 Micro	Lens alone	Normal		1/2X – ∞
	With M2 Ring	Normal		1X – 1/2X
	Bellows PB–3	Normal		2.6X – 1/1.7X
		Reversed		3.5X – 1.5X
	Bellows PB–4, PB–5	Normal		3.4X – 1/1.3X
		Reversed		4.3X – 1/1.7X
200mm f/5.6 Medical	With or without 6 auxiliary lenses	Normal		3X, 2X, 1.5X, 1X, 2/3X, 1/2X, 1/3X, 1/4X, 1/6X, 1/8X & 1/15X

MAGNIFICATION FACTORS OF NIKKOR LENSES MOUNTED IN REVERSE MODE ON CAMERA BODY WITH BR-2 ADAPTER

Lens	Magnification
24mm f/2.8	2.5x
28mm f/2	2.1x
28mm f/3.5	2.1x
35mm f/1.4	1.7x
35mm f/2	1.7x
35mm f/2.8	1.7x
35mm f/2.8 PC	1.6x
45mm f/2.8 GN	1/2x
50mm f/1.4	1.1x
50mm f/2	1/1.3x
55m f/1.2	1.0x
55mm f/3.5 Micro	1/1.1x
43~86mm f/3.5 Zoom	1/3.9x~1.4x

F-mount El-Nikkor adapter permits Leica-thread El-Nikkor lenses to be used on bellows attachments. El-Nikkor lenses are uniquely suitable for close-up work inasmuch as they are corrected for short working distances.

Reverse adapter for El-Nikkor lenses. Two available models as described in text fit into inside front lens threads to permit El-Nikkor lenses to be mounted on bellows in reverse mode for photomacrography.

with a standard lens mounted to its front in reverse mode. Magnifications are found by dividing the focal length of the standard lens into that of the "tele" lens. Thus, the combination of 50mm $f/2$ and 105mm $f/2.5$ would yield a magnification of $2\times$. The aperture of the "tele" lens becomes the working aperture, while the standard lens in reverse mode becomes a supplementary lens. The automatic diaphragm feature is retained. Some lens extension can be introduced between the camera and the lens configuration. Nikon does not offer lens-to-lens attaching rings. They are available in Britain as BDB adapter rings and can also be ordered from some filter supply houses as well as from machine shops in the United States.

d. Extremely short focal length lenses designed for cinephotography can be attached to the camera for extreme magnifications, assuming that the particular lenses have sufficient image-area coverage on the film. Adapters would have to be machined individually for such purposes as they are not offered by Nikon.

General Principles of Close-Up Photography

An immediate problem resulting from extending the lens beyond the ordinary focusing range is that doing so requires conversion of the marked f/number (fr/—) to an *effective* f/number (fe/—). In theory, the marked f/number is true only for the lens at the infinity setting. As soon as the lens is extended away from the film plane in order to focus at closer distances by rotating the lens mount, the values of the marked f/numbers undergo changes commensurate with the amount of extension. In effect, any substantial lens extension results in a

Item	Size	Image ratio on 35mm full frame	Equipment used with 50mm $f/2$ lens
Time	285mm x 210mm	1/8.75	Close-Up No. 1 & 2
Vision	277mm x 210mm	1/8.75	"
Reader's Digest	185mm x 133mm	1/5.5	No. 1
Pelican book	110mm x 180mm	1/5	No. 2
Quarter coin (US)	23mm ϕ	1.04	Bellows
Penny coin (UK)	30mm ϕ	1/1.25	K3, 5, 4, 2 or E2+E2+No. 2
5 French Fr. coin	29mm ϕ	1/1.21	K3, 5, 4, 2
2 Swiss Fr. coin	27mm ϕ	1/1.12	K3, 5, 4, 2

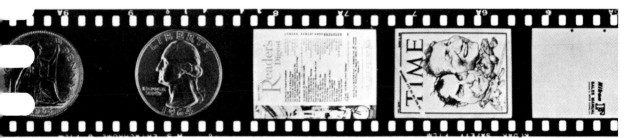

Examples of Close-up Equipment Requirements Using 50mm $f/2$ Lens to Copy Familiar Objects

OBJECT DISTANCE, IMAGE DISTANCE AND REPRODUCTION RATIO

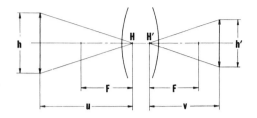

F: focal length
f: lens aperture
u: object distance
v: image distance

h: size of object
h': size of image
m: magnification
H, H': principal planes

The object distance is theoretically defined as a distance from the first principal plane of the lens to the focused object plane, and the image distance from the second principal plane to the image plane on the film. However, the distance engraved on the lens barrel does not represent the object distance, but a distance from the object to the image plane: the sum of the object and image distances, plus the distance between the first and second principal planes.

The following relation will be established between the focal length of the lens (F), object distance (u) and image distance (v):

$$\frac{1}{u} + \frac{1}{v} = \frac{1}{F}$$

The reproduction ratio or magnification (m)—the proportion of the image (h') to that of the object size (h)—is equal to the ratio of the object distance, as shown by:

$$m = \frac{h'}{h} = \frac{v}{u}$$

Consequently, the following relations will be obtained:

$$u = F\left(1 + \frac{1}{m}\right)$$

$$v = F(1 + m)$$

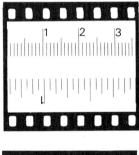

The two key distances used in close-up optical computations. A: free-working distance; B: object-to-film distance.

Image ratio is indicated by the relation between the image size reproduced on the film and the original size of an object. This relation is usually expressed in linear (length or width) rather than in areal measure. Since the picture format of a 35mm camera is 24 × 36mm (1 × 1½ in.), the image ratio will be 1:1 to fill up the picture format with an object of the same dimensions. For example, the image or magnification ratio of a 6mm (¼ in.) square object that fills the 24mm measurement of the 35mm film frame stands at 4:1 (24 ÷ 6). Synonyms for image ratio are reproduction ratio, magnification, and reduction ratio.

The free-working distance between focused object and front edge of lens should be kept as long as possible for unobstructed picture taking. The shorter the focal length, the shorter the working distance with the same image ratio; the longer the focal length, the longer the working distance with the same image ratio. The higher the image ratio, the shorter the working distance with a lens of the same focal length. Accordingly, wide-angle lenses are inconvenient for close-up work, their higher image ratio potentials notwithstanding, because of the difficulty of positioning illumination sources except when copying transparencies. This is why long focal-length lenses are preferred.

decrease in the amount of light reaching the film plane, thereby requiring increased exposure times. In practice, however, adjustments do not have to be made within the normal focusing range because the differences in relative aperture values are very slight. It is when the camera is used at a distance from the object that is closer than eight focal lengths that the relative aperture is changed in value sufficiently to require recomputation. This is the most commonly encountered problem in close-up work. With the built-in metering system it is easily overcome.

The following general principles pertain to all close-up photography regardless of which camera is used and regardless of the focal length of the lens:

1. When the distance of the object from the lens is greater than the distance of the film from the lens—as in most picture-taking situations—the image of the object on the film will be proportionately smaller than the real size of the object.

2. As the lens is brought closer to the object and as the lens-to-film distance is increased, the size of the image becomes greater.

3. When the distance of the object from the lens and the distance of the film from the lens are the same, the image and the real object will be of identical size. The image ratio (the term used to identify relation of image size to object size) is then 1:1. (Note: as used here, *image ratio* is synonymous with *reproduction ratio* and *magnification*. All of these terms are represented by the letter "m" in algebraic formulations given below.)

4. As the image distance (lens to film) begins to exceed the object distance (object to lens), the image size becomes greater than object size. The image ratio is then expressed so that the first numeral is greater than the second one, such as 1.5:1, 2:1, 3:1, and so on (or 1.5×, 2×, 3×, and so on).

5. Image size is governed solely by ratio between image distance and object distance, regardless of the lens used, that is, regardless of focal length.

6. When the *same image size* is achieved on the focusing screen with lenses of different focal lengths, assuming the same marked or engraved f/number is used, the respective lenses will, under those identical conditions, have the same effective lens apertures, exposure-increase factors, and depth of field.

7. At high magnifications, the *ordinary* rule that depth of field is twice as great behind the point of sharpest focus as in front of it does not apply. Depth of field under these conditions is very shallow and is about the same in front of and behind the plane of sharpest focus.

8. At magnifications greater than 1× (1:1), depth of focus (at the image plane) is greater than depth of field as perceived on the focusing screen. Depth of focus may be calculated by multiplying depth of field, if determinable, by m² (or the image ratio squared).

9. At high magnifications, depth of field is increased very little by stopping down the lens while image impairment may result due to movement during long exposures and due to the diffraction phenomenon when apertures such as f/22 and f/32 are used.

10. When short focal length lenses are used at great extensions to achieve substantial magnifications, the lens may be so close to the subject as to interfere with lighting. When, however, the subject is transilluminated, this difficulty is not encountered. The use of longer focal lengths will afford more area in front of the lens for lighting and better control.

Basic Formulary

The following symbols and accompanying definitions are used in the close-up formulae given below:

F = focal length

fr = marked or engraved lens aperture

fe = effective lens aperture

u = object distance from lens

v = image distance = distance from nodal point of lens to film

m = image ratio (or magnification)

d = distance lens extended from infinity setting (= distance of image from optical center or nodal point of lens)

h = size of object

h' = size of image

Nodal points are shown in the diagrams on data sheets available for each lens.

Object distance (u) can be determined for any given lens and for any desired image ratio when other factors are known or given, as in the following formulae:

$$u = \frac{Fv}{v - F}$$

$$u = \frac{v}{m}$$

$$u = \left(\frac{1}{m} + 1\right) F$$

$$u = \frac{hv}{h'}$$

The *image ratio* (m) is the relationship between image size and object size. This ratio is sometimes called the magnification, scale of reproduction, reproduction ratio, negative scale, or the film scale. The image ratio can be predetermined in accordance with the following formulae:

$$m = \frac{h'}{h}$$

$$m = \frac{v}{u}$$

$$m = \frac{v - F}{F}$$

$$m = \frac{F}{u - F}$$

The *image distance* (v) is the distance from the nodal point of the lens to the film plane, when the image is in sharp focus. The image distance therefore includes lens extensions achieved by using the focusing mount and inserting extension accessories between the lens and the camera body. The image distance can be predetermined by working out any of the following formulae:

$$v = (m + 1) F$$

$$v = mu$$

$$v = \frac{Fu}{u - F}$$

In practice, the photographer may wish to predetermine only the amount of physical extension of the lens (d) in addition to the focal length of the lens (F), when set at infinity, or a given set of conditions. The following formulae can then be used:

$$d = Fm$$

$$d = \frac{Fv}{u}$$

$$d = v - F$$

$$d = um - F$$

Image Ratio	Image Area
1/1	36mm x 24mm
1/1.5	54mm x 36mm
1/2	72mm x 48mm
1/3	108mm x 72mm
1/4	144mm x 96mm
1/5	180mm x 120mm
1/6	216mm x 144mm
1/7	252mm x 168mm
1/8	288mm x 192mm
1/9	324mm x 216mm
1/10	360mm x 240mm

Subject areas covered at various image ratios with any suitable lens regardless of focal length.

Scale

0 5 10 15 20 25 30 35 40 45 50 55 60 65 70 75 80 85 90 95 100 105 110 115 120 125 130 135 140

Lengthwise reading (mm)	3	4	5	6	7	8	9	10	11	12	13	14	15	16	17	18	19	20	21	22	23	24	25	26	27	28	29	30	31
Reproduction ratio	12×	9	7.2	6	5.1	4.5	4	3.6	3.3	3	2.8	2.6	2.4	2.3	2.1	2	1.9	1.8	1.7	1.6	1.5		1.4		1.3		1.2		

Lengthwise reading (mm)	32	33	34	35	36	37	38	39~42	43~48	49~55	56~65	66 80	81~103	104~144	145~240	241~380
Reproduction ratio	1.1	×		1				0.9	0.8	0.7	0.6	0.5	0.4	0.3	0.2	0.1

Viewfinder technique applicable to Nikon F and F2 cameras for determining image (or reproduction) ratio. Image ratio can be found directly by observation in the viewfinder and simple computation. Bring left end (zero point) of this scale into field of view so that zero point is at left end of the finder viewfield. Then read scale value at right end of image. The image ratio is found by dividing 36 into the right-hand number. Thus, in the accompanying illustration, 18 is seen at the right. When divided into 36, representing the width of the viewfinder image as well as the width of the film frame, an image ratio of 2 magnifications is found.

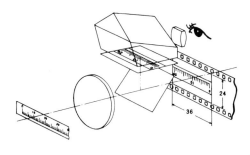

Schematic of viewfinder technique with Nikon cameras for determining image ratio.

As a practical matter, extension is readily determined by multiplying the lens focal length by the desired image ratio or magnification. Suitable close-up accessories and extension devices are described throughout this volume.

When the image has been sharply focused and the photographer wants to ascertain the lens extension (d), a simple method is to measure the additional lens extension effected by use of rings, bellows, and focusing lens mount.

The *effective aperture* (fe) for any given lens extension can be determined with the use of the following formulae:

$$\text{Effective } f/\text{number} = \text{fe} = vfr$$

$$\text{fe} = \text{fr} (m + 1)$$

The photographer may find it more convenient to use the "effective aperture computer" in the *Kodak Master Photo Guide,* available from most photo dealers.

The exposure factor for a given lens extension can be determined from either of the following formulae:

$$\text{Exposure increase factor} \div K = \frac{v^2}{F^2}$$

$$K = (m + 1)^2$$

As indicated earlier, exposure factoring is not necessary when using behind-the-lens finder/meters.

If the image ratio is known, the exposure increase can be determined in accordance with the accompanying table. For purposes of computing image ratio, the image height can be taken either on the narrow side or on the longer dimension of the film frame, corresponding to the relative position of the subject.

EXPOSURE FACTOR TABLE FOR IMAGE MAGNIFICATION

Image Ratio[1, 2]	Exposure Factor[3]	f/Stop Adjustment	Image Ratio	Exposure Factor	f/Stop Adjustment
0.1	1.21	1/4	4.8	33.64	5
0.2	1.44	1/2	5.0	36.00	5 1/4
0.3	1.69	3/4	5.2	38.44	5 1/4
0.4	1.96	1	5.4	40.96	5 1/4
0.5	2.25	1 1/4	5.5	42.25	5 1/2
0.6	2.56	1 1/4	5.6	43.56	5 1/2
0.7	2.89	1 1/2	5.8	46.24	5 1/2
0.8	3.24	1 3/4	6.0	49.00	5 1/2
0.9	3.61	1 3/4	6.2	51.84	5 3/4
1.0	4.00	2	6.4	54.76	5 3/4
1.2	4.84	2 1/4	6.5	56.25	5 3/4
1.4	5.76	2 1/2	6.6	57.76	5 3/4
1.5	6.25	2 3/4	6.8	60.84	6
1.6	6.76	2 3/4	7.0	64.00	6
1.8	7.84	3	7.2	67.24	6
2.0	9.00	3 1/4	7.4	70.56	6 1/4
2.2	10.24	3 1/4	7.5	72.25	6 1/4
2.4	11.56	3 1/2	7.6	73.96	6 1/4
2.5	12.25	3 1/2	7.8	77.44	6 1/4
2.6	12.96	3 3/4	8.0	81.00	6 1/4
2.8	14.44	3 3/4	8.2	84.64	6 1/2
3.0	16.00	4	8.4	88.36	6 1/2
3.2	17.64	4 1/4	8.5	90.25	6 1/2
3.4	19.36	4 1/4	8.6	92.16	6 1/2
3.5	20.25	4 1/4	8.8	96.04	6 1/2
3.6	21.16	4 1/2	9.0	100.00	6 3/4
3.8	23.04	4 1/2	9.2	104.04	6 3/4
4.0	25.00	4 3/4	9.4	108.16	6 3/4
4.2	27.04	4 3/4	9.5	110.25	6 3/4
4.4	29.16	4 3/4	9.6	112.36	6 3/4
4.5	30.25	5	9.8	116.64	6 3/4
4.6	31.36	5	10.0	121.00	7

Notes: 1. Image ratio is indicated in formulas as "m".
2. Image ratios are variously expressed as 0.9x, 9/10, and 9:10, all being equivalent. 1/10x is expressed as 0.1. It may also be expressed as 1:10. Similarly 0.5 equals 1/2x equals 1:2; 1x equals 1:1; 2.6x equals 2.6:1; etc.
3. Shutter speed compensations may be made by multiplying the nominal shutter speed by the exposure factor.

Exposure Increases With Nonsymmetrical Lenses

The foregoing formulae are largely true for symmetrical lenses. With lenses of short focal length, in particular, as well as some telephoto lenses, marked variations from the formula calculations may be found. When exposures are computed with the through-the-lens meters, automatic compensation is made regardless of optical formula. An easy way of determining the variation for any lens, if present, is to compare the formula factor with the automatic camera reading and the nominal f/number of the lens. Thereby, an individual lens factor can be found. In general, the problem is only important with color films, where latitude is narrow. As a rule-of-thumb, make trial exposures of one-half and one stop less with short focal-length lenses (less than standard) and more with longer lenses.

A simple example is offered as to why the ordinary rules of exposure factoring do not apply with nonsymmetrical lenses. Using the formula $K = (m + 1)^2$ to determine the exposure factor, K, for a magnification of $1\times$, we would get $K = (1 + 1)^2 = K = 4$. This would work where the entrance and exit pupils of a symmetrical lens (or one nearly so) are identical or approach a ratio of 1:1. This formula can be used with the 55mm $f/3.5$ Micro-Nikkor-P Auto, the Bellows-Nikkor lenses 105mm $f/4$ and 135mm $f/4$, and the 45mm $f/2.8$ GN Auto Nikkor. Hence, these may be considered as favored lenses for close-up work in the normal mode.

In the case of lenses of retrofocus or telephoto design as well as other non-symmetrical lenses, the formula for K, as above, is not applicable. An optical coefficient (Ψ), the ratio of the diameter of the entrance pupil to that of the exit pupil, must be taken into account in the formula:

Lens in normal position:

$$Kp = \left(\frac{m}{\Psi} + 1\right)^2$$

Lens in reverse position:

$$Kp = \frac{1}{\Psi^2}\,(\Psi m + 1)^2$$

The accompanying exposure factor graphs for close-up work will serve as convenient reference guides in most cases, making it unnecessary to resolve the algebraic formulas.

Lens Selection for Ordinary Closeups

Most close-up work, particularly when it is done to photograph flat or nearly flat objects, is performed with standard lenses, especially 50mm lenses (apart from the 55mm $f/3.5$ Micro-Nikkor-P Auto lenses, which many photographers use both for infinity and close-up work). The magnification range with the K-ring set and a 50mm lens is from 1:9 to 1:1. Although the 50mm $f/1.4$ lens has advantages in coping with adverse light conditions, in close-up work the 50mm $f/2$ yields better overall results, especially with regard to flatness of field. Also, since it is advisable to stop the lens down in any event, the speed of the 50mm $f/1.4$ lens is really of no advantage.

When it is important to have a greater working distance to allow space for lighting setups and to obtain better perspective effects with three-dimensional objects, lenses of longer focal length should be used. The 85mm and 105mm lenses are suitable for intermediate working distances, while for more comfortable working distances the 200mm lens may be used. The latter affords a working distance of eight inches from the subject when extended to achieve a 1:1 image ratio.

The photographer who wishes to be equipped for a variety of picture-taking situations in the field, perhaps limited by what he can carry in a field gadget bag, may want to consider the following:

1. A set of the three supplementary close-up lenses.

2. An Auto Extension Ring Set PK, one or more E2 Rings, or Extension Ring Set K.

3. The 55mm $f/3.5$ Micro-Nikkor Auto with PK-3 or PK-13 Ring (depending on camera/lens combination) as an alternative to the foregoing or in combination.

4. The 105mm $f/4$ Micro-Nikkor Auto with PN-1 or PN-11 Ring (depending on camera/lens combination) when a longer focal length is desired.

CLOSE-UP COMPUTATIONS TABLE

A Image Ratio on Film	B Object-to-lens distance	C Lens-to-image distance	D Combined distance object to film plane (B + C)	E Exposure factor
1:10	11 F	1.1 F	12.1 F	1.21
1:5	6 F	1.2 F	7.2 F	1.44
1:4	5 F	1.25 F	6.25 F	1.56
1:3	4 F	1.33 F	5.33 F	1.77
1:2	3 F	1.5 F	4.5 F	2.25
1:1.8	2.8 F	1.56 F	4.36 F	2.4
1:1.6	2.6 F	1.62 F	4.22 F	2.55
1:1.4	2.4 F	1.71 F	4.11 F	2.9
1:1.2	2.2 F	1.83 F	4.03 F	3.25
1:1	2 F	2 F	4 F	4
1.2:1	1.83 F	2.2 F	4.03 F	4.8
1.4:1	1.71 F	2.4 F	4.11 F	5.7
1.6:1	1.62 F	2.6 F	4.22 F	6.7
1.8:1	1.56 F	2.8 F	4.36 F	7.8
2:1	1.5 F	3 F	4.5 F	9
3:1	1.33 F	4 F	5.33 F	16
4:1	1.25 F	5 F	6.25 F	25
5:1	1.2 F	6 F	7.2 F	36
10:1	1.10 F	11 F	12.1 F	121
20:1	1.05 F	21 F	22.05 F	440

This table serves as a general problem solver with lenses of any focal length. The initial points for problem solving are usually the image ratio or the distance of the object from the lens. Assume that you are using a 50mm lens at a distance of 200mm from the subject. Dividing this into the focal length would give you 4 F. Reference to the table indicates an image ratio of 1:3. The exposure factor is 1.77 which can be multiplied by the shutter speed nominally indicated.

Summary of Close-Up Problems

The main difficulties in close-up photography and ways of coping with them are stated here in summary.

1. *Extremely shallow depth of field.* At close working distances, regardless of lens used, depth of field is reduced to tiny fractions of an inch, hardly more than a plane in image depth. Stopping down the lens will help a little, but this should not be carried to the point of unduly lengthening exposure time and degrading image quality caused by movement or vibration. Careful placement of the object, if it has depth, will be necessary, so that important surfaces will be in the same zone of sharpness.

2. *Extreme sensitivity to camera move-ment.* The magnification of the image on film also makes prominent any image displacement caused by camera movement and vibration. The subject should be securely fixed in place especially if exposures are to be long. The camera should be mounted on a rigid support, perhaps taped to the floor. To overcome external vibration, rubber pads should be used under the camera support. Lightweight tripods are to be avoided. A low center of gravity for the camera support minimizes vibration.

3. *Perspective distortions.* Most commonly, perspective problems with three-dimensional subjects are caused by foreground prominence. The closest-to-camera objects loom disproportionately large.

This can be minimized somewhat by judicious placement of objects. A better approach, however, is to work with longer focal-length lenses, as far away from the subject as is feasible. When photographing subjects in a single plane, as in copying, perspective problems are not encountered, provided the film plane is parallel (and the optical axis perpendicular) to the image target.

4. *Focusing techniques.* In extreme close-up photography, it is most difficult, if not nearly impossible, to focus sharply simply by moving the lens forward or backward using either the lens mount or the bellows. The best approach to exact focusing is to set up the camera with extensions on a tripod to achieve the desired approximate magnification. Then, the entire camera-extension-lens assembly should be moved to or away from the subject until fine focus is achieved.

5. *Practical limits of extension.* A point is reached where increased magnification is offset by inconveniences of increased exposure time and risks of vibration and tremors that degrade image quality. Ex-

ceptionally long extensions bring the front of the lens too close to the subject. They also move the weight balance forward, thus adding to unsteadiness. Beyond some reasonable magnification through lens extension, it is often desirable to use a wide-angle lens, particularly the 24mm, in reverse mode. Further magnification through darkroom technique should be considered beyond such optical procedures.

6. *Exposure compensation.* Any lens extension beyond that which is possible with the focusing mount alone of any ordinary camera lens calls for an increase in exposure time. The simplest and most reliable approach is to use the through-the-lens, exposure-reading systems, since the meter cells measure the amount of light reaching the film plane as first collected on the focusing screen. When extensions are used without through-the-lens metering, exposure times for the nominal lens apertures need to be increased through mathematical computation, reference to tables, and reference to scale indications on bellows rails.

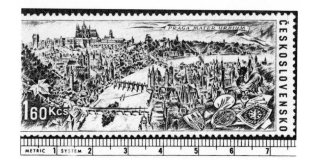

For indexing and comparative reference, the postage stamp used in this series is shown at top in its original size. Below it are sections reproduced with the Micro-Nikkor-P at image ratios of 1:2 and 1:1. In each case, to show image coverage, the full picture area is given. In this entire stamp series, an aperture of $f/5.6$ was generally used. Photography by Nikon technical representative Richard LoPinto. At bottom, to show corner performance of this special-purpose lens (that can also be used in general photography) a section of the stamp is shown blown up.

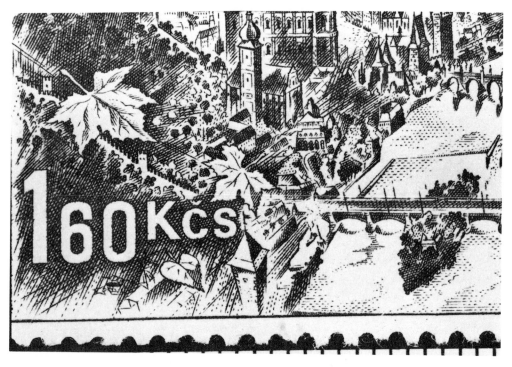

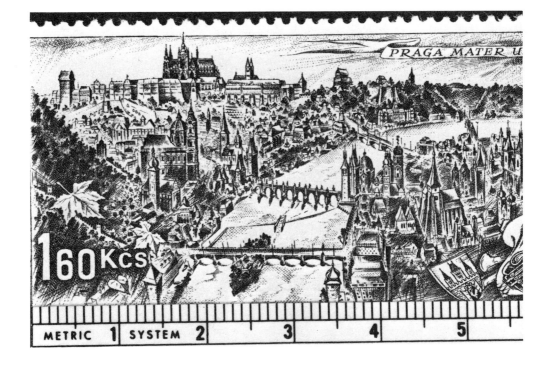

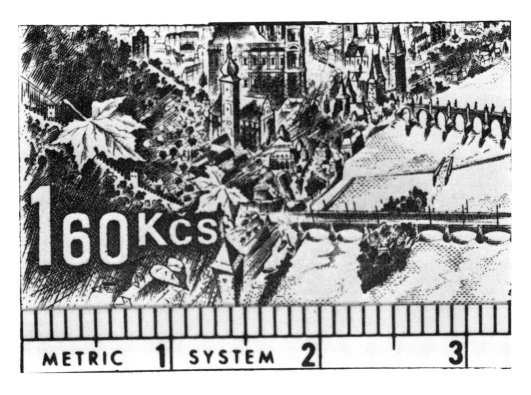

At top, 50mm f/2 + E2 tube + CU no. 1 + CU no. 2. Excellent performance into corners. Bottom, 50mm f/2 + 3 E2 tubes + CU no. 1 + CU no. 2. Here, performance suffers due to addition of close-up attachment lenses when lens is extended further. See next page for further comparison.

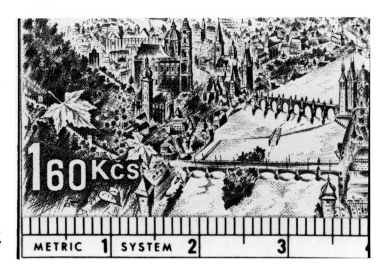

50mm *f/2* + 3 E2 tubes + CU no. 1 shows no quality loss at this magnification.

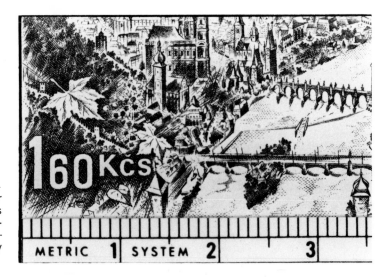

50mm *f/2* + 3 E2 tubes + CU no. 2. The stronger close-up attachment lens yields somewhat more magnification—not much— along with obvious quality loss.

50mm *f/2* + 3 E2 tubes + K set. Greater extension retains quality up to a point where image begins to lose in corners. Results better than with close-up attachments. Stopping down further would have improved results.

Bellows IV with 135mm f/3.5 in normal position, 190mm extension. Image breaks down away from center.

Smaller magnification with telephoto lens reversed; otherwise, same setup. Slight quality loss toward corner, correctable with smaller aperture.

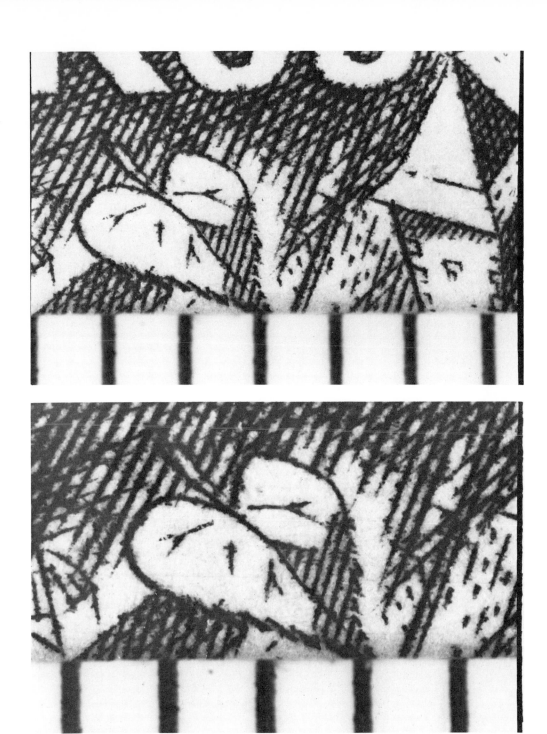

Many lenses give better performance in close-up work when used in reverse with Reverse Adapter as explained in text and in other illustrative matter. Particularly true of wide-angle lenses with retrofocus design, yielding great magnifications. Compare leaf detail with original in lower left of stamp. Both photos made with Bellows III at 140mm extension. Top, with 35mm f/2.8 reversed and bottom with 28mm f/3.5 reversed. Somewhat better image sharpness with 35mm lens, but note that 35mm as shown on scale yields about 7:1 magnification.

CLOSE-UP ATTACHMENT LENSES

Nikkor close-up lenses are simple meniscus lenses with 52mm screw-in threads for attachment to camera lenses. They are available as follows:

No.	Diopter Power
0	0.7
1	1.5
2	3.0

These identifications of Nikon close-up lenses do not correspond to ordinary commercially available meniscus lenses in the range of +1 through +10.

The close-up lenses shorten the focal lengths of the camera lenses to which they are attached. Thereby, the photographer is able to work at closer ranges and obtain larger image sizes. The main advantages of close-up lenses is utter simplicity, portability, and convenience. Used properly, they can perform quite satisfactorily for small objects in the center of the image area where optical definition is likely to be at its best and where optical aberrations are likely to be least evident. Where subject matter must be reproduced faithfully from edge to edge, particularly in copying, other alternatives are preferred as discussed below.

CLOSE-UP NO. 0 NIKON

CLOSE-UP NO. 1 NIKON

CLOSE-UP NO. 2 NIKON

Close-up lenses—dimensional data.

Close-up lenses may be used in combination with extension rings and bellows in order to minimize the amount of lens extension. The advantage of having shorter exposures, as a result, may in some cases more than offset the theoretical advantage of using the prime lens with extension tubes alone. Long exposures necessary with lens extensions cause the camera to be subject to movement, which, in turn, will blur the image.

Nikkor close-up lenses are ground to assure that the optical axis of the attachment lens is in its center, to correspond with the optical axis of the prime lens. Optical distortions may result when cheaper substitutes are used. Independently available close-up lenses can also be used, provided you are assured of their satisfactory optical quality. The numerical designations of these usually correspond to diopters. Some independent manufacturers offer fractional-diopter lenses that are applicable to prime lenses such as the 200mm and 300mm. In general, cheap accessory lenses are to be avoided in order to minimize any risk of degrading image quality of the Nikkor prime lens.

While any of the three Nikkor close-up lenses may be used with any Nikkor camera lenses that accept 52mm screw-in lens accessories, Nos. 1 and 2 close-up lenses are intended primarily for the normal lenses—the 50mm, 55mm, and 58mm. The No. 0 close-up lens is intended primarily for the 43–86mm f/3.5 Zoom-Nikkor Auto, the 105mm, the 135mm, and the 200mm lenses. While Nos. 1 and 2 close-up lenses can be used in combination with the standard lenses, they are not recommended for longer focal lengths, especially with the 200mm lens, because problems of image degradation can occur. The use of more than two close-up lenses in combination is not recommended.

The greater the numerical value of individual or combined attachment lenses, the closer is the working distance and the greater is the image ratio or magnification. Relative apertures of lenses are not substantially affected by use of close-up attachment lenses. When combining two close-up lenses, attach the higher numbered one closest to the camera lens. Measure object distances from the position of the close-up lens (or the front one if two are to be used).

For the approximate focusing distances, image ratios, and subject areas obtained through use of close-up attachment lenses, see the lens data sheets and the accompanying tables. For best results, limit the use of close-up lenses with long-focus lenses (beyond standard focal lengths) to the No. 0 lens alone.

Focusing should be done with matte screens. If the split-image focusing screen is used, focus on the surrounding matte portion. The split-image rangefinder is not designed for extreme close-range work.

The smallest feasible lens apertures should be used both because this improves depth of field and because optical performance is best at apertures of $f/5.6$ and smaller, preferably $f/11$. This is of particular importance in copying and where edge-to-edge fidelity is required.

When a close-up lens is used, it refocuses the camera lens for a distance approximately equal to the focal length of the close-up attachment. This holds true regardless of which camera lens is used—50mm, 105mm, 135mm, and so forth. When the No. 1 attachment is used, the focusing distance is 26.2 inches or 66.7cm. When the No. 2 attachment is used, the focusing distance is about 13 inches or 33.3cm.

The simple formula for determining the focusing distance is to divide the power in diopters into 39.3 inches (approximately one meter) or into 100cm (exactly one meter). Thus, the 3-diopter power of a No. 2 lens, divided into 39.3, gives a distance of approximately 13 inches or 33.3cm.

The combined focal length in millimeters of a camera lens and added close-up lens(es) may be computed according to the following formula:

$$Fc = \frac{1000}{\left(\dfrac{1000}{F} + D\right)}$$

in which:

Fc is combined focal length;
F is camera lens focal length;
D is diopter power.

Thus, assuming $F = 50$mm and $D = 3$ (No. 2 closeup), the formula works as follows:

$$Fc = \frac{1000\text{mm}}{\left(\dfrac{1000}{50} + 3\right)}$$

$$= \frac{1000\text{mm}}{(20 + 3)} = 43.5\text{mm}$$

Hence, it can be seen that $f/$values, if worked out for the combined focal lengths, would not change substantially and need not be taken into account.

Combined focal lengths for other camera lenses with close-up attachments can be computed in the same manner.

EXTENSION RINGS

Extension rings are inserted between the camera body and the lens, thus permitting the use of the prime camera lens without introducing optical alterations caused by alternative use of supplementary close-up lenses. In various sizes and combinations, the extension rings extend the distance of the lens from the film or image plane, thereby causing a larger image to be projected upon the film. Extension rings can be used with bellows for greater magnification.

E2 Extension Ring

The model E2 Ring permits semi-automatic operation of lenses with automatic diaphragms. Depressing a plunger on the E2 Ring fully opens the attached lens diaphragm for ease of focusing. Removing the finger from the plunger causes the diaphragm to be stopped down to the preselected aperture. Each E2 ring adds 14mm to lens extension. For longer extensions, two or three E2 rings can be combined in series.

The use of more than three rings is not recommended. Some photographers carry at least one E2 ring at all times in case the need arises to focus closer with any lens.

Data on ranges of focusing distance, image magnification, and exposure factors with E2 rings can be found in the individual lens data sheets.

Nikon Extension Ring Set K

Nikon extension rings are furnished in a set of five individual rings of different lengths. They are:

K-1—	5.8mm
K-2—	5.0mm
K-3—	5.8mm
K-4—	10.0mm
K-5—	20.0mm
Total	46.6mm

When the complete set of K rings is used with the 50mm $f/2$ Nikkor-N Auto lens, a ratio of 1:1 may be obtained by focusing this lens as far as it will go to its closest focusing distance. This will add an additional 3.4mm, making a total extension of 50mm.

The K-1 ring can be used by itself or in combination with the K-2 and K-3 rings. The K-1 ring can be added to either end of any other feasible combination of K rings. Some photographers take a K-1 ring along with them, as a highly compact extension to provide extra flexibility in close-focusing situations with a variety of lenses.

The K-2 and K-3 rings must always be used together.

The K-4 and K-5 rings can be used only by being threaded individually or in combination between the K-2 and K-3 rings.

The various combinations of the K rings are shown in the accompanying tables, which also give reproduction ratio, subject area coverage, and exposure factor for several Nikkor lenses. Also consult the individual lens data sheets.

As a general rule, err on the short side. Too much lens extension may trim the edges of essential image area. A slightly shorter lens extension is preferable because the loss of image magnification on film can be made up in the darkroom. A slight loss in K-ring extensions can usually be made up by rotating the focusing mount of the lens.

Extension rings can be used in combination with close-up lenses attached to the camera lens. They can also be used in combinations with the bellows extension. When close-up lenses are used, the prime lens should be stopped down for critical work to correct optical defects or aberrations.

Lenses equipped with automatic diaphragms lose that feature when used with K rings. The lenses must then be stopped down manually before exposure. An E2 ring in place of K-1 will provide semi-automatic diaphragm control as explained in the E2 section, above.

The K-2 ring is provided with three holes, one of which fits to the pin on the camera or to the K-1 ring, so that the lens can sit in such a position as to facilitate the reading of the f/number scale on the lens. Line up the index dot nearest to the selected hole with the black dot on the camera or K-1 ring and turn the tube counterclockwise until it clicks into position.

Nikon Extension Ring Set PK

The Extension Ring Set PK consists of three individual rings of different lengths. The PK-11, PK-12, and PK-13 rings are for use with AI lenses only. The PK-1, PK-2, and PK-3 rings are for use with non-AI lenses or with AI lenses on older, non-AI cameras. The PK-rings allow full-diaphragm automation and permit full-aperture exposure metering when used with the appropriate camera/lens combination.

The lengths of the three different PK-rings are as follows:

 PK-1/PK-11 ... 8.0mm
 PK-2/PK-12 ... 14.0mm
 PK-3/PK-13 ... 27.5mm
 Total 49.5mm

The rings may be used in any combination. The accompanying chart shows the extensions possible with the various combinations.

Some camera/lens/ring combinations are not possible, and in other instances full-aperture metering is not possible. For example, only AI lenses may be used with the PK-11, 12, and 13 rings. These rings, however, may be attached to any Nikon or Nikkormat camera, but metering must be in the stopped-down mode with the older, non-AI cameras. Accompanying tables illustrate which camera/lens combinations are possible with each set of rings and explain which modes of operation are required with each compatible combination.

When all three rings are used together, the extension is sufficient to permit an image ratio of 1:1 with a 50mm lens. When the 55mm f/3.5 Micro-Nikkor is used, only the PK-13 (or PK-3) ring is necessary in order to achieve an image ratio of 1:1. The PK-13 (or PK-3) ring has replaced the older M2 ring formerly supplied with the Micro-Nikkor. The M2 ring did not permit full-aperture metering.

Guides to Lens Extension

In order to select a desirable combination of ring extension and lens, you need to relate the image size to the original object size. This is expressed as the reproduction ratio or image ratio. For example, if an object four inches high is to be photographed so that it completely fills the one-inch dimension of the film, the ratio will be 1:4. If an image area is to be reproduced at life-size, the ratio is 1:1. If a tiny object is to be magnified to twice its normal dimensions, the image ratio is 2:1. The greater the image ratio (scale of reproduction), the greater will be the extension of the lens. To obtain a 1:1 ratio with a 50mm lens, the extension must also be 50mm, the same as that of the lens.

Consult the tables and lens data sheets or use a formula as given earlier to figure out how much extension to put between the lens and camera body. It need not be precise, since you will have some flexibility through enlarging. Also, the lens focusing mount can be used to add to extension length. Finally, you can always work by trial and error, making use of the focusing screen in order to observe the image size.

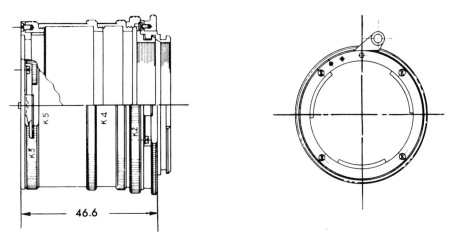

K-tubes—dimensional data

EXTENSIONS POSSIBLE WITH RING SET PK

Ring Combination	Extension (mm)
PK-11 (or PK-1)	8
PK-12 (or PK-2)	14
PK-11 + PK-12*	22
PK-13 (or PK-3)	27.5
PK-11 + PK-13*	35.5
PK-12 + PK-13*	41.5
PK-11 + PK-12 + PK-13*	49.5

*Also applies to corresponding PK-1, 2, and 3 rings.

COMPATIBILITY TABLES FOR CAMERA/LENS/PK-RING COMBINATIONS

Extension Rings PK-11, 12, 13

	AI camera	non-AI camera
AI lens	full-aperture metering; auto-diaphragm	stop-down metering; auto-diaphragm
non-AI lens	not possible	not possible

Extension Rings PK-1, 2, 3

	AI camera	non-AI camera
AI lens	stop-down metering; auto-diaphragm	full-aperture metering; auto-diaphragm
non-AI lens	stop-down metering; auto-diaphragm	full-aperture metering; auto-diaphragm

MOUNTING ARRANGEMENTS FOR K-TUBE SET

Tube	Length	Mount to Lens	Mount to Camera	Notes on Usage
K1	5.8mm	Match black dot of lens to black dot of K1. Female bayonet of K1 attaches to male bayonet of lens	Match white dot of K1 to black dot of camera mount. Fit K1 bayonet mount to camera	K1 can be used by itself or in combination with others of K-Tube set
K2	5mm	Impossible. K2 front has thread	Match black dot of K2 to black dot of camera mount. Fit K2 screw mount to K3 and then K3 to lens bayonet	Used with K3 alone or with K4 and/or K5 between K2 and K3 for additional extension
K3	5.8mm	Match black dot of lens to black dot of K3. Female bayonet of K3 attaches to lens bayonet	Impossible. K3 rear has thread	Used with K2 alone or with K4 and/or K5 between K2 and K3 for additional extension
K4	10mm	Impossible. Both sides have thread mount		
K5	20mm			

K-RING COMBINATIONS

Type	Extension Length	Fitting	Attachable to Lens	Attachable to Camera	Combination
K1	5.8mm	Bayonet mount on both sides.	Yes	Yes	K1 = 5.8mm K3 + K2 + K1 = 16.6mm K3 + K4 + K2 + K1 = 26.6mm K3 + K5 + K2 + K1 = 36.6mm K3 + K5 + K4 + K2 + K1 = 46.6mm
K2	5.0mm	Screw threaded (female) on one side, bayonet mount (male) on the other. Chrome finish.	No	Yes	K3 + K2 = 10.8mm K3 + K2 + K1 = 16.6mm K3 + K4 + K2 = 20.8mm K3 + K4 + K2 + K1 = 26.6mm K3 + K5 + K2 = 30.8mm K3 + K5 + K2 + K1 = 36.6mm K3 + K5 + K4 + K2 = 40.8mm K3 + K5 + K4 + K2 + K1 = 46.6mm
K3	5.8mm	Bayonet mount (female) on one side, screw threaded (male) on the other.	Yes	No	K3 + K2 = 10.8mm K3 + K2 + K1 = 16.6mm K3 + K4 + K2 = 20.8mm K3 + K4 + K2 + K1 = 26.6mm K3 + K5 + K2 = 30.8mm K3 + K5 + K2 + K1 = 36.6mm K3 + K5 + K4 + K2 = 40.8mm K3 + K5 + K4 + K2 + K1 = 46.6mm
K4	10mm	Screw threaded on both sides. Black finish.	No	No	K3 + K4 + K2 = 20.8mm K3 + K4 + K2 + K1 = 26.6mm K3 + K5 + K4 + K2 = 40.8mm K3 + K5 + K4 + K2 + K1 = 46.6mm
K5	20mm	Screw threaded on both sides. Black finish.	No	No	K3 + K5 + K2 = 30.8mm K3 + K5 + K2 + K1 = 36.6mm K3 + K5 + K4 + K2 = 40.8mm K3 + K5 + K4 + K2 + K1 = 46.6mm

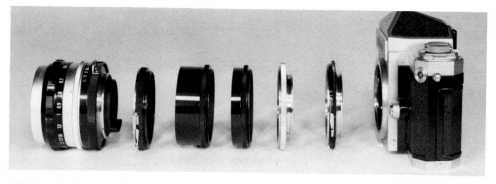

K-ring set between lens and camera, from left to right: lens, K-3, K-5, K-4, K-2, K-1, Nikon F body.

NOMOGRAM FOR USE IN DETERMINING COMBINATIONS OF K-RINGS FOR DESIRED IMAGE RATIOS (MAGNIFICATIONS) AND AREA COVERAGES

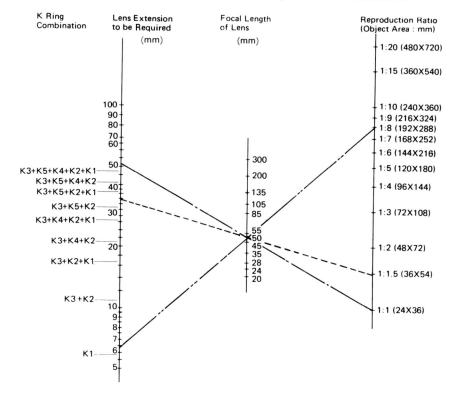

	Maximum Focusing Extension				
20mm f/3.5	2.0mm	35mm f/2.8	6.2mm	105mm f/2.5	13.7mm
24mm f/2.8	2.7mm	PC 35mm f/2.8, f/3.5	6.7mm	135mm f/2.8	15.0mm
28mm f/2	4.0mm	GN 45mm f/2.8	3.1mm	135mm f/3.5	15.1mm
28mm f/3.5	1.6mm	50mm f/1.4, f/2	5.3mm	200mm f/4	28.0mm
35mm f/1.4	4.6mm	55mm f/1.2	6.2mm	300mm f/4.5	28.0mm
35mm f/2	6.4mm	85mm f/1.8	8.7mm		

1. To find lens extension needed (using any device) and combination of K-rings for adequate extension, use ruler or straightedge to connect points representing the two known quantities: righthand column showing object area and center vertical line showing focal length of lens to be used.

2. Continuation of straight line to left vertical column will show amount of lens extension needed as well as combination of K-rings to be used. Any deficit between extension afforded by K-rings and requirements can be made by extending lens-focusing mechanism.

E2 tube usable as 14mm extension singly or in multiples with semi-automatic diaphragm control as shown in related illustrations.

E2 tubes—dimensional data.

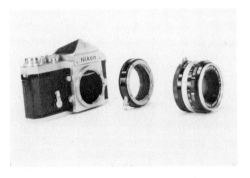

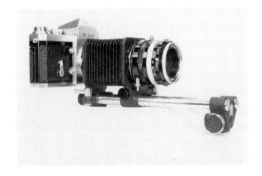

E2 tubes, used between camera body and lens.

E2 tube used between bellows attachment and lens, or between camera and lens, provides semi-automatic diaphragm control.

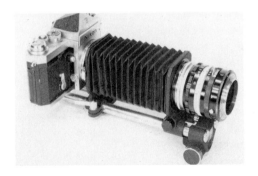

When lens is reversed with the use of BR-2 tube, addition of E2 tube on rear of lens mount (now in front of camera) provides semi-automatic diaphragm control.

Michael Melford

Close-up work is easiest when the subject is more or less on one plane, for depth of field limitations are minimized. Increasing the distance between lens and film enables the lens to focus objects at closer-than-normal distances, and provides the greatest degree of control and better image quality than that achieved with supplementary lenses.

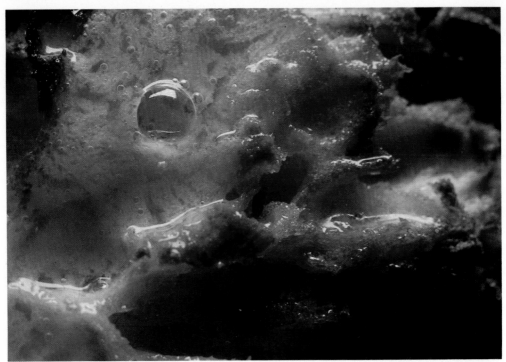

Tom Tracy

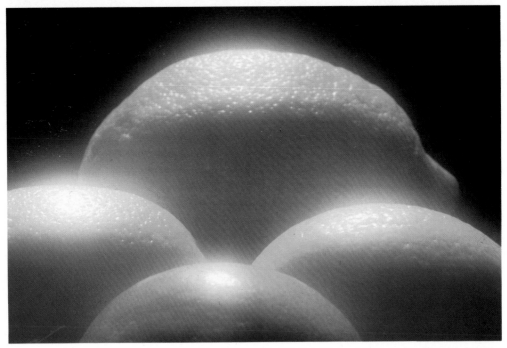

Michael Melford

(Top) Use of flash allows smaller apertures and consequent greater depth of field than would normally be obtained with available light only. Most food and product photography, like this crisp baked meringue, are illuminated by artificial sources. (Bottom) Use of a diffuser over the camera lens produced the halo effect on this fruit arrangement.

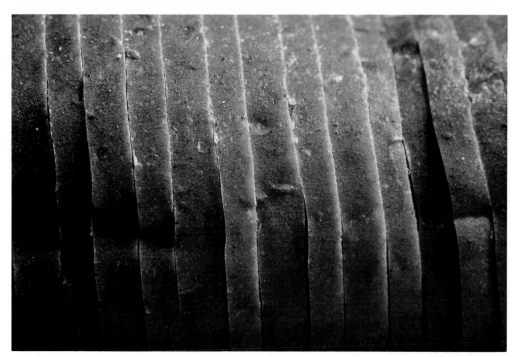

Tom Tracy

(Above) A close-up photograph directs attention to aspects of the subject that might normally go unnoticed. As this photograph of a sliced loaf of rye bread illustrates, the photographer must look for and learn to recognize the visual power of details in small, and often quite commonplace objects. (Right) Shallow depth of field allows the photographer to concentrate on a single, small detail and let everything else blur into background and foreground. Here, a single bubble on a wet surface becomes the center of an entire picture.

Michael Melford

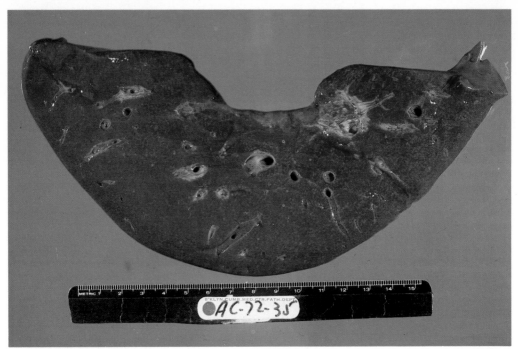

Gerald Finkel, M.D.

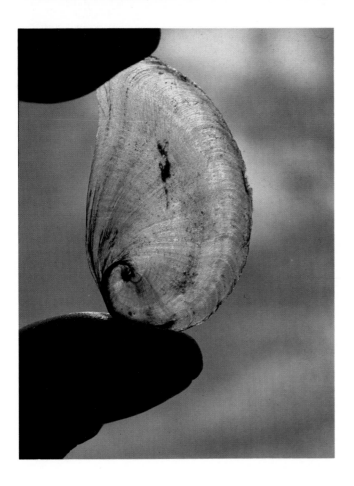

(Above) The micro-Nikkor lens was used to photograph this gross specimen of a human liver riddled with metastatic tumors. Ruler below is used to show scale. (Left) A plate from the shell of a moon snail was trans-illuminated by available light. Exposure was made for the shell only; the fingers holding it are cast into silhouette. Narrow depth of field creates a blurry background that does not detract from the delicacy of the main subject.

Herb Taylor

BELLOWS ATTACHMENTS

Because the bellows focusing attachments permit focusing over a smoothly continuous range of lens extension, they permit much greater flexibility in magnification than with close-up lenses or extension rings except where only minor extension is needed. Lenses to be used include the 24mm $f/2.8$ through the 300mm $f/4.5$ and the 43–86mm $f/3.5$ Zoom-Nikkor Auto. Other lenses may be used with some limitations in range. The 105mm $f/4$ Bellows-Nikkor and the earlier 135mm $f/4$ Bellows-Nikkor were specifically designed for use with the bellows focusing attachments.

Model PB-3 is intended as a portable accessory, whereas Models 2, PB-4 and PB-5 are intended mainly for use under home, laboratory, or darkroom conditions. (Models 2 and PB-3 are no longer being manufactured.)

The Bellows Focusing Attachment PB-6 is the only bellows unit which has built-in provision for utilizing the automatic diaphragm of the lens. With the other bellows units, automatic diaphragm operation is possible when the BR-4 Auto Ring, described below, is used between the lens and the bellows unit. The AR-4 Double Cable Release attaches to the Auto Ring BR-4 and to the camera's shutter release. When the plunger is depressed, the lens diaphragm closes to the selected aperture a moment before the shutter is released.

Vignetting perceived on the focusing screen of the camera is not likely to be reproduced on film.

All bellows models, except PB-3, accept slide-copying attachments.

Model PB-4 is equipped with an integral slider (or focusing rail) on its base for convenience in moving the entire camera-bellows-lens assembly forward or backward without disturbing lens-film plane distances.

All Nikon bellows models have standard front and rear Nikon F bayonet mounts. The bellows unit is attached to the camera and removed from it as is done with a lens.

Bellows Focusing Attachment PB-4

Model PB-4 is a combination bellows and slider. The bellows front has a swing and shift capability. A tripod socket in the base of the slider permits the entire assembly to be mounted on a tripod. The lens and camera carriers can be moved independently, using the sliding knobs on the left side of the bellows, to adjust image size and focus. Two locking knobs on the right hold lens and camera carriers rigidly after sharp focus has been achieved.

The slider is of great convenience in fine focusing when you do not wish to change the positions of the tripod, the subject, or any of the components of the camera-lens-bellows assembly. The slider moves camera, lens, and bellows forward and backward as a unit over a range of 152mm. A slider lock knob fixes the position of the entire bellows assembly rigidly.

To rotate the camera 90 degrees from vertical to horizontal and vice versa, pull the button on the camera carrier toward the bellows.

Bellows-Nikkor 105mm f/4 usable on bellows from close-range to infinity focusing; especially corrected for close-up work.

The lens carrier may be shifted 10mm to the right or left for corresponding changes in image coverage without other movement of subject or camera. This is particularly convenient when slide copying under magnification. The swing of the lens on a left-right pivot of 25 degrees is helpful in increasing depth of field. To change swings and shifts to vertical movements, the bellows assembly can be shifted 90 degrees on a tripod mount.

Slide Copying Adapter PS-4 or PS-5 may be attached to the front of the bellows.

Bellows Focusing Attachment PB-5

The Bellows Focusing Attachment PB-5 is a simplified version of the PB-4. Both have the same range of focus extension, but the PB-5 does not have either the sliding support or the front swing and tilt of the PB-4. Focusing and image control are accomplished by moving the camera and lens carriers after you have made the initial placement of subject and lens. This may be done by table reference or by trial and error.

To rotate the bellows 90 degrees, from horizontal to vertical or vice versa, push the milled release on the camera carrier.

To attach the bellows to a tripod, in general, use the socket on the bottom of the bellows camera carrier. When the weight of camera and lens moves forward, as may be the case when attaching the slide-copying device, use the socket on the bottom of the front-end brace to achieve satisfactory balance.

Double Cable Release AR-4
Auto Ring BR-4

The Double Cable Release AR-4 and Auto Ring BR-4, when used with the Bellows Focusing Unit PB-4 or PB-5, permit automatic operation of the Nikkor lens in use. The BR-4 ring is mounted between the bellows and the lens (providing an extension of 9mm), while the two cables of the AR-4 release are connected to the camera body and the ring, respectively. When both units are mounted, the plunger of the AR-4 release is simply depressed to stop down the lens and release the shutter.

The BR-4 ring is mounted to the bellows in the same manner as a lens. The lens is then mounted to the ring in the same manner as it is attached to the bellows, except that the lens will lock at a point 15 degrees beyond the normal locking position.

The Auto Ring BR-4 is provided with a lever for depth-of-field checks and for stop-down exposure measurement. When depressed, the lever closes the lens diaphragm to its preset aperture. The lever can be locked in position, if desired. When using the camera's metering system, the lens must be stopped down for exposure measurement.

When the lens is mounted in reverse position via the Macro Adapter Ring BR-2, operation of the Auto Ring BR-4 is the same, except that the BR-4 ring is mounted in front of the lens, rather than between the lens and the bellows.

BELLOWS FOCUSING ATTACHMENT PB-6

The Bellows Focusing Attachment PB-6 is a new "system" unit from Nikon offering several advanced features. Chief among these is the unique lensboard which permits "automatic" diaphragm operation when used with the Double Cable Release AR-4. In effect, the Auto Ring BR-4 is a built-in feature of this unit.

Another unique feature of the lensboard is that it may be removed from the focusing rail, reversed, and reinstalled with a lens attached. To do this, first unscrew the bellows retaining screw on the side of the lens panel and detach the bellows from the panel. Then, unscrew the front end-stop from the rail and remove it. Unclamp the lens panel and rack it out to the end of the rail, until it slips easily off the front. Reverse the panel and replace it on the rail with the front of the lens facing the bellows. Clamp the end of the bellows to the front

rim of the lens, gently, by turning the bellows retaining screw. Screw the front end-stop back onto the rail.

This feature effectively eliminates the need to use the Macro Adapter Ring AR-2, except when the Macro Ringlight Unit SM-2 is used. (The Ringlight must be attached to the Macro Adapter Ring AR-2.)

The PB-6E Extension Bellows can be connected to the front of the PB-6 to permit continuous bellows extension up to 438mm. The PS-6 Slide Copying Adapter mounts to the front end of the PB-6 or PB-6E and can be used to duplicate mounted 35mm transparencies or roll film.

The PB-6M Macro Copy Stand attaches to the front end of the rail and acts as both the subject stage and as a support for the camera/bellows/lens assembly in macrophotography.

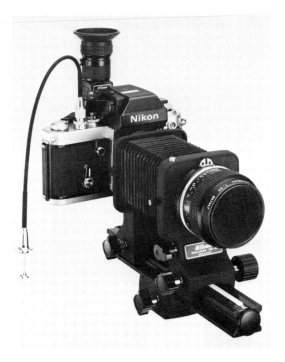

Bellows Focusing Attachment PB-6

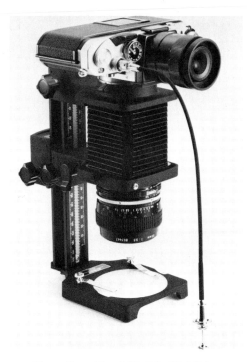

Macro Copy Stand PB-6M with PB-6

PARTS NOMENCLATURE OF
BELLOWS FOCUSING ATTACHMENT PB-6

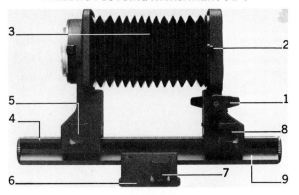

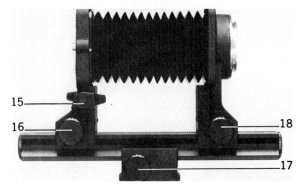

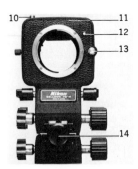
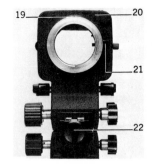

Parts Nomenclature of Bellows Focusing Attachment PB-6

1. Aperture-control lever
2. Bellows retaining screw
3. Bellows
4. Bellows extension scales
5. Camera panel locking knob
6. Tripod head
7. Tripod-head locking knob
8. Lens-panel locking knob
9. Rail
10. Cable-release attachment
11. Lens panel
12. Lens-mounting index
13. Lens-release button
14. Front-end stop
15. Aperture-control lever
16. Lens-panel traversing knob
17. Tripod-head traversing head
18. Camera-panel traversing knob
19. Camera-mounting index
20. Camera panel
21. Camera rotation clamp
22. Rear-end stop

REPRODUCTION

Lens		Mounting position	Reproduction ratio	Subject field
20mm	f/4	Reverse	Extension	
	f/3.5		Working distance	
24mm	f/2.8	Reverse	Extension	
	f/2		Working distance	
28mm	f/3.5	Normal	Extension	
	f/2.8		Working distance	
	f/2	Reverse	Extension	
	f/4 PC		Working distance	
35mm	f/2	Normal	Extension	
			Working distance	
	f/1.4	Reverse	Extension	
			Working distance	
35mm	f/2.8	Normal	Extension	
			Working distance	
	f/2.8 PC	Reverse	Extension	
			Working distance	
45mm f/2.8 GN		Normal	Extension	
			Working distance	
		Reverse	Extension	
			Working distance	
50mm	f/2	Normal	Extension	
	f/1.8		Working distance	
	f/1.4	Reverse	Extension	
	f/1.2		Working distance	
55mm	f/3.5 Micro	Normal	Extension	
			Working distance	
	f/1.2	Reverse	Extension	
			Working distance	
58mm f/1.2 Noct		Normal	Extension	
			Working distance	
		Reverse	Extension	
			Working distance	
85mm f/2		Normal	Extension	
			Working distance	
		Reverse	Extension	
			Working distance	
105mm	f/4 Micro	Normal	Extension	
			Working distance	
	f/2.5	Reverse	Extension	
			Working distance	
135mm	f/3.5	Normal	Extension	
	f/2.8		Working distance	
	f/2	Reverse	Extension	
			Working distance	
180mm f/2.8		Normal	Extension	
			Working distance	
200mm f/4		Normal	Extension	
			Working distance	

(mm)

∞	360	180	144	108	72	36	18	12	9	7.2	6	5.1	4.5	4	3.6	3.3	3	2.6	2.3	2	1.8	1.6	1.5
×	×	×	×	×	×	×	×	×	×	×	×	×	×	×	×	×	×	×	×	×	×	×	×
∞	240	120	96	72	48	24	12	8	6	4.8	4	3.4	3	2.7	2.4	2.2	2	1.7	1.5	1.3	1.2	1.1	1
1/∞×	1/16×	1/8×	1/4×	1/3×	1/2×	1×	2×	3×	4×	5×	6×	7×	8×	9×	10×	11×	12×	14×	16×	18×	20×	22×	24×

Data rows (each lens gives two value rows — bellows extension values and corresponding distance values):

Row 1: 72, 103, 123, 144, 164, 185, 208, 225, 266, 307, 348, 389, 429, 438
Row 1: 38, 36.9, 36.4, 36.1, 35.8, 35.5, 35.3, 35.2, 35, 34.8, 34.6, 34.5, 34.4, 34.4

Row 2: 83, 111, 135, 160, 184, 208, 233, 257, 282, 330, 379, 428, 438
Row 2: 39.8, 38.4, 37.6, 37, 36.6, 36.2, 35.9, 35.7, 35.5, 35.2, 35, 34.9, 34.8

Row 3: 48, 84
Row 3: 7.3, 0

Row 4: 83, 105, 133, 162, 191, 208, 219, 248, 276, 305, 334, 391, 438
Row 4: 42.3, 40.7, 39.2, 38.3, 37.6, 37.3, 37.1, 36.7, 36.4, 36.1, 35.9, 35.5, 35.3

Row 5: 48, 72, 108, 154
Row 5: 18.6, 9.6, 3.6, 0

Row 6: 89, 141, 177, 208, 249, 285, 321, 357, 393, 438
Row 6: 47.6, 42.5, 40.7, 39.6, 38.6, 38, 37.5, 37.1, 36.8, 36.4

Row 7: 48, 72, 108, 144, 180, 208, 252, 288, 324, 360, 396, 438
Row 7: 24.2, 15.2, 9.1, 6.2, 4.4, 3.4, 2.3, 1.7, 1.1, 0.8, 0.4, 0.1

Row 8: 83, 105, 141, 177, 208, 249, 285, 321, 357, 393, 438
Row 8: 48.5, 45.5, 42.5, 40.7, 39.6, 38.6, 38, 37.5, 37.1, 36.8, 36.4

Row 9: 48, 93, 140, 186, 208, 233, 279, 306, 372, 419, 438
Row 9: 73, 51, 43, 39.1, 37.9, 36.8, 35.2, 34.1, 33.3, 32.7, 32.4

Row 10: 57, 94, 141, 187, 208, 234, 280, 327, 373, 420, 438
Row 10: 72, 57, 49, 45.1, 43.9, 42.8, 41.2, 40.1, 39.3, 38.7, 38.4

Row 11: 48, 103, 155, 208, 258, 310, 361, 413, 438
Row 11: 65, 34.3, 25.7, 21.3, 18.8, 17.1, 15.9, 15, 14.6

Row 12: 78, 106, 158, 208, 261, 313, 364, 416, 438
Row 12: 69, 59, 51, 46.5, 43.8, 42.1, 40.9, 40, 39.6

Row 13: 48, 110, 165, 208, 275, 330, 440, 438
Row 13: 65, 29.1, 19.9, 16.1, 12.6, 10.8, 8.5, 8.5

Row 14: 92, 120, 175, 208, 230, 285, 340, 395, 438
Row 14: 71, 61, 52, 48.8, 47.3, 44.5, 42.7, 41.4, 40.6

Row 15: 48, 116, 174, 208, 232, 290, 348, 406, 438
Row 15: 74, 32.7, 23, 19.9, 18.2, 15.3, 13.4, 12, 11.4

Row 16: 88, 125, 183, 208, 241, 299, 357, 415, 438
Row 16: 76, 63, 53, 50, 48, 45.1, 43.2, 41.8, 41.3

Row 17: 48, 85, 170, 208, 255, 340, 438
Row 17: 210, 140, 97, 90, 83, 76, 71

Row 18: 90, 103, 146, 208, 316, 401, 438
Row 18: 290, 200, 120, 83, 62, 55, 53

Row 19: 48, 105, 208, 315, 438
Row 19: 300, 170, 120, 100, 92

Row 20: 133, 142, 151, 168, 208, 221, 326, 438
Row 20: 670, 450, 350, 240, 150, 140, 86, 68

Row 21: 48, 68, 135, 208, 270, 405, 438
Row 21: 520, 420, 280, 230, 210, 190, 190

Row 22: 180, 194, 208, 214, 225, 248, 315, 438
Row 22: ∞, 1400, 680, 570, 440, 300, 170, 100

Row 23: 48, 60, 90, 208, 360, 438
Row 23: 830, 690, 510, 310, 240, 230

Row 24: 48, 67, 100, 208, 400, 438
Row 24: 1200, 920, 720, 520, 420, 420

Notes:
1) AI-Nikkor lens is used; with non-AI Nikkor, the values may be slightly different.
2) Magnifications are those obtained at the infinity setting.
3) If more than one lens is included in each lens column, magnifications apply only to the first lens.
4) The 135mm f/2 and 28mm f/4 PC lenses cannot be used in the reverse position because of the larger size of their attachments.
5) ☐ = with PB-6 alone.
 ☐ = with PB-6 and PB-6E together.

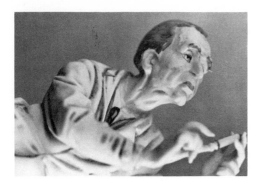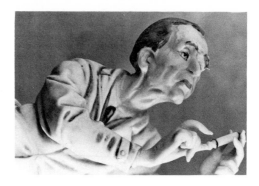

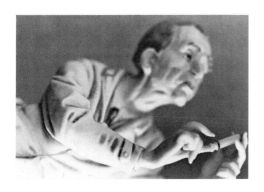

Apparent depth of field increased through use of the swing front of Bellows PB-4. Photos above left and above right show either hand or head of statuette selectively in focus at full aperture with Bellows-Nikkor 105mm f/4 parallel with film plane. Photo at left shows greater apparent depth achieved when lens carrier is turned on its pivot. Effect achieved by swinging lens is to bring the near and far elements of sharpness closer together within the same image plane. Another use of swinging front is to minimize or overcome perspective effects at close range. Photos by J.D. Cooper.

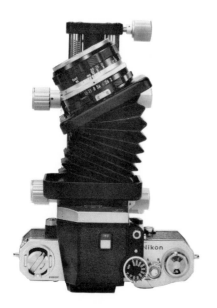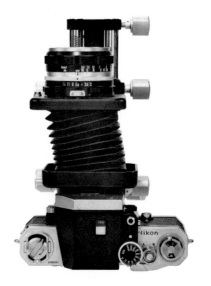

Bellows swing. The effect of increasing depth of field can be achieved by swinging the lens as shown.

Shifting lens. The purpose of shifting the lens is to have more latitude in selection of areas of a transparency to be magnified and copied. Shifting the lens changes the area of coverage.

Bellows 2 (Discontinued)

The magnification range of Bellows Model 2 with the 50mm $f/2$ lens is 1:1 to 3.6:1; while in reverse mode using the BR-2 Macro Adapter Ring, the magnification range is from 1.7:1 to 5.1:1. Bellows 2 is used most commonly with the 50mm $f/2$ lens and the 135mm $f/4$ Bellows-Nikkor short-mount lens. Magnification and exposure scales for both of these lenses are engraved on the bellows rails. Magnification scales for other lenses are shown in the accompanying conversion table.

Earlier versions of Bellows 2 required that the Photomic and Photomic T finders be removed before attaching or detaching the bellows and before changing from horizontal to vertical positions (and vice versa). The final production model (designated here as IIa) corrected this by adding 3mm to the rear standard. When used in conjunction with the 135mm short-mount lens, this extension makes it impossible to focus at infinity when using the standard BR-1 adapter, even though the entire assembly is fully retracted. To compensate for this, a new adapter was brought out, referred to here as the BR-1a, although for simplicity in the succeeding text, it will be referred to generally as the BR-1. The BR-1a is approximately 3mm shallower in depth. The newer model of the Bellows Model 2 (which is identifiable here as Bellows IIa, but which is also referred to generally in the text as Bellows Model 2) is identifiable by the length of the rail slider on the right side of the bellows, when facing it from the front. The rail slider on the IIa is approximately 28mm in length, while on the Model 2 it is about 25mm. These changes were incorporated from serial number 106700 onwards.

The bellows may be extended either at its front end adjacent to the lens or at its rear end adjacent to the camera. At the front end, the bellows is moved by rotating the knurled knob. At the rear, the lock lever is loosened and the bellows is moved forward or backward by hand pressure. When sliding the lens-mount end of the bellows, the camera-mount end should be securely fastened by the lock lever.

Approximate magnifications are set as follows:

1. With the 50mm $f/2$ lens focused at the lens-mount end of the bellows, make sure first that the camera end is locked firmly against the rear stops. Rotate the knurled knob until the front edge of the lens-mount slider is brought to the desired number on the left-hand rail (viewed from the camera). Fine focusing is then done by looking through the viewfinder. Image magnification can also be adjusted from the camera-mount end of the bellows. This may be necessary when the front part of the bellows rails prevents approaching the subject. In this case, the lens-mount slider is moved forward against the front stops. The camera-mount slider is then moved forward to the desired reproduction ratio number engraved in red. Red numbers are read with the rear edge of the camera-mount serving as the index. The black and red scales are identical except that they read in reverse directions.

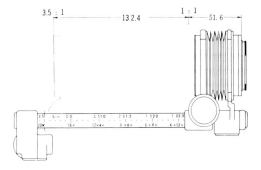

Bellows Model II—dimensional data.

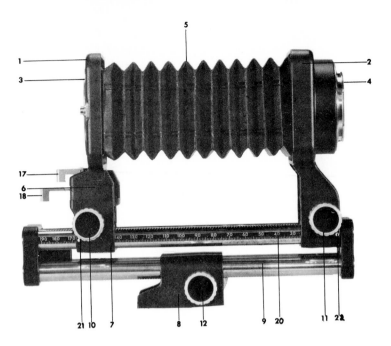

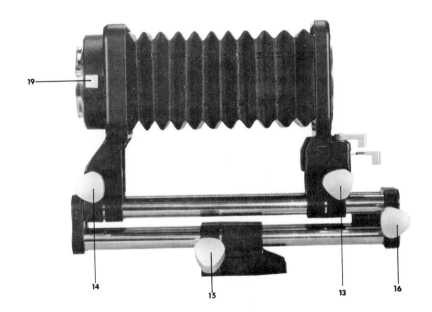

Parts Nomenclature of Bellows Attachment PB-4

1. Lens carrier
2. Camera carrier
3. Lens-mount bayonet
4. Camera-mount bayonet
5. Bellows
6. Shift and swing slider
7. Lens slider
8. Tripod head

9. Sliding support
10. Lens-sliding knob
11. Camera-sliding knob
12. Sliding-support knob
13. Lens lock
14. Camera lock
15. Sliding-support lock
16. Slide-copying adapter lock

17. Shift lock
18. Swing lock
19. Camera-position changing button
20. Scale
21. Scale index (yellow, lens side)
22. Scale index (white, camera side)

40

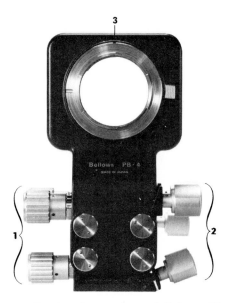

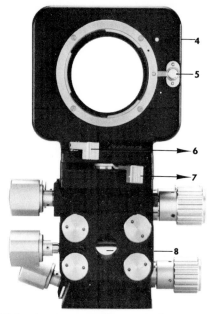

Front and rear views of Bellows Attachment PB-4, showing operating controls.

1. Sliding knob
2. Clamp
3. Camera attaching index notch
4. Lens attaching index dot
5. Lens detaching button
6. Shift (releasing direction)
7. Swing (releasing direction)
8. Slide-copying adapter attaching hole

Rotation of the camera between vertical and horizontal positions on the bellows is accomplished by pulling the camera-position changing button toward the bellows. This releases the camera for turning.

Image-ratio readout. Dot shown below right-hand knob is white. Dot below lefthand knob is yellow. Difference between two readouts from scale indexed by outside edges of slider supports gives reference number through which reproduction ratio may be found in accompanying tables. Thus, in this illustration, difference between yellow side 140 and white side 44 is 96. Reference to table showing 50mm f/2 in reverse position gives image ratio of about 2.5×.

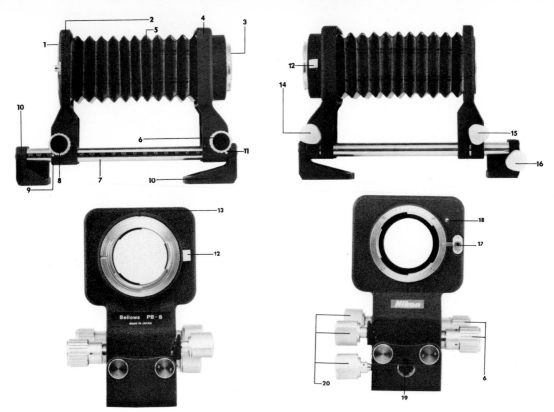

Parts Identification of Bellows Model PB-5

1. Lens-mount bayonet
2. Lens carrier
3. Camera-mount bayonet
4. Camera carrier
5. Bellows
6. Camera-sliding knob
7. Scale
8. Lens-sliding knob
9. Scale index (yellow, lens side)
10. Tripod head
11. Scale index (white, camera side)
12. Camera-position changing button
13. Camera-attaching index notch
14. Camera lock
15. Lens lock
16. Slide-copying adapter lock
17. Lens-detaching button
18. Lens-attaching index dot
19. Slide-copying adapter attaching hole
20. Clamp

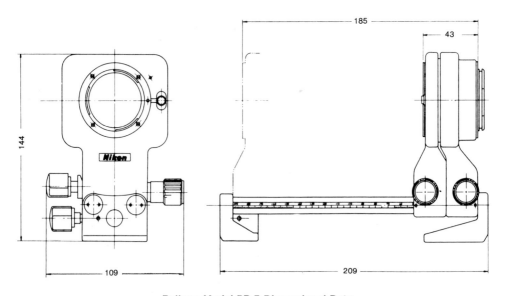

Bellows Model PB-5 Dimensional Data

42

Swing correction at full aperture with Bellows PB-4 and 105mm f/4 Bellows-Nikkor lens shown in right photo as compared to left which has no swing correction at all.

Joe Di Maggio

Effort to obtain greater depth of field in left photo was attempted with 105mm f/4 lens on normal optical axis. Note that at close range with bellows, sharpness still does not reach to rear figure. Swing adjustment yielded full sharpness and also brought in background pattern more clearly. Photos by Joe Di Maggio, Nikon technical representative.

 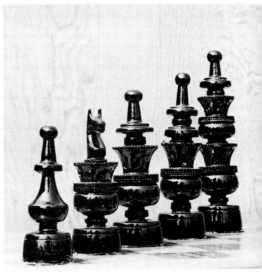

MAGNIFICATION RANGE OBTAINED BY NIKON BELLOWS ATTACHMENT MODEL II (Lens Set at ∞)*

Lens Type	Position	Magnification Range (12× → ½)	NOTES
Nikkor 21mm f/4	Normal	0.5 — 1.1	A
	Reverse	0.9 — 1.1	
Nikkor Auto 24mm f/2.8	Reverse	3.7 — 3.8	A
Nikkor Auto 28mm f/3.5	Normal	0 — 0.7	B,C
	Reverse	3.8 — 4.2	A
Nikkor Auto 35mm f/2	Normal	0 — 2	C
	Reverse	4.2 — 5	A
Nikkor Auto 35mm f/2.8	Normal	0 — 2	C
	Reverse	4 — 4.8	A
PC-Nikkor 35mm f/3.5	Normal	0.3 — 2.5	C
	Reverse	4.7 — 5.5	C
Nikkor Auto 50mm f/1.4	Normal	0.9 — 5.2	B,C
	Reverse	4.8 — 6.2	E
Nikkor Auto 50mm f/2	Normal	2.6 — 6.8	C
	Reverse	4.9 — 6.8	F
Nikkor Auto 55mm f/1.2	Normal	1.5 — 6.9	B,G
	Reverse	4.7 — 7.6	E
Micro-Nikkor Auto 55mm f/3.5	Normal	1.5 — 6.6	A
	Reverse	5 — 6.8	

(Wide-angle lenses: 21mm–35mm; Standard lenses: 50mm–55mm)

A—Image quality is best at f/8 and degenerates as lens is stopped down further.
B—Suitable for normal close-up photography but unsuitable for copying.
C—The further the lens is stopped down, the better the image quality.
D—Image quality is good at high magnifications but corner image quality degenerates at infinity.
E—Corner image quality degenerates at low magnifications.
F—At high magnifications, corner-image quality degenerates somewhat when the lens is stopped down further than f/8.
G—Since corner-image quality is poor it is advisable to stop down the lens as far as possible.

Lens Type	Position	Magnification Range (enlarged ← 7× ... 1× ... → reduced 1/∞×)	NOTES
Nikkor Auto 85mm f/1.8	Normal	8.8 — 21	C
	Reverse	8 — 19	E
Nikkor Auto 105mm f/2.5	Normal	16 — 33	C
	Reverse	12 —	D
Nikkor Auto 135mm f/2.8	Normal	22 — 51	C
	Reverse	20 —	D
Nikkor Auto 135mm f/3.5	Normal	24 — 53	C
	Reverse	25 —	D
Nikkor for Bellows 135mm f/4	Normal	23 —	C
Nikkor Auto 200mm f/4	Normal	55 — 126	C
Nikkor Auto 300mm f/4.5	Normal	98 — 233	C
Reflex-Nikkor 500mm f/5	Normal	165 — 214	
Zoom-Nikkor Auto 43-86mm f/3.5 — 43mm	Normal	0 — 3	C
43mm	Reverse	4.6 — 5.5	
86mm	Normal	6.5 — 16	
86mm	Reverse	(Lens focused at 1.2m) 6.8 — 13.4	

(Telephoto lenses: 85mm–500mm; Zoom lens: 43-86mm)

* This table of magnification ranges includes lenses available at the time this bellows model was in active production.

MAGNIFICATIONS DEPENDING UPON EXTENSION OF THE BELLOWS MODEL II*

24 mm f/2.8
- Scale: 140 130 120 110 100 90 80 70 60 50 40 30
- Normal: 2×(0) 1.5×(0.2)
- Reverse: 8.5×(3.8) 8×(3.8) 7.5× 7×(3.8) 6.5× 6×(3.9) 5.5× 5×(3.9) 4.5× 4×(4.1)

28 mm f/3.5
- Scale: 140 130 120 110 100 90 80 70 60 50 40 30
- Normal: 3×(0) 2.5×(0.1) 2×(0.4) 1.5×(0.9)
- Reverse: 7×(3.9) 6.5×(3.9) 6×(3.9) 5.5×(4) 5×(4) 4.5×(4.1) 4×(4.2) 3.5×(4.3)

35 mm f/2
35 mm f/2.8
- Scale: 140 130 120 110 100 90 80 70 60 50 40 30
- Normal: 3.5×(0.2) 3×(0.4) 2.5×(0.6) 2×(1) 1.5×(1.6) 1×(2.8)
- Reverse: 5.5×(4.4) 5×(4.4) 4.5×(4.5) 4×(4.6) 3.5×(4.7) 3×(4.9) 2.5×(5.1)

50 mm f/1.4
- Scale: 140 130 120 110 100 90 80 70 60 50 40 30
- Normal: 2.5×(1.5) 2×(2) 1.5×(2.9) 1×(4.6)
- Reverse: 3.5×(5.2) 3×(5.4) 2.5×(5.8) 2×(6.3)

50 mm f/2
- Scale: 140 130 120 110 100 90 80 70 60 50 40 30
- Normal: 2.5×(3.3) 2(3.8) 1.5(4.7) 1×(6.4)
- Reverse: 3.5×(5.2) 3(5.4) 2.5(5.8) 2(6.3) 1.5(7.1)

55 mm f/1.2
55 mm f/3.5
- Scale: 140 130 120 110 100 90 80 70 60 50 40 30
- Normal: 2.5×(1.8) 2×(2.3) 1.5×(3.2) 1×(5.1) 0.6×(8.8)
- Reverse: 3.4×(5.2) 3×(5.5) 2.5×(5.8) 2×(6.4) 1.5×(7.3)

85 mm f/1.8
- Scale: 140 130 120 110 100 90 80 70 60 50 40 30
- Normal: 1.5×(11) 1×(13.5) 0.5×(22)
- Reverse: 1.5×(9.5) 1×(12) 0.5×(21)

105 mm f/2.5
105 mm f/4
- Scale: 140 130 120 110 100 90 80 70 60 50 40 30
- Normal: 1.3×(18) 1×(21) 0.5×(32) 0.3×(44)
- Reverse: 0.8×(15) 0.5×(26) (∞)

135 mm f/2.8
- Scale: 140 130 120 110 100 90 80 70 60 50 40 30
- Normal: 1×(26) 0.5×(39) 0.3×(68)
- Reverse: 0.5×(31) (∞)

* This table of magnification ranges includes lenses available at the time this bellows model was in active production.

IMAGE (REPRODUCTION) RATIOS FOR BELLOWS MODELS PB-4 AND PB-5

Relation between rail marking and reproduction ratio of Bellows Focusing Attachment PB-4 and PB-5.

Reading of rail marking: 50, 60, 70, 80, 90, 100, 110, 120, 130, 140, 150, 160, 170, 180, 190

Lens	Position	Readings (rail marking → ratio × (distance))
24mm f/2.8	Reverse	4.5x(4), 5x(3.9), 6x(3.8), 7x(3.8), 8x(3.7), 9x(3.7), 10x(3.7)
28mm f/3.5	Normal/Reverse	1.5x(0.9), 2x(0.4), 2.5x(0.1), 2.9x(0); 3.6x(4.2), 4x(4.2), 4.5x(4.1), 5x(4), 5.5x(4), 6x(3.9), 6.5x(3.9), 7x(3.9), 7.5x(3.8), 8x(3.8), 8.5x(3.8)
35mm f/2 [35mm f/2.8, 35mm f/2.8PC]	Normal/Reverse	1.2x(2.2), 1.5x(1.6), 2x(1), 2.5x(0.6), 3x(0.4), 3.5x(0.2), 4x(0.1), 4.5x(0); 3x(4.9), 3.5x(4.7), 4x(4.6), 4.5x(4.5), 5x(4.4), 5.5x(4.4), 6x(4.3), 6.5x(4.3)
45mm f/2.8 GN	Normal/Reverse	1x(7.4), 1.5x(5.9), 2x(5.1), 2.5x(4.6), 3x(4.3), 3.5x(4.1); 1.5x(6.7), 2x(5.9), 2.5x(5.4), 3x(5.1), 3.5x(4.9), 4x(4.7)
50mm f/1.4	Normal/Reverse	1x(4.6), 1.5x(2.9), 2x(2), 2.5x(1.5), 3x(1.2), 3.5x(0.9); 2x(6.3), 2.5x(5.8), 3x(5.4), 3.5x(5.2), 4x(5), 4.5x(4.8)
50mm f/2	Normal/Reverse	1x(6.4), 1.5x(4.7), 2x(3.8), 2.5x(3.3), 3x(3), 3.5x(2.7); 1.6x(6.9), 2x(6.3), 2.5x(5.8), 3x(5.4), 3.5x(5.2), 4x(5.1), 4.3x(4.9)
55mm f/1.2 [55mm f/3.5 Micro]	Normal/Reverse	1x(5.1), 1.5x(3.2), 2x(2.3), 2.5x(1.8), 3x(1.4), 3.3x(1.2); 2x(6.4), 2.5x(5.8), 3x(5.5), 3.5x(5.3), 4x(5)
85mm f/1.8	Normal/Reverse	0.6x(18), 0.8x(16), 1x(14), 1.2x(12), 1.4x(11), 1.6x(10), 1.8x(9.8), 2x(9.3); 0.6x(16), 0.8x(14), 1x(12), 1.2x(11), 1.4x(10), 1.6x(9.2), 1.8x(8.6), 2x(8.1)
105mm f/2.5	Normal/Reverse	0.4x(36), 0.6x(28), 0.8x(24), 1x(21), 1.2x(19), 1.4x(18), 1.6x(17); (∞), 0.2x(57), 0.4x(31), 0.6x(22), 0.8x(18), 1x(15), 1.2x(14)
135mm f/2.8 [135mm f/3.5]	Normal/Reverse	0.4x(46), 0.6x(35), 0.8x(29), 1x(26), 1.2x(24), 1.3x(23); (∞), 0.2x(74), 0.4x(41), 0.6x(29), 0.8x(24)
135mm f/4 Bellows	Normal	(∞), 0.2(81), 0.4x(47), 0.6x(36), 0.8x(30), 1x(27)
180mm f/2.8	Normal	0.3x(77), 0.4x(62), 0.5x(53), 0.6x(47), 0.7x(43), 0.8x(40), 0.9x(37), 1.(35)
200mm f/4	Normal	0.3x(101), 0.4x(84), 0.5x(74), 0.6x(68), 0.7x(63), 0.8x(60), 0.9x(57)
300mm f/4.5	Normal	0.15x(254), 0.2x(204), 0.3x(154), 0.4x(129), 0.5x(114), 0.8x(104)

Note: Figures in parentheses indicate distance between the lens front and the subject.

MAGNIFICATION RANGES, FREE WORKING DISTANCES AND RELATIONS OF ACTUAL MAGNIFICATION TO BELLOWS II RAIL SCALE *

Type of lens	Position of lens attached	Magnification range (Working distance)		Actual magnification in relation to rail marking						
		Max.	Min.							
Nikkor-H Auto 28 mm f/3.5	Reverse	8.8× (37 mm)	3.8× (42 mm)	Mag.	4	5	6	7	8	8.8
				Rail	1.0	1.5	2.1	2.6	3.2	3.5
Nikkor-S Auto 35 mm f/2.8	Reverse	6.8× (41 mm)	2.9× (48 mm)	Mag.	3	4	5	6	6.5	
				Rail	1.0	1.7	2.4	3.1	3.5	
Nikkor-S Auto 50 mm f/1.4	Reverse	4.7× (49 mm)	2× (64 mm)	Mag.	2	2.5	3	3.5	4	4.5
				Rail	0.9	1.4	1.9	2.4	2.9	3.4
Nikkor-S Auto 50 mm f/2	Normal	3.6× (31 mm)	0.9× (77 mm)	Coincide with each other. Use the figures on the left-side rail.						
	Reverse	4.2× (47 mm)	1.6× (69 mm)	Mag.	2	2.5	3	3.5	4	
				Rail	1.4	1.9	2.4	2.9	3.4	
Nikkor-H Auto 50 mm f/2	Normal	3.7× (26 mm)	0.9× (72 mm)	Coincide with each other. Use the figures on the left-side rail.						
	Reverse	4.3× (50 mm)	1.7× (70 mm)	Mag.	2	2.5	3	3.5	4	
				Rail	1.3	1.8	2.3	2.8	3.3	
Nikkor-S Auto 58 mm f/1.4	Reverse	4× (50 mm)	1.6× (73 mm)	Mag.	2	2.5	3	3.5		
				Rail	1.4	2	2.5	3.1		
Micro-Nikkor 55 mm f/3.5	Normal	4.4× (18 mm)	0.8× (73 mm)	Mag.	1	1.5	2	2.5	3	
				Rail	1.1	1.6	2.2	2.7	3.2	
	Reverse	4.2× (50 mm)	1.7× (70 mm)	Mag.	2	2.5	3	3.5	4	
				Rail	1.2	1.7	2.3	2.8	3.3	
Micro-Nikkor Auto 55 mm f/3.5	Normal	3.8× (17 mm)	0.8× (71 mm)	Mag.	1	1.5	2	2.5	3	
				Rail	1.1	1.6	2.2	2.7	3.2	
	Reverse	4.2× (50 mm)	1.7× (70 mm)	Mag.	2	2.5	3	3.5	4	
				Rail	1.2	1.7	2.3	2.8	3.3	
Nikkor in short mount 135 mm f/4	Normal	1× (230 mm)	1/∞×	Coincide with each other. Use the figures on the right-side rail.						
Nikkor 105 mm f/2.5	Normal	1.9× (162 mm)	0.4× (355 mm)	Mag.	0.5	1				
				Rail	1.2	2.6				
	Reverse	1.3× (123 mm)	1/∞×	Mag.	1/∞	0.5				
				Rail	1.5	2.8				
Nikkor 105 mm f/4	Normal	2× (125 mm)	0.4× (319 mm)	Mag.	0.3	0.5	0.7	0.9		
				Rail	1.2	2	2.7	3.5		

* This table of magnification ranges includes lenses available at the time this bellows model was in active production.

MAGNIFICATION RANGES, FREE WORKING DISTANCES AND RELATIONS OF ACTUAL MAGNIFICATION TO BELLOWS II RAIL SCALE *

Type of lens	Position of lens attached	Magnification range (Working distance)		Actual magnification in relation to rail marking			
		Max.	Min.				
Nikkor–Q Auto 135 mm f/3.5	Normal	1.5× (261 mm)	0.3× (552 mm)	Mag.	0.5	1	1.5
				Rail	1.1	2.1	3.1
	Reverse	0.7× (246 mm)	1/∞×	Mag.	1/∞	0.5	1
				Rail	1.1	2.1	3.1
Nikkor–Q Auto 200 mm f/4	Normal	1× (546 mm)	0.25× (1140 mm)	Mag.	0.5	1	1.5
				Rail	1	2.1	3.1

* This table of magnification ranges includes lenses available at the time this bellows model was in active production.

When using the 135mm f/4 short-mount lens (with the BR-1 adapter), the proper scale is on the right-hand rail (viewed from the camera). The scale markings for this lens are for focusing from the lens-mount end.

3. For other lenses, refer to the table of magnifications converted from the scale reading on the left-hand rail.

4. When the BR-2 Macro Adapter Ring is used, the engraved image ratios on the bellows rail are no longer applicable. The image ratio must then be found by formula, given earlier in this chapter.

Bellows PB-3 (Discontinued)

The image magnification range of Bellows PB-3 with the 50mm f/2 lens in normal position is 0.6× to 2.8×. In reversed position, the range is 1.4× to 3.5×. The range of extension is 35–142mm.

This unit is of single-rail construction with dovetailed groove for rigidity and precision. It may be added or removed without disturbing the Photomic-series viewing heads. It cannot be rotated. For vertical or horizontal pictures, the entire camera-bellows assembly must be turned on the tripod mount. It does not accept a slide-copying attachment.

Extension or compression of the bellows is performed by turning the focusing knob on either side of the bellows. A fastening lever on the base of the bellows will lock the position.

The extension is read at the point of the triangular index mark next to the millimeter scale on the side of the rail. The image ratio is found by dividing the scale extension in millimeters by the focal length of the lens in millimeters. If extension tubes are added to the unit, the amount of extension in millimeters must be included in the computation. This computation does not pertain to use of supplementary close-up lenses unless a corrected focal length is derived as shown above in the section on such lens attachments.

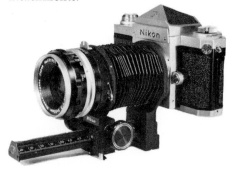

Bellows Model PB-3 on Nikon F.

MAGNIFICATION RANGES OBTAINED WITH NIKON BELLOWS MODEL PB-3*

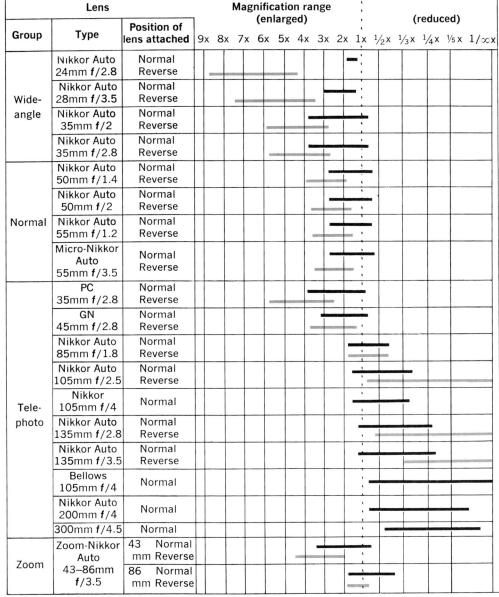

Group	Type	Position of lens attached	Magnification range (enlarged) — 9x 8x 7x 6x 5x 4x 3x 2x 1x / (reduced) ½x ⅓x ¼x ⅕x 1/∞x
Wide-angle	Nikkor Auto 24mm f/2.8	Normal / Reverse	
	Nikkor Auto 28mm f/3.5	Normal / Reverse	
	Nikkor Auto 35mm f/2	Normal / Reverse	
	Nikkor Auto 35mm f/2.8	Normal / Reverse	
Normal	Nikkor Auto 50mm f/1.4	Normal / Reverse	
	Nikkor Auto 50mm f/2	Normal / Reverse	
	Nikkor Auto 55mm f/1.2	Normal / Reverse	
	Micro-Nikkor Auto 55mm f/3.5	Normal / Reverse	
Tele-photo	PC 35mm f/2.8	Normal / Reverse	
	GN 45mm f/2.8	Normal / Reverse	
	Nikkor Auto 85mm f/1.8	Normal / Reverse	
	Nikkor Auto 105mm f/2.5	Normal / Reverse	
	Nikkor 105mm f/4	Normal	
	Nikkor Auto 135mm f/2.8	Normal / Reverse	
	Nikkor Auto 135mm f/3.5	Normal / Reverse	
	Bellows 105mm f/4	Normal	
	Nikkor Auto 200mm f/4	Normal	
	300mm f/4.5	Normal	
Zoom	Zoom-Nikkor Auto 43–86mm f/3.5	43 mm Normal / Reverse	
		86 mm Normal / Reverse	

(**Note:** Lens being set at ∞)

* This table of magnification ranges includes lenses available at the time this bellows model was in active production.

49

MAGNIFICATION DEPENDING UPON EXTENSION OF THE BELLOWS MODEL PB-3
(Lens Set at ∞)

24 mm f/2.8

Scale: 140 130 120 110 100 90 80 70 60 50 40 30

Normal: 2×(0) 1.5×(0.2)

Reverse: 8.5×(3.8) 8×(3.8) 7.5× 7×(3.8) 6.5× 6×(3.9) 5.5× 5×(3.9) 4.5× 4×(4.1)

28 mm f/3.5

Scale: 140 130 120 110 100 90 80 70 60 50 40 30

Normal: 3×(0) 2.5×(0.1) 2×(0.4) 1.5×(0.9)

Reverse: 7×(3.9) 6.5×(3.9) 6×(3.9) 5.5×(4) 5×(4) 4.5×(4.1) 4×(4.2) 3.5×(4.3)

35 mm f/2
35 mm f/2.8

Scale: 140 130 120 110 100 90 80 70 60 50 40 30

Normal: 3.5×(0.2) 3×(0.4) 2.5×(0.6) 2×(1) 1.5×(1.6) 1×(2.8)

Reverse: 5.5×(4.4) 5×(4.4) 4.5×(4.5) 4×(4.6) 3.5×(4.7) 3×(4.9) 2.5×(5.1)

50 mm f/1.4

Scale: 140 130 120 110 100 90 80 70 60 50 40 30

Normal: 2.5×(1.5) 2×(2) 1.5×(2.9) 1×(4.6)

Reverse: 3.5×(5.2) 3×(5.4) 2.5×(5.8) 2×(6.3)

50 mm f/2

Scale: 140 130 120 110 100 90 80 70 60 50 40 30

Normal: 2 5×(3.3) 2(3.8) 1.5(4.7) 1×(6.4)

Reverse: 3.5×(5.2) 3(5.4) 2.5(5.8) 2(6.3) 1.5(7.1)

55 mm f/1.2
55 mm f/3.5

Scale: 140 130 120 110 100 90 80 70 60 50 40 30

Normal: 2.5×(1.8) 2×(2.3) 1.5×(3.2) 1×(5.1) 0.6×(8.8)

Reverse: 3.4×(5.2) 3×(5.5) 2.5×(5.8) 2×(6.4) 1.5×(7.3)

85 mm f/1.8

Scale: 140 130 120 110 100 90 80 70 60 50 40 30

Normal: 1.5×(11) 1×(13.5) 0.5×(22)

Reverse: 1.5×(9.5) 1×(12) 0.5×(21)

105 mm f/2.5
105 mm f/4

Scale: 140 130 120 110 100 90 80 70 60 50 40 30

Normal: 1.3×(18) 1×(21) 0.5×(32) 0.3×(44)

Reverse: 0.8×(15) 0.5×(26) (∞)

135 mm f/2.8

Scale: 140 130 120 110 100 90 80 70 60 50 40 30

Normal: 1×(26) 0.5×(39) 0.3×(68)

Reverse: 0.5×(31) (∞)

MAGNIFICATION DEPENDING UPON EXTENSION OF THE BELLOWS MODEL PB-3

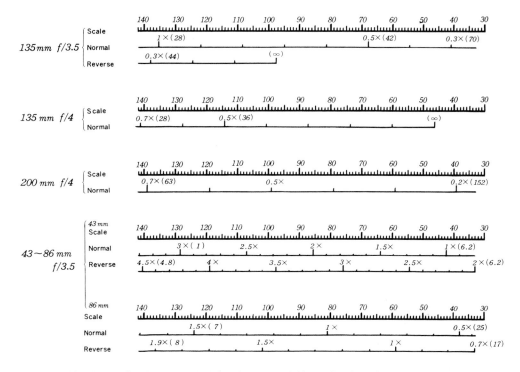

135mm f/3.5
Scale — Normal — Reverse
1×(28) 0.5×(42) 0.3×(70)
0.3×(44) (∞)

135 mm f/4
Scale — Normal
0.7×(28) 0.5×(36) (∞)

200 mm f/4
Scale — Normal
0.7×(63) 0.5× 0.2×(152)

43～86 mm f/3.5
43 mm Scale — Normal — Reverse
3×(1) 2.5× 2× 1.5× 1×(6.2)
4.5×(4.8) 4× 3.5× 3× 2.5× 2×(6.2)

86 mm Scale — Normal — Reverse
1.5×(7) 1× 0.5×(25)
1.9×(8) 1.5× 1× 0.7×(17)

* This table of magnification ranges includes lenses available at the time this bellows model was in active production.

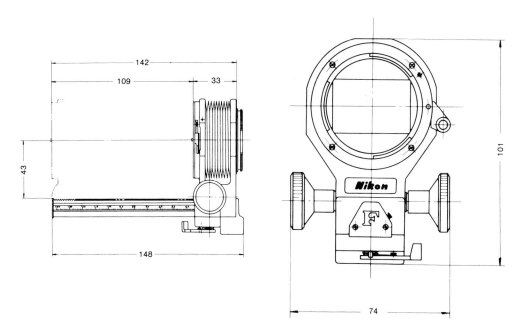

Bellows Model PB-3—dimensional data

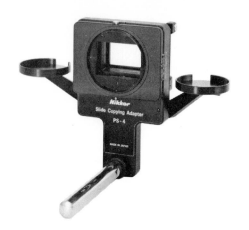

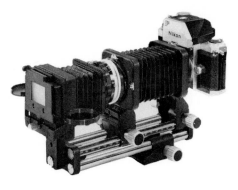

Bellows PB-4 with 50mm f/2 lens coupled to slide-copying adapter PS-4 to which is attached stripped film holder.

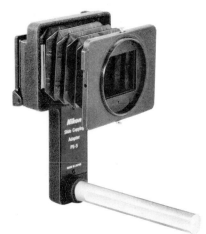

Slide-Copying Adapters PS-4 and PS-5 for use with any of the Nikon bellows-focusing attachments. Both permit same range of slide magnification in normal and reverse mode of lens, but PS-4 permits vertical and horizontal shift of film-retaining plate for precise cropping in magnification. Roll-film trays are available for the PS-4.

BR-3 tube serves as reverse adapter to couple slide-copier bellows to rear of lens.

Comparison Between Slide Copying Adapters			
Characteristics		PS-4	PS-5
Magnification w/50mm f/2 lens	Normal	1/1.2-2.4X	
	Reverse	1.6-4.4X	
Copying frame area		25 x 37mm	
Bellows extension		60mm	
Extent of shifts		6mm, vertically; 9mm, horizontally	
Trays for roll film		Available	No
Dimensions mm (in.) (width x height x length)		188(7.40) x 132(5.20) x 162.2mm (6.39'')	82.5(3.25) x 132(5.20) x 147.2mm (5.80'')
Weight		500g (17.6 oz)	360g (12.7 oz)

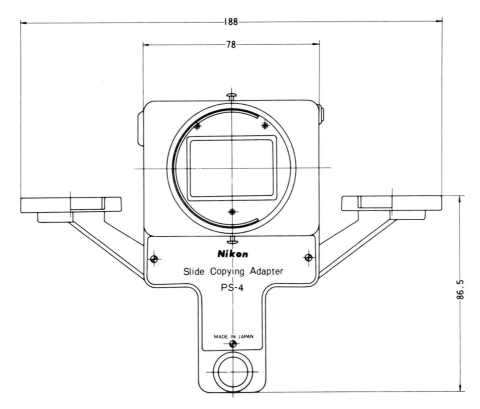

Dimensions for Slide-Copying Adapter PS-4

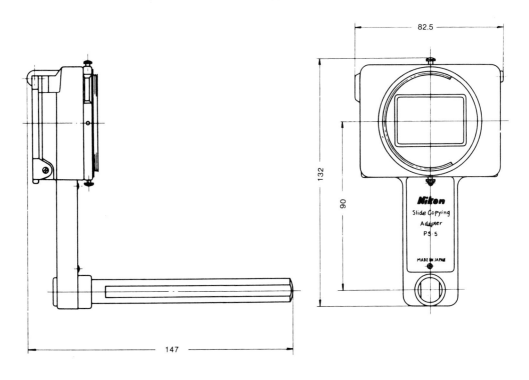

Dimensions for Slide-Copying Adapter PS-5

REVERSE ADAPTER

BR-2 Macro Adapter Ring

Any lens designed primarily for general use does not yield best performance at close range and particularly at magnifications higher than $1\times$. At these higher magnifications, a lens of asymmetrical design may be used in a reversed position using the BR-2 Macro Adapter Ring. The effect is to move the nodal point of the lens farther from the focal plane. This reduces the need for auxiliary lens extension and permits the object distance to be longer than otherwise, a particularly desirable feature with short-focus lenses. It is believed, also, to give better flatness of image overall. Again, when the Nikkor 50mm $f/1.4$ or the 50mm $f/1.2$ are used at magnifications approaching $1\times$ and higher, no satisfactorily sharp image over the whole picture field will be obtained. However, reversing the lens helps correct this somewhat. Nevertheless, even with the use of the BR-2, the diaphragms of these lenses should be stopped down as far as possible.

The BR-2 ring has a male (outside) thread on one side to fit into the female thread of the lens mount. A male bayonet on the other side of the BR-2 fits into the female bayonet flange on the camera body or bellows. When mounted directly onto the camera body, the BR-2 serves as a fixed image-ratio device for the indicated lenses, thus:

50mm lens = 1.14:1
35mm lens = 1.6:1
28mm lens = 2.28:1

The 55mm $f/3.5$ Micro-Nikkor-P Auto, when mounted in the reversed position on the bellows, covers the magnification range from $4.2\times$ to $1.7\times$, but not down to $1\times$. Therefore, the highest resolution over the entire picture area may not be expected for the magnification range of $1.7\times$ to $1.2\times$ because the lens must be used in the normal position for this range. Reversal of this lens achieves considerable extension away from the film plane due to the deep-set optics in normal mode.

The Auto Ring BR-4 can be mounted at the rear of any lens (facing front) for automatic diaphragm control in conjunction with the Double Cable Release AR-4. An E2 ring can be mounted for semi-automatic diaphragm control. The addition of any ring to the lens does not affect lens extension, since the ring is now in front of the lens.

SLIDE-COPYING ADAPTERS AND ACCESSORIES

Comparative features of Slide Copying Adapters PS-4 and PS-5 are given in the accompanying chart. The essential difference is that the PS-4 affords both vertical and horizontal shifts for selective cropping, whereas the PS-5 has a fixed slide-framing area. Either slide copier can be used with Bellows Focusing Attachments PB-4 or PB-5. Any Nikkor lens in the range of 24–85mm can be used.

Procedure for Slide-Copying Adapter

Slide Copying Adapter PS-4 or PS-5 is attached to the bellows focusing attachment. The slide-copying adapter has its own bellows, which is normally attached to the 50mm $f/2$ Nikkor-H Auto lens, the most commonly used lens. This bellows acts as a lightproof tunnel to prevent reflections from lighting sources in front of the film. The transparency to be copied is held in the film carrier with the emulsion surface facing the opal glass.

To attach the slide-copying adapter to the bellows focusing attachment, release

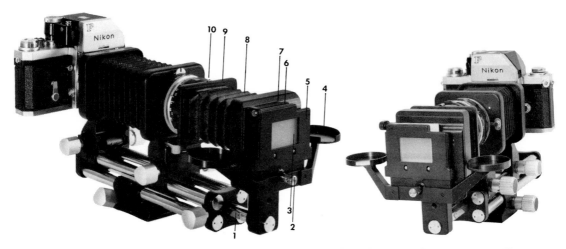

Parts identification for Slide-Copying Adapter
PS-4.

1. Attaching rail
2. Trimming lock
3. Opal plate
4. Receptacle
5. Film-retaining plate
6. Roll-film inserting
 slit
7. Slide-inserting
 slit
8. Light-tight
 bellows
9. Connecting plate
 of light-tight
 bellows
10. Attaching clip

Cropping is possible with magnification greater than $1\times$ when using adapter PS-4. Lateral shift is about 9mm and vertical shift is about 6mm. To achieve desired shift, release trimming lock; tighten when desired position is achieved.

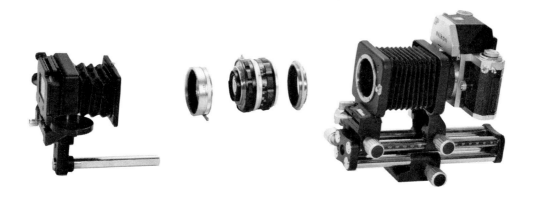

Using lens in reverse with slide copiers. If magnification exceeds $1\times$, reverse lens and connect it to slide copier and bellows through use of BR-3 and BR-2 Rings.

the lock knob found at the bottom socket of the bellows. Then insert the adapter rod through the socket hole. The lock knob may be tightened temporarily to hold the adapter in place.

The slide-copying attachment is then clamped to the lens end of the bellows focusing attachment by drawing out the intermediate bellows of the slide copier and clamping it to the lens. The clamping is done just as though a lens cap were being spring-attached to the lens.

The mounted slide is inserted from above into the slit with the emulsion side facing the opal glass. To insert a film strip, open the retaining plate, fit the film into the guide grooves (emulsion side toward the opal glass), and close the plate. With the Slide Copying Adapter PS-4, both ends of the long lengths of film are placed on the receptacles.

When cropping is desired with the PS-4, release the lock knob and move the film-retaining plate vertically or laterally until the desired area is brought within the field of view. The combined use of vertical and lateral movement can result in the effect of diagonal movement. The shift front of the Bellows Focusing Attachment PB-4 used with either model slide copier also affords some latitude in lateral cropping.

When the lens is attached in the reverse position, use the BR-3 Adapter Ring to couple the slide-copier bellows to the rear of the lens. The BR-3 Adapter Ring has a female bayonet mount that attaches to the rear of the reversed lens and a female thread to which the slide-copier bellows is attached.

Techniques for slide copying are covered in Chapter 2, "Single Plane Close-ups and Copying."

Magnification With Nikon Slide Copiers

The preferred lens for slide copying is the 55mm $f/3.5$ Micro-Nikkor in normal position for 1× reproduction and in reverse position for greater magnifications—up to about 4.3×. The 50mm $f/2$ or $f/1.8$ Nikkor lenses are also excellent and should be used similarly. The 50mm $f/1.4$ and $f/1.2$ and the 55mm $f/1.2$ should be used in reverse mode only. Wide-angle lenses from 24mm through 35mm should also be used only in reverse mode for magnifications up to approximately 9.5×.

At a magnification of about 1×, using the lens focusing ring might be convenient for fine adjustment. The magnification changes noticeably, although focusing changes only slightly. Slight adjustments can then be made with the bellows extensions.

The following is a convenient method of achieving a desired magnification greater than 1×. Take a discarded slide and score a line *horizontally* whose length is obtained by dividing 36mm by the desired magnification. For example, if a 2× magnification is desired, dividing this into 36mm would give a line 18mm in length. This line should be scored midway between the two ends of the slide. Then mount this slide and move the slide-copying adapter in either direction, while also adjusting the camera-mount slider on the bellows, until the image of the horizontal line drawn on the slide fully extends from one end to the other on the focusing screen. A full-frame slide mount is needed.

55mm f/3.5 MICRO-NIKKOR:
CLOSE-FOCUSING LENSES

The Micro-Nikkor 55mm close-focusing lenses are optically and mechanically designed for focusing at both infinity and close ranges. These lenses produce flatness of field, excellent color correction, high image contrast, and fine resolution exceeding that of ordinary films.

The differences between the 55mm f/3.5 Micro-Nikkor-P Auto, the earlier model 55mm f/3.5 Micro-Nikkor Auto, and the later model 55mm f/3.5 Micro-Nikkor should be noted. The former and the latter are primarily intended for use with through-the-lens metering systems. The earlier model 55mm f/3.5 Micro-Nikkor Auto was intended for use with cameras that did not have such metering. This particular lens featured an internal mechanism which opened the diaphragm as the lens was focused at close distances, to automatically compensate for the transmission loss at greater magnifications. All versions have the same focusing ranges: as close as 9½ inches for an image ratio of 1:2, and, with the appropriate PK-ring, as close as 8 13/32 inches (21.4cm) for a 1:1 ratio.

An earlier model, the 55mm f/3.5 Micro-Nikkor, offered continuous focusing from infinity up to a 1:1 image ratio without the use of an intermediate extension ring. It was not diaphragm-coupled.

The Micro-Nikkor 55mm lenses may be used in conjunction with all other close-up accessories.

Operation of the 55mm f/3.5 Micro-Nikkor-P Auto

The lens by itself, directly attached to the camera, is both diaphragm-coupled and meter-coupled. With the PK-ring added between lens and camera, both diaphragm and meter-coupling are retained. The M2-ring, formerly used to attain a 1:1 image ratio, caused meter-coupling to be disengaged. It has been superseded by the PK-3 ring (non-AI) or the PK-13 ring (AI). These rings provide a lens extension of 27.5mm.

With any other ring or Nikkor bellows extension between the lens and the camera, coupling of both diaphragm and meter are disengaged, thereby requiring that the lens diaphragm be stopped down manually and that exposures be determined by the stop-down method. As mentioned earlier, the BR-4 ring, used with the AR-4 Double Cable Release, restores diaphragm automation.

When the lens is attached to a camera without through-the-lens metering, exposures must be determined through use of an independent meter or by trial and error. When image ratios are greater than 1:10, exposure factors should be used in exposure determination. For this purpose, consult the table of image ratios and exposure factors given earlier in the chapter.

At magnifications greater than 1:10, the nominal f/stops engraved on the lens are no longer applicable because of the greater extension of the lens from the focal plane. Effective lens apertures must then be computed by formula as discussed in the theory section. As a practical matter, when using through-the-lens metering, such computation is unnecessary.

The focused distance is from the subject to the film plane, as indicated by the top edge of the serial number on the camera body. The image ratio within the range of 1:10 to 1:2 is determined by reading the orange figures engraved on the distance-scale ring as they appear opposite the black indicator line.

The distance and image ratio scales on the focusing ring are ignored when the PK-ring is attached. Instead, refer to the blue engraving to the far right of the black indicator line of the lens mount. When not elongated, the edge of the focusing ring coincides with the line 1:2 and 9½ inches. As the lens is elongated, two additional lines are encountered for a reproduction ratio of 1:1.5 and 8¾ inches, and for a natural size reproduction of 1:1 and 8 13/32 inches. These distances are all from the film plane.

For image ratios greater than 1:1, additional extension devices can be used:

1. A second PK-13 (or PK-3) ring will produce 1.5:1. The 8mm PK-ring or the 14mm PK-ring may also be used in combination or singly for extensions ranging from 8mm to 49.5mm.

2. Two additional PK-13 (or PK-3) rings will produce 2:1.

3. Mounted in reverse on the bellows with the BR-2 Macro Adapter Ring, a reproduction ratio of from 1.7:1 to 4.2:1 is obtainable. Use of the BR-4 ring and AR-4 Double Cable Release will provide automatic diaphragm operation.

Operation of the Earlier Model Micro-Nikkor Auto 55mm f/3.5 (Discontinued)

When the Micro-Nikkor Auto 55mm f/3.5 lens (the version without the letter "P" in its name) is focused for a distance from infinity up to a 1:2 reproduction, the brightness difference (or normal decrease in relative aperture) is automatically compensated. This feature has advantage when through-the-lens metering is not used. When, for example, the lens is focused for a reproduction of 1:2.5, its aperture will automatically be enlarged one stop. Of course, this cannot be achieved at the maximum opening of f/3.5. In this case the maximum opening is not changed but the decreases in relative aperture shown by f/numbers 4, 4.5, and 5 are pointed progressively to the left of the black indicator line on the lens mount. The edge of the focusing ring is used as the indicator when aligning the dots above each of the three compensated f/numbers. For instance, if the lens is elongated to the position of the dot above f/4.5, this tells you that the maximum, effective-aperture ratio of f/3.5 at minimum extension is reduced to f/4.5 at that working distance.

The focusing ranges and the use of the intermediate M-ring are identical to those described above for the Micro-Nikkor-P Auto. The new f/numbers, when using the M-ring, are engraved in blue at the edge of the M-ring. They are brought into coincidence with the black indicator line on the exposure-meter coupling prong found on the aperture ring of the lens. Note that the f/number range is reduced one full stop throughout. Instead of a range from f/3.5 through f/32, the new range is from f/5.6 to f/45. Immediately to the right of the black indicator line is a scale of black numbers and indicator dots (to be read at the edge of the focusing ring), which show the reduction of the maximum f/number from f/5.6 to f/7.1.

Focusing

A matte-surface finder screen should be used in focusing. Finder screens with split-image meter areas may be used up to a distance of about 15 inches, corresponding to about a 1:5 magnification. At closer distances, focusing should be done on the surrounding matte portion of the finder screen. Ideally, a type B or E screen is recommended.

Repro. ratio \ Aperture	f/3.5	f/5.6, f/8, f/11, f/16, f/22	f/32
1/∞—1/10	Compensation is not necessary		"Stop-down" method is used.
1/10—1/4		Stop down ½ stop more, after exposure setting.	
1/4—1/2		Stop down 1 stop more, after exposure setting.	

Adjustment table for use with the discontinued, automatic exposure-compensating Micro-Nikkor.

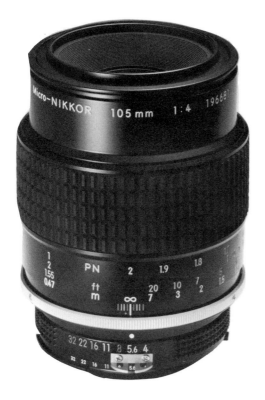

The 105mm f/4 Micro-Nikkor, left, can focus to a reproduction ratio of 1:2 without extension rings. The reproduction ratio is extended to 1:1 when the PN-11 ring, above, is attached between the lens and the camera body. Full-aperture metering and automatic diaphragm operation are retained with the PN-11 ring.

105mm f/4 Micro-Nikkor

The 105mm f/4 Micro-Nikkor is a longer focal length macro lens which permits more distance between the lens and subject than does the 55mm Micro-Nikkor, at equivalent magnifications. The lens alone focuses close enough to permit a reproduction ratio of 1:2. The Auto Extension Ring PN-11 (PN-1 for the non-AI version) permits reproduction ratios of from 1:2 to 1:1 to be achieved.

While the 105mm Micro-Nikkor is optically corrected, especially for close-up work, it also functions well when used for infinity focusing. This feature makes it useful as a moderate-telephoto lens appropriate for portraiture, sports or general photography.

The lens has two reproduction-ratio scales engraved next to the focusing scale. One gives the various reproduction ratios achieved when the lens is used alone and the other gives the magnifications achieved when the lens is used with the PN-11 (or PN-1) ring.

MEDICAL-NIKKOR

The Medical-Nikkor is a general-purpose close-up lens which, while of prime use in medical photography, also serves the nature photographer, the watchmaker, the electronics engineer, and the stamp or coin collector. The long focal length of the lens permits working at a distance from hot, delicate, or otherwise inaccessible objects.

This lens ingeniously coordinates the working distances governed by close-up lenses (used singly or in combination) with a built-in electronic light source—a ring flash whose duration is from 1/500 sec. to 1/600 sec. This light surrounds the lens and delivers shadow-free illumination of 60 w-sec. It is not necessary to figure guide numbers or exposure factors, since these are achieved automatically. Optical and mechanical specifications are given in the lens data sheet. The Medical-Nikkor may be used with or without the built-in light source.

If the utmost in high resolution is desired and if a longer working distance is not required, use of one of the Micro-Nikkor 55mm $f/3.5$ lenses is recommended.

Operating Instructions

The Medical-Nikkor outfit consists of three major operating elements: the master lens with built-in light source, six auxiliary lenses, and a power source. The complete outfit consists of:

1 master lens
6 auxiliary lenses
1 power supply (AC or battery)
1 power-source cord (1.5 meter)
1 synchro cord
1 front lens cap
1 rear lens cap
1 socket cover
4 spare focusing-lamp bulbs
1 AC unit (DC portable battery pack available as accessory)
1 leather compartment case
1 safety cover for the Nikon F top synchro contact
A 10m power-supply cord is available on order.

Set the ASA film speed on the scale at the rear of the lens and lock it in place by loosening and tightening the locking screw in front of the ASA scale. For color film, use the red reference line, and for black-and-white film use the white reference line. The scale ranges from ASA 10 to 800 with intermediate markings.

The correct combination of lenses is determined from the accompanying table. The six auxiliary lenses are used either singly or in tandem combinations to give various image ratios from 1:8 to 3:1. Each lens is marked with the image ratio it provides. A diagram on the lens barrel shows the lens combinations required to produce the image ratios of 1:3, 2:3, 1.5:1, and 3:1.

Ordinarily, the governing factor in selecting a lens combination might be the object field to be encompassed, but you might also predetermine a desired image ratio. It is also possible to start with a predetermined working distance from the object to the front surface of the lens. Reference to any of these in the table will determine the combination of auxiliary lenses and master lens. For an image of 1:15, the master lens alone is used at a distance of not quite 11 feet. The use of a single $1/8\times$ auxiliary lens will cut this distance to closer working distances of about six feet. Other auxiliary lenses, and combinations of lenses, can further reduce the working distance progressively down to as close as 2.76 inches (70mm) for a reproduction ratio of 3:1 and area of 0.33 inches \times 0.50 inches (8.4mm \times 12.6mm).

Select the one or two auxiliary lenses needed, by reference to the table, and screw them onto the front of the Medical-

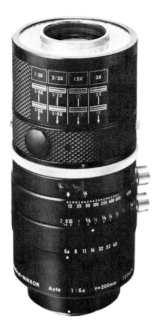

200mm f/5.6 Medical-Nikkor. For nomenclature see following page.

Nikkor. When using two auxiliary lenses, attach them as indicated by the figures on the front part of the lens barrel. Set the image ratio (reproduction ratio) on the yellow scale and lock it in place. Focusing is done by moving the lens/camera combination in and out until the image is seen in the viewer in sharp focus.

Electrical Instructions

Connect the four-core socket on the lens to the socket in the power unit with the thick gray-colored cord. With the AC unit, connect the brown cord to the AC power source.

The built-in flash is connected to the synchro socket on the camera by means of the black synchro cord. This is attached to the small socket on the lens beneath the four-core socket.

A high-voltage power source is used for illumination. The flash contact on the camera accessory shoe or flash socket should not be touched when flash photography is being performed. For safety, attach the protecting cover onto the accessory shoe of Nikon F cameras and

into the flash socket of the F2. Do not attempt repair of the power unit. Take it to an authorized Nikon agency or return it through your dealer to the Nikon distributor. If the DC unit is used, remember to turn the power source switch to "off" when exchanging batteries.

Before each exposure make sure that the signal neon lamp is illuminated and that two or three additional seconds have elapsed. As an aid to focusing, pushing the micro switch will light four small bulbs.

If the lens has not been used for a long time, the recharging time will be prolonged for the first two or three shots while the condenser is being reformed. This delay will show in the longer time required for the neon lamp to be lit. Recycling time on AC units is about 13 sec.; on DC units recycling is governed by battery-charge conditions.

Automatic Aperture Setting

When the built-in electronic ringlight is used, the setting of the image ratio governs the automatic functioning of the lens aperture to assure satisfactory exposure under average or typical conditions, provided focusing is done properly. The ASA rating must also have been set appropriately.

Loosen the locking screw of the aperture ring and turn the ring until its yellow index line appears opposite the image ratio to be used. For example, with an image ratio of 1:2 (one-half), using the corresponding auxiliary lens so marked, set the aperture ring so that the index line appears opposite the one-half setting of the image-ratio scale. The correct aperture now appears opposite the index dot in front of the aperture scale. (When using the Medical-Nikkor with natural or artificial continuous lighting sources, this "automatic" aperture-setting procedure is not coupled to the through-the-lens full-aperture metering systems. In such cases, stop-down or independent metering is required.)

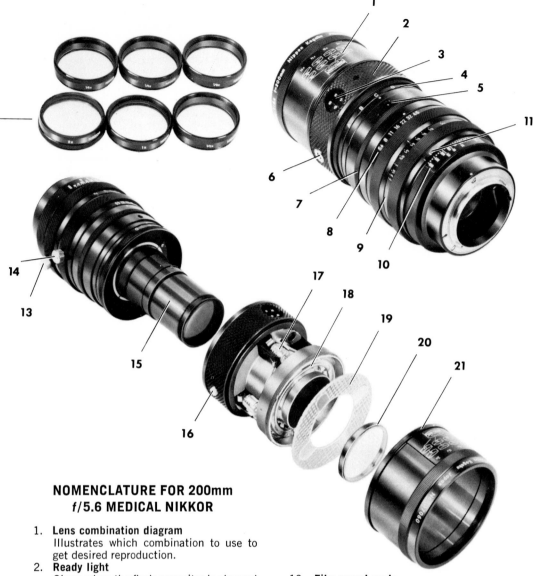

NOMENCLATURE FOR 200mm f/5.6 MEDICAL NIKKOR

1. **Lens combination diagram**
 Illustrates which combination to use to get desired reproduction.
2. **Ready light**
 Glows when the flash capacitor is charged and ready to fire.
3. **Power socket**
 Accepts the connecting cord from the AC or DC power unit.
4. **Indentification number and Reproduction-ratio adjuster**
 Adjusts the intensity of leakage light according to film speed.
5. **Indicator window**
 Shows which number or magnification will be printed on the film.
6. **Synch socket**
 Accepts a synch cord from the camera's flash-synch socket.
7. **Selector ring**
 Turn to select an identification number or magnification to be printed on the film.
8. **Aperture scale**
8(a). **Aperture-index dot**
9. **Magnification scale**
9(a). **Magnification-index dot**

10. **Film-speed scale**
11. **Film-speed index dot**
12. **Auxiliary lenses**
 Screw onto the front of the prime lens to get a variety of magnifications.
13. **Film-speed locking screw**
 Locks the ring to prevent accidental shifting of the settings.
14. **Aperture-ring locking screw**
 Locks the aperture ring to prevent accidental shifting of the setting.
15. **200mm f/5.6 prime lens**
16. **Focusing-lamp switch**
 Press to switch on the focusing lamps.
17. **2.5v bulbs for focusing light**
18. **Ringlight flash tube**
19. **Plastic protective cover**
20. **Lens-front ring**
 Unscrew to remove the ringlight for servicing.
21. **Protecting ring**
 Unscrew when replacing 2.5v bulbs.

IMAGE RATIO RANGES AND APERTURE SETTING WITH FLASH

ASA \ Reproduction ratio	1/15	1/8	1/6	1/4	1/3	1/2	2/3	1	1.5	2	3
10							7.1	10	13	18	16
									6.7	9	8
12						5.6	8	11	16	19	18
								5.6	8	9.5	9
16						6.7	9	13	18	22	20
								6.4	9	11	10
20						7.1	9.5	14	19	25	22
								7.1	9.5	13	11
25					5.6	8	11	16	22	27	26
							5.6	8	11	14	13
32					6.4	9	12	18	25	32	29
							6.4	9	12	16	14
40					7.1	10	13	20	27	36	32
							6.7	10	13	18	16
50				5.6	8	11	16	22	32	40	38
						5.6	8	11	16	20	18
64				6.7	9	13	18	25	36	45	40
						6.4	9	13	18	22	20
80				7.1	10	14	19	29	38	45	
						7.1	9.5	14	19	25	22
100			5.6	8	11	16	22	32	45		
					5.6	8	11	16	22	27	25
125			6.7	9	13	18	25	36			
					6.4	9	13	18	25	32	29
160			7.1	10	14	20	27	40			
					7.1	10	14	20	27	36	32
200		5.6	8	11	16	22	32	45			
				5.6	8	11	16	22	32	38	36
250		6.7	9.5	13	18	26	36				
				6.7	9	13	18	25	36	45	40
320		7.1	10	14	20	29	38				
				7.1	10	14	19	29	38	45	
400		8	11	16	22	32	45				
			5.6	8	11	16	22	32	45		
500		9	13	19	25	36					
			6.7	9.5	13	18	25	36			
640	5.6	10	14	20	29	40					
			7.1	10	14	20	29	40			
800	6.4	11	16	22	32	45					
		5.6	8	11	16	22	32	45			

Numbers in the colored blocks indicate the correct aperture setting, with upper numbers for full light output and lower ones for 1/4 output.

☐ = Effective reproduction ratio range

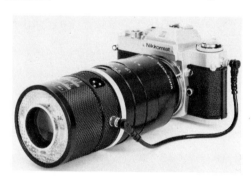

The built-in ringlight synchronizes with the shutter of any of the Nikon or Nikkormat camera models. Nikon F2 at 1/80 sec. or slower, Nikon F at 1/60 sec. or slower, and Nikkormat at 1/125 sec. or slower.

ASA number of film in use must be indexed in order to obtain correct exposures with ringlight flash. Loosen locking screw on film-speed scale ring and turn until desired ASA speed is opposite appropriate indicator mark —white diamond for full flash output and 1/4 mark or 1/4 reduced output. Dots between numbers represent intermediate settings as shown in illustration. Retighten locking screw.

By itself, Medical-Nikkor is a fixed-focus lens with image ratio of 1:15. To change working distances, auxiliary lenses (set of 6) are used individually or in pairs to give ten additional image ratios. Each auxiliary lens is marked with ratio it produces. Combination ratios are shown on lens barrel together with sequence in which auxiliary lenses are to be screwed in. Lenses are color-coded for ease of selection.

Power output can be reduced to ¼ of full value through use of light-output selector switch on top of power unit. This achieves same effect as stopping down lens by two stops. It permits shooting closeups at higher ratios without switching to slower film. At reduced output, readjust aperture ring so that ASA film speed appears opposite ¼ mark. (With color films, aperture setting may be readjusted manually to compensate for predominantly light or dark subject areas.)

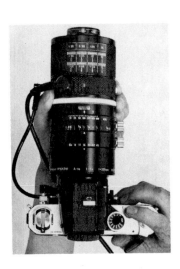

Lens can be used with or without flash. To set aperture for automatic flash, loosen locking screw on aperture ring and turn until white arrow is opposite ratio selected. Numbers on scale are color-coded to correspond to colored rings around auxiliary lenses. Then, retighten locking screw. Scale at rear edge of aperture ring shows selected aperture in range from f/5.6 to f/4.5. Range of useable ratios is determined by film speed in use.

An identification number or the image ratio used may be printed directly on each frame of film. By turning the white knurled ring (above left), any number in the sequence 1 through 38 will appear behind the window opposite the white diamond. Alternatively, image ratios in the range of 1/15× to 3× can be made to appear. If you wish no numbers to be printed, turn the white knurled ring until the black dot appears opposite the white diamond. Since the Medical-Nikkor is a fixed-focus lens, focusing is done by aiming the camera at the subject and moving back and forth until the subject comes into sharp focus on the viewing screen (above right). Focusing will be at full aperture while exposure will be at the automatically stopped-down preselected aperture. For assistance in focusing in dim light, the four focusing lamps mounted behind the ringlight may be used to illuminate close subjects. To switch on the lamps, press the white button on the lens barrel. The lamps will go out when pressure on the button is withdrawn. Depth of field at a particular distance may be ascertained through use of the preview button or the depth-of-field table. The type B focusing screen is recommended for use with the Nikon F or F2 as the central range-finder circle of the type A screen will black out. When using a Nikkormat, focus on the matte field which surrounds the central focusing circle.

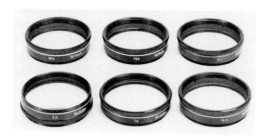

Six auxiliary lenses yield individual image ratios of ⅛, ⅙, ¼, ½, 1×, 2×; in combination, ⅓, ⅔, 1.5×, 3×.

For unusually dark subjects, when more brilliant illumination is needed, a simulated lower ASA rating may be set on the lens; a one-stop difference would call for a halving of the ASA rating, and so on. Conversely, for exposure reduction, ASA ratings should be increased by doubling for one stop, quadrupling for two stops, and so on.

When photographing glossy, reflective surfaces, avoid pointing the camera head-on. Doing so will produce flare and perhaps an image of the ringlight flash. Aim the camera at an oblique angle.

Printing Numerical Figure

The film can be imprinted numerically at the time it is exposed. Light from a xenon discharge lamp is utilized. White figures from 1 to 39 may serve for printing film number, date, diagnosis-card number, and so on. Yellow figures from 1/15× to 3× can be used to imprint the reproduction ratio. To imprint such numbers, rotate the large milled ring in the center of the lens until the appropriate figure appears in the circle. This knurled ring is located directly beneath the letters A, B, C, and D. These letters control the brilliance of imprinting. "A" is for color film ASA 64 or lower and black-and-white film ASA 32 or lower. "B" is for color films ASA 80 to 400 and black-and-white film ASA 40 to 200, while "C" is for faster films. If no imprinting is desired, letter "D" is selected. The photographer can, with experience, make his own letter selections in order to subordinate or emphasize the imprinting as desired.

Image (Reproduction) Ratios and Working Data for Use With Prime Lens and Auxiliary Attachments.

Reproduction ratio	Combination of lenses	Lens-to-subject distance inch (mm)	Subject field inch (mm)
1/15X	Prime lens	10' 11.89" (3,350)	14.17 x 21.26 (360 x 540)
1/8X	1/8X + Prime lens	5' 10.08" (1,780)	7.56 x 11.34 (192 x 288)
1/6X	1/6X + Prime lens	4' 4.64" (1,336)	5.67 x 8.50 (144 x 216)
1/4X	1/4X + Prime lens	2' 11.04" (890)	3.78 x 5.67 (96 x 144)
1/3X	1/4X + 1/6X + Prime lens	2' 1.0" (635)	2.72 x 4.06 (69 x 103)
1/2X	1/2X + Prime lens	1'5.56" (446)	1.89 x 2.83 (48 x 72)
2/3X	1/2X + 1/4X + Prime lens	1'0.83" (326)	1.38 x 2.09 (35 x 53)
1X	1X + Prime lens	8.70" (221)	0.94 x 1.42 (24 x 36)
1.5X	1X + 1/2X + Prime lens	6.06" (154)	0.67 x 0.98 (17 x 25)
2X	2X + Prime lens	4.25" (108)	0.47 x 0.71 (12 x 18)
3X	2X + 1X + Prime lens	2.83" (72)	0.33 x 0.50 (8.4 x 12.6)

Equipment Data

To replace the focusing-lamp bulbs, first disconnect the gray cord for safety. Then unscrew the protecting tube at the end of the lens.

The AC unit is designed for use with 100v, 117v, and 220v power sources. To adjust the primary voltage correspondingly, open the lid of the leather case of the AC unit. Using a small screwdriver, set the direction of the groove of the voltage regulator until it is turned opposite the figure desired. If the voltage is 115v or 120v, set the groove to 117v.

For the DC battery unit, use one 240v laminated high-voltage dry cell and four D-type batteries, each 1.5v. When installing the batteries, position them according to the plus (+) and minus (−) indications.

When the unit is not in use, turn the power switch to "off" to prevent battery drain. If the unit is not to be used for a long time, the batteries should be removed. Consecutive use of the unit over a short period will exhaust the batteries much more rapidly than if used intermittently.

A vinyl tape in the 240v battery chamber, passed under the battery, makes removal easier.

When Medical-Nikkor lens is used with an AC or DC unit, the flash contact on the accessory shoe of the Nikon F should be covered with the accessory-shoe safety cover supplied with the lens (left). Before opening the battery compartment turn power switch to OFF. Do not attempt personally to repair the AC or battery units; tampering with internal circuitry can result in a dangerous electric shock. To replace focusing lamps, unscrew protective ring (right). Four spare bulbs are supplied initially with the lens.

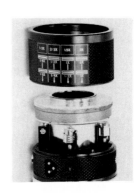

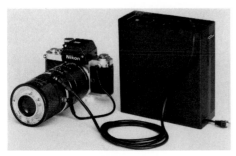

AC unit adapts Medical-Nikkor to any standard house current. Unit must be set for appropriate voltage—100, 117, 220 and 240v —using small coin to turn screw until slot points to proper setting. When AC unit is plugged in and power switch turned on, pilot lamp will glow. Recycling time is approximately 8 sec. and 5 sec. on 1/4 power.

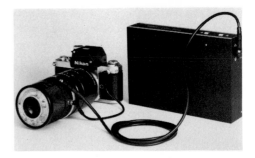

Battery unit holds eight 1v D-type batteries to power ringlight and four focusing lamps. Number of flashes and recycling time for different D-type batteries are given in accompanying table. If unit has been out of use for some time it may take longer than usual for ready light to come on. When replacing batteries, replace all eight at once. Make sure that positive and negative poles are aligned correctly as shown inside battery chamber.

D cells	Number of flashes		Recycling time	
	full	1/4	full	1/4
General	50 approx.	120 approx.	14 sec. approx.	6 sec. approx.
High-rate	110 approx.	260 approx.	12 sec. approx.	5 sec. approx.
Alkaline	600 approx.	1400 approx.	9 sec. approx.	4 sec. approx.

REPRO-COPY OUTFIT

The Nikon Repro-Copy Outfit Model PF-2 is a vertical copying stand that can be used for permanent installation or as a portable unit. It assures that the camera and subject are parallel. The kit is available with a wooden carrying case that serves, when unfolded, as a baseboard. A table-clamp accessory is also available.

The camera is fastened to the bracket by means of the camera-tripod socket screw. An adjacent screw-hole on the camera holder permits fastening the camera with the motor-drive unit attached.

Focusing and framing are done by loosening the wingscrew on the bracket, attaching the unit to the upright post, and moving the entire assembly up and down to get the area desired into approximate focus. The bracket screw is then tightened. Turning the adjusting knobs at the bottom of the camera holder permits more accurate framing. The camera is then fixed in place with the lock knob.

Fine focusing is done by rotating the lens focusing ring. For greater accuracy, the waist-level finder with either the B, D, or E screen or the angle finder—depending on the camera—is used.

When photographing large areas, swing the bracket around 180 degrees and place the outfit at the edge of a table. Be sure to counter-weight the baseboard to prevent the unit from tipping and to ensure extra stability. Alternatively attach the upright post to the edge of the desk by means of the accessory table clamp. In either case, set the material to be photographed on the floor.

When photographing wall-mounted copy, unlock the rear thumbscrew and rotate the camera holder 90 or 45 degrees. Positioning pins maintain alignment in either position.

When using Bellows Focusing Attachment PB-4, attach it to the supporting bracket directly. Fine focusing can be performed by means of the sliding support of the bellows. Bellows Focusing Attachments PB-3 and PB-5 can also be attached to the bracket directly, but they do not allow for fine focusing.

Parallel alignment of image and film plane is essential in copying. Use the E screen with its scored groundglass, especially in copying linear materials. Distances to corners of object from center of lens should be identical.

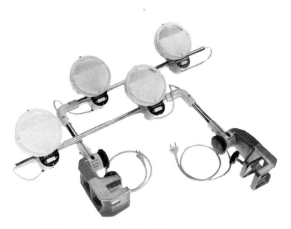

Modified parts

Trimmed by 3mm x 3mm

Extended by 2mm

When photographing flat copy or small objects with the Repro-Copy Outfit PFB-2 (baseboard), attachable lights such as the Durst copy lights (above left) will be useful. Modification of Repro-Copy Outfit PF-2 (above right) to accept Nikkormat EL camera. Owners of earlier models of this copy stand can make modifications to accept the Nikkormat EL as shown in the illustrations. Models after Serial No. 16904 already include the modifications.

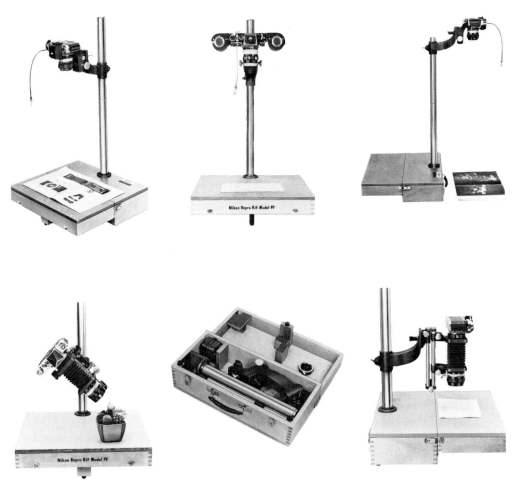

The Repro-Copy Outfit PFC-2 (with storage-box base) or PFB-2 (with baseboard) is used in vertical photography. Recommended lenses are the 50mm f/2 and the 105mm f/4 Bellows-Nikkor. The motor drive with bulk-load attachment is for quantity reproduction. The camera support arm has an attaching screw, a fine screw-focusing knob, and a locking knob.

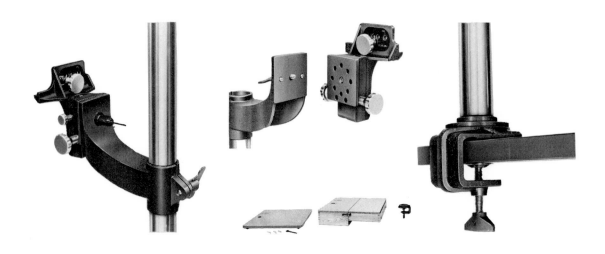

CHAPTER 2

Copying of Films and Other Single-Plane Subjects

The unique problems of making reproductions from film originals, both black-and-white and color, are covered in this chapter. Copying of opaque originals are also covered. In common, these subjects present a simplification in procedures in that they do not have a depth-of-field problem. On the other hand, since edge-to-edge sharpness is a requirement, optics must be selected for flatfield characteristics.

The opening section in this chapter covers the various reproduction-equipment systems that can be used in copying 35mm films in both black-and-white and color. More detailed guidance for use of Nikon equipment will be found in the chapter which includes operating instructions and specifications.

The section on black-and-white film procedures pertains mainly to copying color transparencies. This procedure is applicable to the creative derivations for which monochromatic intermediates are needed; to the salvaging of color slides whose density otherwise makes them unavailable for use in color form; to the creative modification of color originals from which interesting black-and-white effects may be derived; and to the conversion of color for black-and-white publication. Procedures are also indicated for making black-and-white positives from black-and-white negatives for projection purposes.

Making positive color reproductions of positive color originals is discussed next. A principal application for this technique is making slide "dupes," the short form for "duplicates,"—although, as explained later, it is virtually impossible to make an exact duplicate. More advanced techniques covered in the color section include making creative and corrective alterations of color and making a wide variety of creative pictorial alterations. This section discusses various ways by which one can improve upon the original in-camera exposure.

The concluding section covers copying of both black-and-white and color originals by reflected light as distinct from copying films by transillumination.

The reader who is interested in making color copies of color films is advised to acquaint himself first with the black-and-white procedures even if doing so is limited to reading. The color section includes the fundamental procedures but contains additional steps.

REPRODUCTION SYSTEMS: FILM COPYING

Most of the procedures for copying from film originals, particularly color slides, can be performed with Nikon bellows and slide-copying attachments. Other procedures can also be. followed, as described later, particularly when the aim is to go directly from the 35mm original to an enlarged film or paper copy. The reproduction systems options that follow are, in the main, applicable both to color and black-and-white media.

Basic Requirements

The optical system, including the prime lens and extension devices (bellows or extension rings) requires, as a minimum, the ability to make a 1:1 ($1\times$) reproduction. The lens should be selected ideally from among those designed for short-distance focusing as distinguished from lenses whose corrections are intended for infinity focusing. Focal length is not a consideration otherwise, for the light source will be in back of the single-plane subject. Some lenses designed for infinity focusing may be used in reverse mode.

The original film or transparency must be squarely perpendicular (90 degrees) to the optical axis drawn from the film plane through the lens to the subject.

The light source must be diffused and, if intended for color reproduction, the color temperature of the lighting must be balanced to the type of film to be exposed. The diffusion system will vary according to the procedure to be followed. It could involve the simple use of an acrylic plate as incorporated into Nikon slide-copying attachments, opal glass forming the surface of a light box, bounce-light surfaces between lamp sources and the surface of the light box or stage, etc. A masking system should be employed to eliminate extraneous light that could contaminate image quality. Ordinarily, this is provided for in the design of the Nikon slide-copying attachments. If a light box or stage is used, an area beyond the dimensions of the slide aperture should be masked with an opaque material. If slides or film strips are projected through a darkroom enlarger onto sheet or roll film, the surrounding area on the easel should be draped or masked so as to eliminate light-bounce effects.

A voltage regulator should be used when critical, repetitive results are to be achieved in conjunction with continuous light sources used in balance with color films.

Standard unmasked image area produced by Nikon and other conventional double-frame 35mm cameras, as compared to retained image area after masking with standard slide mount. Note that there are variations in slide mounts so that the latter must be verified.

All elements of film selection, illumination (source and mode), applicable filtering, and developing must be brought mutually into balance to achieve consistently desired effects. Dust elimination must be a constant preoccupation. Tiny specks of dust or lint on either of the surfaces of a slide will show up as dirty or untidy work when seen in projection afterwards. While most home darkrooms are not likely to afford mechanical air compressors, disposable compressed-air cans for hand use are available through photographic dealers.

Slide-Copying Attachments

Nikon slide copying attachments are designed for use with Nikon bellows-extension units as described in Chapter 1. These are usually mounted on tripods, away from table surfaces, in order to afford free access to a lighting source. In conjunction with lenses of short focal lengths ranging from 55mm and downward in the scale, the bellows draw permits making greater than 1:1 magnifica-tion both in normal and reverse mode as indicated on the lens data sheets.

Some independent slide-copying attachments are available with their own built-in optics. These are designed for making 1:1 copies without flexibility for magnification and for selective cropping. The quality of these convenience devices will vary according to the source of manufacture.

An evenly distributed light source must be placed in front of the opal acrylic screen at the back of the slide-copying attachment. The light source must be brilliant in order to reduce exposure time. The simplest method is to shine a light directly toward the opal screen—a frosted flood reflector or electronic flash. To protect filters and transparencies when copying under this arrangement, insert a heat-absorbing glass in the light path (such as Pittsburgh No. 2043, 3mm thickness).

Since some hot-spotting could take place, thereby causing the negative to be exposed unevenly, indirect lighting is

MAGNIFICATION RANGES AVAILABLE WITH SLIDE-COPYING ATTACHMENT PS-4 OR PS-5

Position	Lens	Magnification	10x	9	8	7	6	5	4	3	2	1x	½
Wideangle Lens	Nikkor Auto 24mm f/2.8	Reverse	●——————————● (10x–6x)										
	Nikkor Auto 28mm f/3.5	Reverse	●—————————● (10x–6.5x)										
	Nikkor Auto 35mm f/2	Reverse					●————————● (6x–3x)						
	Nikkor Auto 35mm f/2.8	Reverse					●————————● (6x–3x)						
	PC-Nikkor 35mm f/2.8	Reverse					●————————● (6x–3x)						
Normal Lens	GN Auto Nikkor 45mm f/2.8	Normal/Reverse							●—————————● (4x–1x)				
	Nikkor Auto 50mm f/1.4	Reverse							●————————● (4x–1.5x)				
	Nikkor Auto 50mm f/2	Normal/Reverse							●————————● (4x–1.5x)				
	Nikkor Auto 55mm f/1.2	Reverse							●—————————● (4x–1x)				
	Micro-Nikkor Auto 55mm f/3.5	Normal/Reverse							●—————————● (4x–1x)				
Telephoto Lens	Nikkor Auto 85mm f/1.8	Normal/Reverse									●———● (2x–1x)		

Note: BR-3 Ring is used to mount the lens in reverse.

preferable, especially for critical work.

A ring flash positioned around the opal screen could be an excellent source, aimed at a reflector board some inches away, depending on test shots.

If a single flood is bounced off a dead white reflector board, remove the slide-copying attachment, stop down the lens, and observe the evenness of illumination on the reflector board as seen through the viewfinder. You may need to readjust the position of the reflector board so that it reflects directly toward the lens. If two floods are used, they should be positioned so that the left one lights up the right side of the board and vice versa. The board should be parallel to the camera back.

If an electronic flash is used at the camera position, find the correct position of the reflector board by first substituting a studio lamp or flood. Follow the procedure stated above. Then replace the flash and make test exposures. The short electronic-flash exposure is best, for it minimizes movement and vibration that may occur with time exposures, and it provides soft, contrast-free light.

Upright Reproduction Stands

When both volume and frequency of use justify it, a convenient apparatus is the Bowens Illumitran. This is an upright stand with camera support, bellows extension, slide holder, illumination stage, focusing lamp, exposure meter, light-intensity control, and electronic flash for shutter-coupled exposure. Adapters are available for mounting a Nikon camera and lens. A motor-driven attachment cannot be used, for there is insufficient space for it within the upright configuration. Inasmuch as the focusing lamp and electronic flash are established in a coordinated relationship with the Illumitran exposure controls, those of the camera system are not used.

One could, of course, work out further relationships between the camera's exposure-metering system and that of the Illumitran, particularly when control is desired over a limited area covered by the center-weighted meter. An advantage of the Illumitran is that all magnification and illumination relationships can be readily established and maintained precisely even with intermittent use because of the integrated structure of the apparatus and its components. One must have sufficient volume, however, to justify the cost of the apparatus.

Owners of the Nikon Multiphot can use this integrated reproduction stand for making 35mm copies or for making enlarged reproductions on either wet-process films or Polaroid roll or sheet films. The Multiphot is used as a selectively coordinated system of components suited to the particular needs of the situation. In this case, diascopic and electronic-flash illumination systems can be used in conjunction with suitable Macro-Nikkor lenses, camera holder, bellows extension, and—for roll or sheet film—a suitable film holder. The greater magnifications possible with this equipment call for the use of sharp resolution, fine definition films such as Kodachrome 25. For purposes of creative diversification, other films of higher exposure ratings and progressively coarser grain structure can also be used. Interesting patterns can be observed in the breakdown of image structures.

The Multiphot is used to best advantage with large format films. These make it possible to achieve greater image magnification in the first step removed from the film original, thereby minimizing the need for subsequent magnification. In the wet-process category, a wide variety of commercial, professional, and graphic arts film materials is available. The Polaroid Land film can, of course, be ex-

posed and developed indoors or outdoors without the need for a darkroom, thereby enabling the photographer to have instant feedback for purposes of exposure correction as necessary.

Owners of the Polaroid Land MP Industrial View Camera can make macrocopies within a magnification range of 1:1 to 10:1, depending upon lenses used. To cover the indicated range completely, one would have to have the 127mm, 75mm, and 35mm lenses, the last with bellows-extension unit. A separate diascopic light stage would be necessary for use with continuous or electronic-flash lighting sources.

Regardless of the camera or film you are using, the lighting used will determine the quality of results. The basic principle is even light applied from *under* the transparency being copied.

To provide even lighting, suspend over the light source a sheet of white, translucent plexiglass that has been masked off with tape or black paper to cover everything except a "window" the size of the slide to be copied. In the simplest form, several film boxes, books, or similar objects are placed under the edges of the "copying stage" and the light source is placed in the open space underneath. For more permanent use, the copying stage can be built into the top of a wood or metal box with a light source built-in. In some cases, a standard X-ray viewing box with an appropriate paper or cardboard mask can be used.

For black-and-white copy, almost any light source will work equally well. Common examples are incandescent (ordinary light bulb), fluorescent (common in X-ray view boxes), and electronic flash or "strobe." A photographic flashbulb may also be used if the shutter speed is first set at 1/15 sec.

For color copy, the light source and film must be of the same temperature balance. Electronic-flash units or blue flashbulbs are both designed to be used with Polacolor (daylight) film with no filtration. Electronic flash is by far the more convenient of these two choices, and in the long run will be the most economical. Other light sources will require filtration over the light or the camera lens to give proper color balance. The following is a partial list of lighting sources and possible filtration:

Source	Beginning Filtration
electronic flash	none
blue flashbulb	none
white flashbulb	No. 80C (Wratten)
incandescent	No. 80C + CC40B
fluorescent	No. CC40M—may vary widely!

Enlarger Projection Systems

The enlarger is preferred by some photographers because of the advantages of exercising selective control. One advantage is the ability to focus and study the projected image at the film plane, using a film ranging in size from $4'' \times 5''$ to $8'' \times 10''$. Another is the ability to control exposure by dodging and to be able to crop selectively, just as in ordinary print-making.

Some photographers feel they get the best detail out of a 35mm slide only by projecting it onto sheet film. Through proper film selection, exposure, and development, adequately detailed 35mm negatives can be made that will be quite satisfactory.

In enlarging, the lens is of utmost importance. The lens must be corrected for even, edge-to-edge sharpness. A poor lens may give sharp center areas, but will yield blurred images at the edges, especially at wider lens apertures.

The 50mm $f/2.8$ El-Nikkor lens ("El" stands for "enlarging lens") is matched for 35mm originals. The wide aperture is best for focusing due to a shallow depth of focus. The optimal stop-down aperture for exposure is $f/5.6$. Smaller apertures, for critical exposure control, go down to $f/16$, with convenient click stops. Other El-Nikkor lenses may be used, if optically matched to the enlarger and its lighting system.

The El-Nikkor has the following attributes that are ideally suited to the needs of projecting 35mm color originals:

1. Lens aberrations have been corrected for short projection distances.

2. The focus of the image on the easel does not shift due to stopping down of the lens aperture.

3. The resolution of the enlarging lens is superior to that of the camera lens.

4. Correction for chromatic aberrations includes near ultraviolet rays to which films are sensitive, thereby assuring that perceived focus will be maintained.

5. Light is uniformly distributed over the entire image area.

Check the enlarger for light leaks in a totally darkened room. Complete darkness is essential. Light is most likely to leak around the negative carrier and lamp house. The slightest leak could fog the film. Try a black hood around the lamp house and negative carrier. Blackened masking tape can also be used.

A condenser enlarger is recommended. Use a glassless negative carrier with the film emulsion side facing the baseboard. A less powerful bulb can be used in the lamp house for better exposure control. An opal glass *between* the condensers and negative carrier will soften contrasts and cut down on light intensity.

Exposures are most conveniently made on sheet film in regular film holders with dark slides. To focus, use a piece of white card or a fogged sheet of film inserted into the film holder. Then replace the focusing sheet with unexposed film or with another holder in which film has already been inserted. Test exposures by the bracketing method can be made on the first sheet of film in order to ascertain the desired combination of lens aperture and exposure time.

You must also pre-position the film holder before exposure. Trace the outline of the holder on a firm base—a paper easel, enlarger baseboard, or a piece of ¾-inch plywood. If you use the last, pins or nails can be used as guides. Otherwise, you can also attach stop guides with rubber cement so as not to damage the easel or baseboard. Focusing is done with the holder moved into place under the projected image. The guide technique enables the unexposed film holder to be put in place while the darkroom lights are on, before making the actual exposure.

An alternative method is to expose film held in place on a regular paper easel. Film can also be positioned on the enlarger baseboard. In either case a sheet of black interleaving paper from the film carton should be put under the film.

Exposures can be made directly on 35mm film within a camera body in the normal mode except that the lens is removed. The camera is placed on its back on the projection easel on a suitable support to assure that it is level from corner to corner. Viewing and focusing is done through the mirror-reflex system. With Nikon cameras, the simplest arrangement is either the removal of the viewfinder entirely or the substitution of the waist-level finders: the regular waist-level finder or the $6\times$ ocular finder.

Contact Printers

The contact printer is one of the earliest and simplest forms of photographic reproduction; it brings a film original in contact with photosensitive material. Typically, the contact printer has a storage chamber in which is loaded a bulk

Larry West

Flash picture of white-footed mouse made with 105mm f/2.5 lens extended with short K-ring. Original on Kodachrome II copied onto Panatomic X, overexposed and under-developed in Rodinal. El-Nikkor lens used for slide copies.

Larry West

Spider web photographed on extremely foggy day. Each strand of web brought out by tiny beads of moisture. The 200mm f/4 lens plus a short tube was used to take the original picture. The web was illuminated by flash. Slide duplicating was done as above.

supply of film, an open exposure platen over which the film is advanced, and a take-up film chamber into which exposed film is stored. A film holder is provided, usually hinged so that the film original can be brought into contact with the copy film. A light source is placed behind the 24 × 36mm film-aperture window so as to provide illumination for the actual exposure.

One of the simplest of contact printers is the Kindermann Dia-Printer 35, as shown in the accompanying illustrations. The storage chamber accommodates up to nine feet of film. After each exposure, an exact length of film is advanced into the take-up chamber. This printer is the current version of the Eldia printer originally designed and manufactured by E. Leitz of Wetzlar, West Germany.

More elaborate contact printers are available from professional photographic supply houses for use where there are production-printing requirements.

A contact-printing system built around the use of Metro/Kalvar films permits making black-and-white film prints without use of a darkroom or wet-chemical processing. The films are exposed by ultraviolet light to form a latent photographic image and then heated to permanently develop the image. The film

can be handled openly under ordinary room light. The effects are those to be encountered with conventional films; opaque areas in the original are rendered as clear areas in the copy and vice versa, while intermediate tonal areas are reversed proportionately. This film material can be used for immediate creation of black-and-white transparencies from either black-and-white negatives or color negatives (matched or unmatched), as well as black-and-white negatives from color transparencies. Metro/Kalvar films are used for making motion-picture release prints, teaching-machine prints, projection slides, and black-and-white filmstrip duplicates. The type 28 emulsion is used for continuous-tone reproduction, while type 18 is used for high-contrast requirements. The film has a useful shelf-life of at least five years under normal storage conditions.

A special outfit is available for printing and developing with Metro/Kalvar films. It is the Canon Kalvar slide-making system. The outfit consists of an ultraviolet-ray printer and a heating apparatus for making visible the latent image. The outfit can make slides from negatives for projection or filmstrip negatives from positives for use in making black-and-white prints.

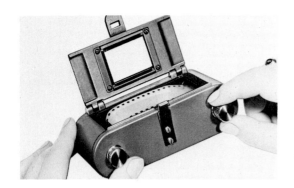 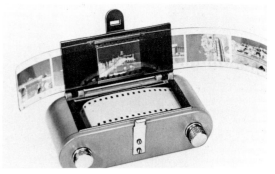

Kindermann contact printer for darkroom use.

BLACK-AND-WHITE FILM PROCEDURES

The key problems in making good black-and-white copies from color transparencies are: (1) the selection of suitable originals, (2) the control of tonal contrast, and (3) the determination of individual-frame exposures. All are interrelated, as will be explained below. While this section is devoted mainly to making copies from color originals, reference also is made to making black-and-white positives for projection purposes.

Selection and Treatment of Originals

The best original has (1) a long tonal scale, (2) sharp image contours, and (3) details in shadows and highlights. Copying tends to produce an image of greater contrast than the original transparency. Hence, unless the building up of contrast is specifically desired, the ideal original should tend to be of somewhat soft contrast. That is, there should not be too sharp a difference between the principal light-and-dark tonal areas of the transparency.

Sharpness must be checked out carefully. Some color transparencies may seem sharp because of contrast of color masses. Color sharpness is associated, also, with rich, deeply saturated, bright hues. When translated into monochromatic tones, color contrasts are subdued. Obliquely-lit subjects with pronounced shadow patterns contribute to the sense of sharpness (but shadow areas should have reproducible details). All of these sources of a psychological illusion or impression of sharpness pertain to black-and-white originals also, but they exert a more powerful influence when color perception is involved. In selecting a slide, therefore, make sure that the most important visual targets are critically sharp. In portraits, for example, at least the eyes should be sharply defined.

Poorly exposed slides that are not ideally suitable for projection or color printing may be salvaged by copying onto black-and-white film. A slightly dark transparency with full detail is more suitable for this than a thin or washed-out color positive that may have lost its detail.

The original must be clean and free of scratches or abrasions. Dust and lint can be removed with an air blower—preferably—or camel's-hair brush. Fingerprints and oily smudges can be removed with a fluid cleaner, such as Kodak Film Cleaner. Touching the slide with a grounded metallic source should destatic the film, making it easier to remove dust and lint.

Film Selection and Development

A copy tends to be more contrasty than the original. This may be quite satisfactory when you wish to add bounce or zip to what, in the original, is a flat scene or subject. If, however, the original is otherwise satisfactory, the act of copying tends to yield a more contrasty effect. A corrective approach would be to use a low-contrast film to balance things out. Among the available still-camera films, those that best meet this requirement are in the high-speed group, which, unfortunately, do not have the same image-resolution and fine-grain properties that are found in some of the slower color films, notably Kodachrome 25.

The solution is to use one of the slower films, notwithstanding their tendency to be rather contrasty, and to overcome this tendency by overexposure and underdevelopment. The procedure will be explained more specifically below, but briefly stated one would overexpose by a factor of two or three and underdevelop within the range of 20 to 60 percent, depending upon the characteristics of the original. Ideal films for this purpose would be Agfa Isopan IF (ASA 40),

Ilford Pan F (ASA 50), and Kodak Panatomic-X (ASA 32). The developer should be of the surface-acting or compensatory type, the latter achieved in some cases by diluting the developer in accordance with the manufacturer's instructions.

In sheet-film format, you will have a wide variety from which to select. One recommended film is Kodak Super-XX Pan 4142 film; it has both speed and tonal scale. It is a panchromatic film used in making color separations.

Exposure Determination

There are two routes to determining and making good exposures. One involves the use of continuous sources of light for both focusing and exposing, while the other uses a combination of focusing lamp and electronic flash for the actual exposure. In either case, shutter speeds are held constant with variations made in lens aperture and lighting brilliance.

The first step in exposure determination is to create a file reference of typical exposures. You would start with three basic examples. The first would be what you regard as a typical *average* subject or scene photographed with front lighting or otherwise so as to have a minimum of shadows in a fairly wide tonal range. This would be your type II slide. Type I would be a scene of limited tonal range, such as a landscape or a fairly flat, shadowless subject. A type III slide would represent contrasty scenes with pronounced shadows caused by sidelighting and backlighting.

Each of these will then be copied onto black-and-white film under trial procedures that will yield exposure-and-development guidelines for other transparencies that compare with type I, II, or III.

FILM TYPES FOR VARIOUS ORIGINALS AND REPRODUCTION PURPOSES

Original		Purpose	Type of Film Recommended
Black-and-white negative	Ordinary gradation	Black-and-white slide projection	Microfilm, Diapositive film
	High contrast	Black-and-white slide projection	Negative film for general use
Black-and-white slide		Black-and-white slide projection	Black-and-white reversal film
		Intermediate negative for making print	Negative film for general use
Color negative		Black-and-white slide projection	Panchromatic negative film for general use
Color slide		Color slide projection	Color reversal film
		Color negative for color print	Color negative film
		Black-and-white slide projection	Black-and-white reversal film
		Intermediate negative for black-and-white film	Panchromatic film for general use

BACKGROUND EXPOSURE COMPENSATION IN SLIDE-COPYING

When copying slides with light background:

Film	Color reversal, color negative, panchromatic
Compensation	Decrease the ASA speed 4 marks (Increase the exposure about 1½ stops)

When copying slides with light figures or letters on a dark background:

Film	Color reversal, color negative, panchromatic
Compensation	Increase the ASA speed 5 marks (Decrease the exposure about 1½ stops)

The procedures will vary slightly according to whether continuous lighting sources or electronic flash are to be used. We will start with the tungsten procedure. In either case, the lighting source should be a minimum of three inches away from the acrylic plate or other mutual diffusing glass or plate. A continuous lighting source would have to be very bright if it is to permit making very short exposures. This is more easily obtained when using professional equipment with built-in lighting sources whose output can be brought to bear most efficiently. When using photofloods or incandescent bulbs in a home darkroom setup, the tendency is to make longer exposures. It should be kept in mind that a lens extension that permits a 1:1 image ratio calls for a $4\times$ increase in exposure as a starter. The longer the exposure—a function of lighting source, lens extension, relative aperture, and characteristics of the original—the greater is the tendency for the copy to build up contrast.

With simple equipment, utilizing the camera and its exposure-metering capabilities, the first step is to make an initial estimate of exposure from a typical section of the slide, bearing in mind that the exposure-reading area on the focusing screen is the central area. The exposure index to be set on the ASA dial should be the adjusted ASA rating. Thus, if you start by overexposing one stop, using an ASA 40 film, you would set the dial for E.I. 20. For a two-stop overexposure as a further trial, the exposure index would be 10. With a tungsten (continuous) light source, a tentative reading is easily obtained through the meter/finder.

Having arrived at a tentative combination of aperture and shutter speed, you then would bracket within a range of two f/stops on either side of the tentatively correct f/stop, at half-stop intervals. For example, if your reading indicates an exposure of $f/8$, you would run a series of exposures at the same shutter speed at half-stop intervals beginning with $f/4$ through $f/16$. For a single developing trial with a film overexposed one stop, you might try one-third less than normal time. After developing the film, you would examine the series to select the frame that adequately accommodates both highlights and shadows, revealing details within each. The exposure details should be indicated on the type II original for use with comparable originals to be copied thereafter, assuming that all elements of the copying procedure are held constant.

You can try different combinations of overexposure and underdevelopment with the aim of finding the result on film that offers a desired tonal range with adequate shadow and highlight rendition.

Electronic flash is the preferred method with simple systems such as are described herein because the brief exposure, which ranges from 1/500 to 1/1000 sec. depending upon equipment used, overcomes hazards of movement and vibration and, most important, assures that the same volume of illumination is delivered each time, provided a full charge of power is allowed to build up before firing the flash unit. The brief duration of the flash is preferred by many photographers because it yields a softer or less contrasty effect.

Exposure-control variations are attainable only by altering flash output or lens aperture, but not by changing the shutter speed. Some flash units have high and low output switches. A single thickness of handkerchief will reduce output by one f/stop equivalent; two thicknesses will cut output by two f/stop equivalents. In addition to the flash source, a focusing lamp, preferably at the same distance as the flash, is needed. Readings from the slide illumination provided by the focusing lamp can be used to find correlations with most satisfactory exposures achieved with flash, as explained below.

For the type I and III reference slides, similar procedures can be followed with

both continuous and electronic illumination sources. The procedure for overexposure and underdevelopment is least applicable to type I originals and most applicable to type III originals. In fact, slide copying is often used to introduce contrast into an unacceptable picture. After making trial runs with your complete set of types I, II, and III slides, you can create a set of exposure ratios among them for future reference. Keep in mind that for analysis of the original you are considering the contrast range within the entire image area. If you are to reproduce only part of the original, you must expose and develop for that selective area. For example, a portrait of a light subject against a dark background (or a dark-hued subject against a light background) would present a contrast that seemingly might come under type III. However, since you are interested only or primarily in portrait rendition, you would expose for the contrast characteristics of the subject alone.

Under production conditions, slides should be grouped according to their type I, II, and III characteristics and should not be mixed on the same length of film.

When copying slides of greater or lesser density, as compared with the reference originals, you can use the camera-metering system to find the exposure variance from the original. This also is applicable to magnifications. Alternatively, you can use a larger lens aperture for greater magnification, based on the table of magnifications and exposure factors in Chapter 1. (Direct exposure readings taken from the slide itself are possible. You can use an independent exposure meter, preferably one with a narrow angle of view. The Illumitran takes integrated exposure readings directly from the transilluminated slide. The Nikon Multiphot has an accessory exposure meter for spot readings from transparencies.)

Creative Variations

Filters can be used to alter tonal characteristics and colors, just as in making original black-and-white exposures. For example, a blue sky can be darkened with a yellow or red filter. With panchromatic films, flesh tones can be improved through use of a green filter. For pictorial scenes use a medium or dark yellow filter.

Skies rendered hazy on the original will *not* be improved by using ultraviolet, yellow, orange, or red filters. Where skies are rendered on originals as bright, clear, blue, you will have no need to filter out excessive ultraviolet radiation, for it will have been disposed of in the original.

Colors that are separated on the originals might not contrast with each other when reproduced monochromatically. This can be corrected by filtering. In general, filters corresponding to subject colors will lighten them; filters for complementary colors will darken them. See the section on copying, below, for suggestions on tonal control through filtering. Where color separation on the original is tonal or monochromatic, filtering will not alter the tonal contrasts.

While the foregoing procedures aim at the avoidance of contrast in reproducing original slides, this inherent tendency of the copying process can be used deliberately for achieving special effects. Successive copying of the same subject will build up increasingly sharper contrast. This can be accentuated by using high contrast copying films and special graphic-arts films available in 35mm formats.

Additional suggestions for creative variations are to be found toward the end of the succeeding section on color film procedures.

Black-and-White Slides

Black-and-white slides bring out more of the pictorial potentials of negatives

than do paper prints. The projections have more brilliance than prints that are viewed by reflected light.

For direct black-and-white slide making from color slide originals use Kodak Direct Positive Panchromatic Film. This is an ASA 80, fine grain, medium-speed, reversal film. Processing is by the reversal method as explained in the instruction sheet accompanying the 100-foot bulk-load film. Kodak Panatomic-X film, available in 20- and 36-exposure loads, can also be exposed and processed in the same way.

To make positive copies from black-and-white negatives, use a slow- or intermediate-speed film with a full tonal scale. Metro/Kalvar film may also be used.

COLOR SLIDE DUPLICATES AND VARIATIONS

As a starting point, we must clarify our terminology. In a literal sense, there is no such thing as a "slide duplicate," for there are infinite variations, however slight, between the original and its reproduction as to contrast range, color saturation, highlight and shadow details, overall density, and other attributes. At the very least, it is practically impossible to find an exact match in the chemical properties and resulting characteristics of the original film and that used for making the duplicate. Nevertheless, the term duplicate is used commonly, even for the designation of "duplicating films." Hence, to the extent that the term is used here, it should be understood that it refers to a copy that is as faithful to the original as is reasonably possible.

Making duplicate transparencies is rather easily accomplished if only a pleasing effect is desired and if high fidelity in reproduction is not important. With a little more care, however, you can come reasonably close to the original.

Refer to the preceding section on making black-and-white negatives for general procedural guidance. The special procedural problems in copying color slides to be taken up below are:

1. Films, light sources, and filters for color duplicating;
2. Determining correct exposures and filter modifications; and
3. Techniques for reducing contrast.

Transparencies suitable for copying have rich tones, with well-defined details in shadows and highlights. The ideal transparency for copying is *slightly* on the dark side (underexposed) without harsh shadow contrasts. Overexposed originals are poor for copying. Underexposed original transparencies can be salvaged within limits, but obviously colors will shift.

This section concludes with a discussion of creative and corrective techniques to be followed either to improve upon the original or to achieve specifically desired effects.

Films and Matching Light Sources

While information is provided concerning both ordinary camera films and special "duplicating" films, the latter have particular advantages. Also, while information is given on both continuous and flash illumination, the latter is favored, at least for use with equipment described in this book.

The ideal film for color duplicating has a built-in softness that offsets the tendency of color duplicates to build up contrast. Ordinary camera films do not meet this requirement, although they are useful in adding contrast to flat originals. Kodachrome 25 and Kodachrome 40 (Professional, Type A) are ex-

cellent films provided they are preflashed or prefogged (done easily as explained below) when used with full-scale or contrasty originals. Alternatively, Ekachrome 64 may be used as a compromise, offering fine grain with tonal scale. The Ektachrome films can be contrast-controlled by overexposing them and then curtailing the time of the first developer.

Different brand color films may yield different renditions of original subject colors. Characteristics of the same film change from time to time, due to manufacturing changes and advances. You must choose a film suited to your needs and tastes, based on current availabilities. Furthermore, the same film type will shift color from batch to batch. The same piece of film will change with age.

To minimize shifts in color in different production batches, film should be bought either in long rolls or in professional packs of 35mm camera loads. Unused film can be stored for long periods in the refrigerator or indefinitely in the freezer. If regular camera loads are purchased, they should be in bulk sealed cartons or packages, to assure that they have the same emulsion number. Otherwise, for *critical* work, film with an emulsion number different from that used in making reference exposures, may have to be checked out through the entire exposure and development procedure each time a new batch is bought.

The light source must match the film type. A workable combination is a daylight color film and electronic flash, together with an 81C filter, to correct for a slight excessively blue brilliance. AG-1B or AG-3B (blue) bulbs can be used, but these are more expensive per flash— a real consideration if you intend to do a lot of artificial-light shooting—and do not have the same softness of lighting as electronic flash. The electronic-flash unit should be powered by the house current, preferably, for output consistency.

KODACHROME—CORRECTIONS FOR VARIATIONS FROM A ONE-SECOND EXPOSURE

Exposure Time	1/8 Second	1 Second	10 Seconds	100 Seconds
Kodachrome 25	No adjustment	+1 stop CC10M	+1½ stops CC10M	+2½ stops CC10M
Kodachrome 40	No adjustment	+½ stop No filter	+1 stop No filter (5 sec.)	Not Recommended

KODAK FILTERS TO BE USED FOR NIKON SLIDE-COPYING ADAPTER

Light source	Film Kodachrome & Kodak-Ektachrome Daylight type	Kodachrome Professional Type A	Kodak Ektachrome Type B
Daylight	No. 82B	No. 81D + No. 81C	No. 85C
Blue flash bulb	No. 82B	Not recommended	Not recommended
Blue photoflood lamp	Not recommended	Not recommended	Not recommended
Clear flash bulb	No. 80C + No. 82	No filter needed	No. 81A
Photoflood lamp	No. 80B + No. 82	No. 82B	No. 82
3200 K lamp	No. 80B + No. 82B	No. 82C	No. 82B

Daylight is not recommended because of blue-sky toning and haze-filtering. In an emergency, however, point the unit toward the clear sun and use a UV filter.

Tungsten films (indoor color film types) may be used with photoflood or 3200 K lamps, as appropriate. Kodachrome 40, Type A, is balanced for 3400 K photoflood without a filter, while with 3200 K, an 82A filter is required.

When exposure times longer than 1/10 sec. are used with either Kodachrome 25 or Kodachrome 40, Type A, it is necessary to compensate for the reciprocity characteristics of this film by increasing the exposure and using the Kodak Color Compensating Filters suggested in the accompanying table.

Exposure times longer than 100 seconds are not recommended for this film. The information in the table applies only when the film is exposed to the light source for which it is balanced. When other light sources are used, additional adjustments in exposure and filtration are required.

With photofloods and other lamps, best results are obtained when lamps are used for no more than half their rated lives, thereby avoiding noticeable shifts in color temperature. Professional tungsten-halogen lamps maintain accurate color temperature for most of their rated lives, but conventional photoflood lamps do not. Since line voltage is likely to vary at different times of the day, particularly with fluctuations in load, a voltage regulator should be used for critical work.

Ektachrome Slide Duplicating Film, Type 5071 is designed primarily for use with artificial light such as a photoenlarger lamp or a slide projector lamp with a color temperature of 3200 K. The film has a low sensitivity to light. Since films of this type do not have ASA ratings in the normal sense, an indicated rating of ASA 8 is to be regarded only as a starting point. Good results can be obtained with a 500-watt lamp at a distance of about 20 inches (50cm) from the slide. Camera settings for the average picture would be one second at $f/5.6$.

For a tungsten light source, the exposure should be about one second, and for electronic flash about 1/1000 sec., subject to variations required for one's own equipment. Different filter packs are required for originals from different films. When electronic flash is used, additional filtration is indicated to compensate for the 5500 K color temperature of the flash and for the reciprocity characteristic color shift caused by the short duration of the flash exposure. Suggested starting filter packs for various originals and light sources are included in the instructions packed with the film. When a Kodak Infrared Cutoff Filter No. 304 is used at the light source, the same filter pack may be used to copy originals from different films. The Infrared Cutoff Filter, however, is quite expensive, and the more common practice for small-volume users is to simply change the filter pack when originals from different emulsions are copied.

Kodak Slide Duplicating Film 5071 may be processed in conventional E-6 chemicals with no adjustment in development time.

Francisco Hidalgo, who contributed the accompanying layout sketch of his equipment setup stated, "The fidelity in color is pretty good and sometimes better than the original. The best $f/$stop is $f/8$ with my Micro-Nikkor lens. I focus carefully, for at 1:1 I have just one millimeter of depth of field. Of course, with any material you increase the contrast, but if you are familiar with this problem you will be delighted with the film.

"I compute exposure for every picture I copy. By putting a 4+ close-up lens in front of the meter, I can take a closer reading of the subject. Generally, I read from the lighted areas of the picture. I

aim for a duplicate with thoroughly saturated colors, as these are better for printing in publications and projection.

"Whenever I make a duplicate I enter the details on the original slide. If two months later I need to make another duplicate from the same original, I can be certain of the same results, provided I give the film to a good lab whose work I know to be constant."

Kodak Vericolor Slide Film 5072 (long rolls) and Vericolor Print Film 4111 (sheets) are used to make transparencies from color negatives. Photographing the negatives with ordinary color negative film, in an effort to produce transparencies, will not produce good results.

If the illuminating source is of a different color temperature than that for which the film is balanced, a suitable color-balancing filter should be placed over the lens or the light source. Standard filters, such as the 85B, 80A, 82A, etc. are available, or the mired system may be used. A mired is a color temperature, expressed by its reciprocal, multiplied by one million.

The mired of the compensating filter is determined by this formula:

Mired of filter = mired of illuminating light − mired of film.

If the difference is positive (+), blue filters should be used, while for a minus (−) difference, yellow filters should be used. The closer the match in color temperature of film and light source, the lower will be the density of the compensating filter, and the lesser will be the filter factor.

(Special note for early model Nikon Slide-Copiers: Even though there is a perfect match between illumination and film, a filter of +30 mireds must be used to compensate for a lowering of color temperature of the light source, caused by the opal-acrylic plate diffuser of earlier models of the Nikon Slide Copying Adapter for the Bellows Model 2. *This does not pertain to the PS-4 PS-5 and PS-6 Slide Copiers.)*

When the original slide or test duplicate slide is examined, you may find an overall hue you wish to modify by using color-compensating filters. To effect a change in predominant color balance, when exposing a reversal film, subtract a filter of a color of the overall hue or add a filter complementary to the overall hue, as shown in the following table. When filtering at the lens, use gelatin filters (CC). Filters placed behind the color slide can be the less expensive acetate color-printing (CP) filters.

Electronic flash setup used by Francisco Hidalgo as described in the accompanying text. Flash unit has heavy duty output.

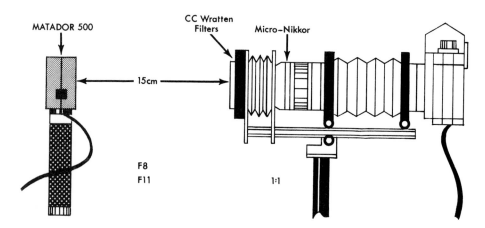

MATADOR 500

CC Wratten Filters

Micro−Nikkor

15cm

F8
F11

1:1

MODIFICATION OF COLOR BALANCE BY USE OF COLOR-COMPENSATING FILTERS

If the overall color balance is:	Add these filters:	or	Subtract these filters:
Yellow	Magenta + Cyan (or Blue)		Yellow
Magenta	Cyan + Yellow (or Green)		Magenta
Cyan	Yellow + Magenta (or Red)		Cyan
Blue	Yellow		Magenta + Cyan (or Blue)
Green	Magenta		Cyan + Yellow (or Green)
Red	Cyan		Yellow + Magenta (or Red)

Additional information on color-balancing filters is to be found in the *Kodak Color Dataguide,* available through Kodak dealers.

Contrast Reduction

With ordinary camera films, in particular, the tendency to build up contrast is advantageous when it is desired to add "snap" to otherwise flat effects in an original. Otherwise, slides that are well-balanced tonally will tend to reproduce with too much contrast when copied. One means of overcoming this is to manipulate exposure and development. Instead of using Ektachrome 64 or Ektachrome 50 Professional (Tungsten) at their respective ratings of 64 and 50, they should be exposed at 32 and 25, respectively. This effectively doubles the exposure. The next step is to reduce the time of the first developer as recommended by the manufacturer. Since this might work better with some subjects than with others, test runs are advisable.

Preflashing is a technique for minimizing or reducing contrast by subjecting the film on which transparencies are to be copied to a very low level of uniform exposure before the copies are to be made. The effect is to lower maximum density and to reduce contrast between shadows and highlights. Preflashing in

the camera is quite simple with the Nikon F2 by making a double exposure. The first exposure is made with a neutral density 2.0 (1 percent transmission) filter right over the lens. This is then followed by a second exposure of the same frame in the normal manner, but without the neutral density filter. Alternatively, through use of a modified darkroom lamp with suitable filtration, you can flash an entire strip of film. The light source must have a color temperature equivalent to the one used in the camera setup. With a continuous lighting source this should be no problem, but if final exposure is to be made with flash equipment, the darkroom lighting would have to be modified accordingly. Additionally, a 2.70 neutral density filter should be used to reduce light output. The duration of flashing will be governed by film speed, intensity of light output, and distance of the film from the lighting source. As a starter, a length of film should be placed six feet away from the light source. Then, make a series of tests starting with about a 20-second exposure.

Exposure Procedures for Color Reproduction

In reproducing a color slide, the first question is how much fidelity of reproduction is to be achieved. Is it essential

to reproduce the original as closely as possible, keeping in mind that a copy can never reproduce *all* of the colors of the original precisely? And that, furthermore, the original film can never precisely duplicate the colors of the original scene in real life. What, then, is fidelity? The strategy in color reproduction may be to *attempt* to match the original or to improve upon it.

If a copy is to be used in place of the original to go out to art directors and editors, it would be important to get as close a reproduction as possible. The same pertains to films that might actually be used in photographic reproduction. On the other hand, if Aunt Priscilla or Uncle Harry should want a copy of that cute picture of the new baby or of Junior taking a whack at an approaching ball, it might be sufficient to get a pretty good reproduction with a minimum of contrast and fair density without too much concern over the matter of color fidelity.

A copy can never reproduce equally well all of the colors of the original. You might succeed in correcting for particular tonal areas, but in doing so you might have to make compromises for others. Particularly with people pictures, your aim will usually be to obtain the greatest accuracy in matching flesh tones while in other cases your aim would be to give priority to the most important elements, particularly the prominent lighter colors. If the recipient of a slide duplicate will not have the original for comparison, he might be quite pleased with the result. If critical fidelity is not needed, you would therefore be better off to evaluate results without making critical comparisons.

The procedure to be described herein is basically similar to that described above for making black-and-white negatives from color originals. The starting point is to select examples of well-exposed transparencies that you regard as typical of flat, average, and contrasty subjects, identified earlier as types I, II, and III. Next, you make a series of trial exposures of the type II transparency using either a continuous light source or a flash source. With flash, you have a choice of holding the shutter speed constant and varying the f/stop or holding both of these constant and varying the distance of the flash from the slide holder, whether it is the slide-copier attachment for the bellows unit or a lightbox setup. With more sophisticated equipment such as the upright Illumitran and Repronar Universal copy stands in which physical relationships of the flash unit are fixed, exposure control is possible only by varying the f/stops or by using neutral density filters. With continuous lighting, exposure control would be achieved by varying the lens aperture while holding the shutter speed constant or by varying the shutter time while holding the f/stop constant.

Whatever system you use for arriving at your exposure standards, your actual exposures based on those standards should aim to hold exposure times constant. With flash this is automatically achieved provided the unit is used consistently at the same power setting and is fully cycled before being discharged. With continuous illumination, the same exposure duration should be followed, since color films tend to react differently to different durations of exposure.

For critical work, a new film type, a new batch of film, or a film that has aged out of cold storage must be "locked in" or calibrated. This pertains also to changes in equipment. The purpose is to identify reference exposures and filtration for each batch of film under your own operating setup, particularly concerning optics and illumination.

The procedure for "locking in" on a particular film-and-equipment setup calls for two series of exposures. In the first, you are seeking the basic exposure setting that will give you a duplicate whose *density* compares faithfully to that of the

original even though there may be differences in color rendition. The second series is intended to provide the corrections that will render colors faithfully and, if necessary, that will soften undesirable contrast.

When using a simple flash setup, with the flash directed toward the back of a slide holder or bouncing indirectly off a reflecting surface onto the slide, your starting point for determining a basic reference exposure is to use the flash guide number with an adjustment for light loss due to diffusion. For example, with the flash directed toward the acrylic plate in the slide holder of the copying attachment, divide the distance of the flash from the diffusing plate into the flash guide number for the particular film being used. Then, add a crude compensatory factor of two f/stops of increased opening for diffusion light loss.

A more systematic approach would be to use a tungsten light source with and without intermediate diffusion to find the amount of light loss occasioned by diffusion. First, you would take an exposure-meter reading of the light source without anything between it and the exposure meter. A second reading would be made with the same distance between light source and meter, but this time you would have the diffusing plate directly in front of the meter. The difference in f/stop reading between the two will indicate the amount of compensation needed that can then be used to modify the flash exposure.

Having determined an approximate exposure or starting point, you then would make a series of nine exposures at half-stop intervals, four of them at larger lens apertures, one at the starting lens aperture, and four at smaller apertures, as described earlier in the section on black-and-white reproductions.

The next step is to select the exposure that most closely resembles the density of the type II original being used for the series. Now you must make a second series of density samples consisting of the master duplicate you have just selected and one each at plus one stop, plus one-half stop, minus one-half stop, and minus one stop. This will constitute your basic reference series for a type II original for density comparison purposes only. Similar reference tests can be made of type I and III originals. The reference sets can be used for exposure correction of both originals and duplicates. With an original, for ease of comparison, it is suggested that the reference slides be placed in a protective acetate sleeve ranging in order from a one-stop overexposure progressively through a one-stop underexposure.

Before copying an original, you should compare it with the five-step reference series (types I, II, and III) to find the best density match for your original regardless of whether or not it is properly exposed. If your slide should match the correctly exposed reference slide you can use that as your starting exposure, subject to other corrections. Otherwise, if it matches an overexposure or an underexposure this is an indication to compensate accordingly. Thus, one-half stop overexposure in your original would be compensated by one-half stop *less* exposure when you make your duplicate, again subject to other filter corrections if necessary. Similarly, after you have made a duplicate, you can compare it with the appropriate set of reference exposures to ascertain how much more or how much less exposure should be made.

With a continuous light source, the procedure for making the *first* test series would be somewhat different. Setting the lens at f/8 or f/11, make a series of test exposures beginning with $1/2$ sec. and continuing through increments of $1/2$ sec. up to four seconds with the appropriate filter pack in place. Then, select the best match with your ideal original and use it as the middle selection for your group of five reference slides.

When the image magnification is

changed, an exposure factor must be used for the corresponding decrease in brilliance of the image at the focal plane. For noncritical work, reference can be made to the accompanying table of exposure factors for size ratios of duplicates. With Nikon cameras, comparative size ratios can be determined easily through use of ruler scales at the subject. Keeping in mind that the short dimension of the image area with Nikon cameras, as perceived on the groundglass, is 24mm, the diminished coverage of a metric scale can be used to set up a ratio of magnification that will indicate the additional exposure needed, as shown in the accompanying table. *This table shows exposure factors in addition to that already accommodated by a 1:1 magnification.* Inasmuch as Nikkormat cameras and fixed-prism Nikons have less than a 24 × 36mm image as perceived through the viewing screen, you have to set up a before-and-after image ratio based upon actually perceived coverage of the millimeter scale in the viewfinder.

Alternatively, exposure factors can be found to compensate for greater magnification or greater or lesser density by comparing relative brightness between comparable areas of transparencies as viewed on the focusing screen. This is feasible only with the Nikon cameras whose viewfinders can be removed. The probe of a photometer can be used to take a reading of an important area of brightness at both a 1:1 magnification and at greater magnifications of the same slide. The difference in intensity of illumination between the two will provide exposure adjustment information. The same approach can be used when comparing slides of different density. Of course, all other factors must remain constant, including lens aperture, the lamp used, distance of lamp to color slide, and the like when making exposure comparisons and computations.

EXPOSURE FACTORS FOR SLIDE-COPYING MAGNIFICATIONS

SIZE-RATIO OF DUPLICATE TO BE MADE*	EXPOSURE FACTOR
1:1	1
1:1.25	1.56
1:1.5	2.25
1:1.75	3.06
1:2	4
1:2.25	5.06
1:2.5	6.25
1:2.75	7.56
1:3	9
1:3.25	10.56
1:3.5	12.25
1:3.75	14.06
1:4	16

*The first figure "1" in the ratio refers to the diagonal of the reference transparency, using it as base. The number following the colon represents the comparative size of the diagonal of the copy that is to be made.

Color Correction

While density control is achieved through exposure variation, correction or balancing of the color properties of the slide is achieved by adding or subtracting filters. For this purpose, it is important that the transparency be viewed on a standard illuminator whose light has a color temperature of 5000 K (in accordance with ANSI Standard PH2.31-1969). Such an illuminator provides correct spectral distribution characteristics at the proper light intensity for critical analysis of color transparencies. If you are making a duplicate, the procedure is to place it alongside the original on the illuminator and then to view the duplicate through various color-compensating filters or combinations of filters either of the CC or CP type. The CC filters are made of gelatin and are

MIRED NOMOGRAPH FOR LIGHT SOURCE CONVERSION

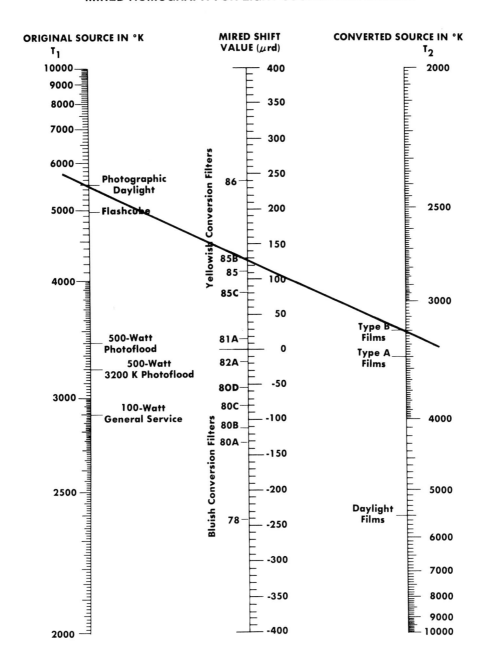

The Mired Nomograph can be used to find the filter required or a particular conversion by placing a straightedge from an original source (T₁) to a second source (T₂) as illustrated above by the diagonal line. In the illustration, daylight illumination at 5500 K requires an approximate +130 mired shift to convert to Type B illumination at 3200 K. Kodak Daylight Filter No. 85B with a mired shift value of +131 meets this requirement.

Reproduced with permission from the copyrighted Eastman Kodak publication *Kodak Color Films*, publication E-77.

ordinarily intended for use over the lens, whereas the CP filters are made of acetate and are ordinarily intended for use over the lighting source. Either can be used for this analytical purpose. When you find a desirable effect matching as closely as possible the important color area or areas of the original, you will have determined, at least initially, the required filter pack. For purposes of judging, you should look at the middle tones rather than highlights or shadows. The required filter-pack adjustment involves removing a filter of the color of the overall hue or adding a filter complementary to the overall hue as shown in the accompanying table.

A few simple rules must be kept in mind. One is to keep to a minimum the number of filters in the pack. Another is to have not more than two subtractive colors in the pack because if three are present neutral density will be the result, requiring the removal of one of the three colors. An example is given in which a filter pack contains 40C + 40M + 20Y. The lowest value filter is removed by total subtraction while the values of the other two are similarly reduced:

Filter Pack 40C + 40M + 20Y
Subtract 20 20 20
 (to remove neutral density)

Minimum
Filter Pack 20C + 20M

You can reduce the filter pack further from a 20C + 20M to a 20B, as indicated in the accompanying chart. Because the cyan filter prevents transmission of red light, and the magenta filter prevents transmission of green light, the net effect of the two filters is to transmit the blue component of light.

The addition of a filter or a change in the filter pack requires making exposure adjustments to compensate both for the loss of light as a result of the color-filter-ing action and the loss of light due to reflection from filter surfaces. One way to calculate exposure adjustments is to increase the exposure for each filter by the amount indicated in the accompanying table of f/stop adjustments for CC filters, and then to increase exposure further according to the number of filters used. Each filter calls for a 10 percent increase in f/stop. Hence, the addition of three filters would, in itself, require 30 percent additional exposure. If the filter pack is adjusted to achieve the same effect through the use of two filters, only a 20 percent adjustment would be required. Of course, where continuous lighting is used, exposure time can be substituted for f/stop adjustment.

An alternative method of adjusting exposure for filters is to use the accompanying table of computer numbers and factors for Kodak CC and CP filters. If the pack is changed by only one filter, you need refer only to the appropriate factor column for the one factor. If two or more filters are used, multiply their individual factors together and use the product as the filter factor in adjusting your exposure. Another system is to use the color-printing computer in the *Kodak Color Dataguide*.

Creative Slide Copying

Thus far, the procedures covered here have related to both duplicating original slides and improving upon them by correcting over- or underexposure and color balance. Once the basic techniques are learned, you can alter images in many different ways to achieve effects outside of the ordinary camera operation. Most obvious is to enlarge and crop the image so as to exclude unwanted matter. Some distortion of vertical lines due to perspective foreshortening can be corrected through tilting. Multiple exposures can be made either through release of the camera-shutter mechanism repeatedly or

KODAK COLOR COMPENSATING FILTERS

Peak Density	Yellow (Absorbs Blue)	Exposure Increase in Stops*	Magenta (Absorbs Green)	Exposure Increase in Stops*	Cyan† (Absorbs Red)	Exposure Increase in Stops*
.025	CC025Y	—	CC025M	—	CC025C	—
.05	CC05Y‡	—	CC05M‡	1/3	CC05C‡	1/3
.10	CC10Y‡	1/3	CC10M‡	1/3	CC10C‡	1/3
.20	CC20Y‡	1/3	CC20M‡	1/3	CC20C‡	1/3
.30	CC30Y	1/3	CC30M	2/3	CC30C	2/3
.40	CC40Y‡	1/3	CC40M‡	2/3	CC40C‡	2/3
.50	CC50Y	2/3	CC50M	2/3	CC50C	1

Peak Density	Red (Absorbs Blue and Green)	Exposure Increase in Stops*	Green (Absorbs Blue and Red)	Exposure Increase in Stops*	Blue (Absorbs Red and Green)	Exposure Increase in Stops*
.025	CC025R	—	—	—	—	—
.05	CC05R‡	1/3	CC05G	1/3	CC05B	1/3
.10	CC10R‡	1/3	CC10G	1/3	CC10B	1/3
.20	CC20R‡	1/3	CC20G	1/3	CC20B	2/3
.30	CC30R	2/3	CC30G	2/3	CC30B	2/3
.40	CC40R‡	2/3	CC40G	2/3	CC40B	1
.50	CC50R	1	CC50G	1	CC50B	1 1/3

*These values are approximate. For critical work, they should be checked by practical test, especially if more than one filter is used.

†Another series of cyan color-compensating filters with more absorption in the far-red and infrared portions of the spectrum is available in the listed densities. These filters are designated with the suffix "-2" (i.e., CC025C-2) and should be used in preference to other cyan filters when required in filter packs for printing Kodak Ektacolor and Ektachrome Papers. Similar Kodak Color Printing Filters (Acetate) are available in .025, .05, .10, .20, and .40 cyan densities.

‡Similar Kodak Color Printing Filters (Acetate) are available. For further information, see the Kodak Data Book, *Printing Color Negatives*.

COMPUTER NUMBERS AND FACTORS FOR KODAK CC AND CP FILTERS

Filter	Computer No.	Factor	Filter	Computer No.	Factor
05Y	.04	1.1	05R	.07	1.2
10Y	.04	1.1	10R	.10	1.3
20Y	.04	1.1	20R	.17	1.5
30Y	.05	1.1	30R	.23	1.7
40Y	.05	1.1	40R	.29	1.9
50Y	.05	1.1	50R	.34	2.2
05M	.07	1.2	05G	.06	1.1
10M	.10	1.3	10G	.08	1.2
20M	.16	1.5	20G	.12	1.3
30M	.22	1.7	30G	.15	1.4
40M	.27	1.9	40G	.18	1.5
50M	.32	2.1	50G	.22	1.7
05C	.06	1.1	05B	.04	1.1
10C	.08	1.2	10B	.12	1.3
20C	.12	1.3	20B	.21	1.6
30C	.15	1.4	30B	.29	2.0
40C	.18	1.5	40B	.38	2.4
50C	.21	1.6	50B	.47	2.9

To use computer numbers: Add the computer-number values for all the filters in the old pack. On the "Density" scale of the Color-Printing Computer, set the sum of the computer numbers so that it is opposite the exposure time used. Read the new exposure time opposite the sum of the computer numbers for the new pack.

To use factors: First divide the old exposure time by the factor* for any filter removed from the pack. Then multiply the resulting time by the factor* for any filter added.

*For two or more filters, multiply the individual factors together and use the product.

through excessive use of open flash. Zoom effects can be achieved by varying the distance of the slide from the lens during exposure using a continuous source of illumination.

Additionally, sandwiching two or more color slides often yields interesting effects and provides uses for slides that might not otherwise have pictorial value. An adaptation of the sandwiching technique is to add a texturizing slide to an ordinary scene or a portrait. Many of the techniques for manipulating ordinary black-and-white films with photosensitive paper in the darkroom can be adapted to slide duplicating.

DOCUMENT (REFLECTED LIGHT) COPYING

The term *document copying,* as used here, covers flat originals photographed mainly by reflected light—although there are exceptions in which partial or total transillumination may be used. The originals may be letters, clippings, photographs, paintings, charts, fabrics, etchings, postage stamps, legal papers, and "clue" materials. These exist mainly in a single plane of focus, without depth. Again, there are exceptions, for some originals have obvious texture depth, such as oil paintings, wood grain surfaces, fabrics, and raised letter printing. In fact, microscopic techniques reveal depth to all seemingly smooth, flat, depthless surfaces.

Photographic method and technique in copying are governed by the end in mind—whether to store information on film in order to conserve space, to create a film from which to make paper prints, or to produce a transparency for projection. Most of the information presented pertains to black-and-white negative photography, but the techniques apply also to color.

Most copying is not done at extremely close range although important exceptions include magnifying portions of color slides, copying postage stamps, etc. The special problems of copying include achieving uniform lighting, avoiding undesirable reflections, achieving even illumination, and preserving correct tonal qualities and contrasts, including preserving proper line thickness in line copying. Filters are used to screen out stains and discoloration, to bring out alteration of documents, and to help establish authenticity or originality of paintings.

More specifically, this section covers:

1. Equipment and films for copying work.

2. Originals and variations of treatment.

3. Lighting and control of reflections.

4. Restrictions on copying.

Exposure has, in general, been covered earlier. Some aspects of exposure will be covered in connection with the discussions of treatment of different types of originals and handling lighting setups.

Lenses, Camera Supports, and Films

Lenses. The lenses most suited to taking pictures of reflection copy *at close range* are the 55mm $f/3.5$ Micro-Nikkor, the 105mm $f/4$ Micro-Nikkor, and the 200mm $f/4$ Micro-Nikkor IF. The 50mm $f/1.8$ and $f/2$ may also be used if mounted in reverse. Consult the chart on page 18 to determine working distances at various magnifications.

Long lenses will be found to be helpful to avoid reflections. The long lens has a narrow angle of view, while lighting sources can be placed at more oblique angles so that tiny irregularities on the copy material surface are less

likely to throw reflections into the field of view of the lens. The El-Nikkor enlarging lenses are also suitable in view of their correction for close-range work. Other long lenses should be used at $f/11$ or $f/16$.

Copy stand. The Nikon Repro-Copy Outfit Model PF-2 is a vertical camera copying stand that can be used for permanent installation or as a portable outfit.

Films. Films for continuous black-and-white copying are low ASA Agfa Isopan IF, Ilford Pan F, and Kodak Panatomic-X. Projection positives can be made with Kodak Direct Positive Panchromatic Film.

For color copying, Kodachrome 25 is a favorite, particularly because of its brilliance. But, other good films include any of the Agfachromes, Ektachrome 64, and Ektachrome 50 Professional (Tungsten).

A film for black-and-white line copying (letters, line drawings, newspapers, books, charts, and typewritten matter) is Kodak High Contrast Copy Film. This film is exceptionally fine-grained, permits extreme reduction, and is panchromatic. Black-and-white copying, especially of fine line work, can be done very well with Kodachrome 25. Line copying of color is best done with Kodachrome 25 or Kodachrome 40, Professional (Type A).

CHART OF FILM-FILTER COMBINATIONS FOR VARIOUS COLOR ORIGINALS

ORIGINAL		REQUIREMENTS	FILM TYPE	FILTERS
Paper Color	Ink Color			
White	Black	High Contrast	Positive	No Filter
White	Blue	High Contrast	Pan	R-60
White	Red	Eliminate Red High Contrast	Pan Positive Pan	X-1 No Filter R-60
Yellow	Black	High Contrast	Pan	Y-48 Y-52
Yellow	Blue	High Contrast	Pan	Y-52
White or Yellow	Blue or Red	High Contrast	Pan	X-1
Green	Black or Red	High Contrast	Pan	X-1
Blue	Red	Eliminate Blue Eliminate Red	Pan Positive	R-60 No Filter
Pink	Black or Blue	High Contrast	Pan	R-60
Red	Violet	High Contrast	Pan	R-60
Sepia—Faded Photo Color		Natural Tone	Pan	Y-44 Y-48
Old Drawing		Brush Contrast Drawing	Infra Red	R-60
Printed Color		Natural Tone	Pan Tungsten Color Daylight Color Color Neg.	X-1 Flood Lamps B12 (Flood Lamps) No Filter
High Brilliance		Eliminates Reflection	Color B & W	Polarizer

FILMS, LIGHT SOURCES, AND FILTER COMBINATIONS IN COPYING

Film used	Light source	Filter
Daylight-type color film	Photo-floodlight	B 12
	Tungsten-Halogen lamp	B 12
	Blue floodlight lamp	Not needed
	Speedlight	Not needed
Tungsten-light-type color film	Photo-floodlight	Not needed
	Tungsten-Halogen lamp	Not needed
Black-and-white film	Photo-floodlight	Not needed
	Speedlight	Not needed
	Natural light	Not needed
	Fluorescent light	Not needed
	Iodine lamp	Not needed

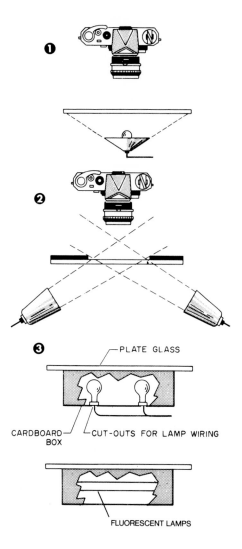

Above, basic lighting arrangement for copying flat originals. Below, improvised copying stand utilizing tripod with inverted elevating pole.

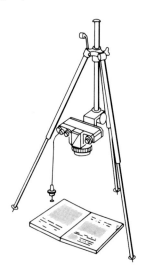

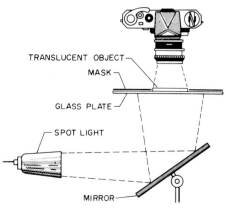

Various arrangements for lighting subject by transillumination. Improvisations can also be made of rear-projected viewing screens.

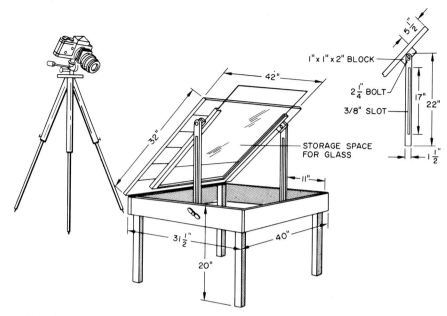

1" x 1" x 2" BLOCK

$2\frac{1}{4}$" BOLT

3/8" SLOT

STORAGE SPACE
FOR GLASS

42"

32"

11"

$31\frac{1}{2}$"

40"

20"

$5\frac{1}{2}$"

17"

22"

$1\frac{1}{2}$

Adjustable photographic stage that permits orientation of copy at varying angles in rela-
tion to camera, from vertical to horizontal. Suggested project for amateur or professional
cabinet maker.

Lighting for Photocopying

Most photocopying is by reflected light, as covered here. Where transparent or translucent materials are to be copied, with a main light source in back of the subject, facing the camera, avoid having reflections bounce off the front surfaces of the subject by working in a darkened room.

Distributing light uniformly. In standard lighting setups for copying flat originals, two lamps are placed at either side of the copy, out of view of the camera lens. The angles of reflection and incidence should be about 45 degrees. The angle of the optical axis and lighting axis, converging on the subject, should also be about 45 degrees, positioned so that each illuminates a quarter of the target. If texture of the subject shows up undesirably, lights should be moved closer to the subject, while the camera, with longer lens, should be moved back.

Uniformity of lighting and avoidance of hot-spotting are essential. Turn on one light at a time and observe the effects with the lens stopped down. Make necessary lamp adjustments. A slight excess of corner illumination may be desirable as an offset to the tendency of lenses to transmit more brilliance in the center. With larger subjects, such as paintings, lights should be aimed more obliquely, crossing each other as they are targeted toward the far ends of subjects, thereby bringing out surface texture. (See also below.)

As a check on lighting balance, hold a pencil or card in the center of the subject, in line with the optical axis. Either there should be no shadows, or, if present, their lengths should be identical. If not, light positions should be altered. Differences in shadow length can be used to guide the placement of lamps. An exposure meter (that of the camera, or an independent reflected-light meter) can be used to take readings from the subject surface.

Permanent lighting setups must be checked from time to time, because light output varies among bulbs.

Lamps should be of the same age, par-

Use of 50mm El-Nikkor lens on camera body using special adapter ring. Image ratio of detail shown here, enlarged to same size as original, was approximately $1/6\times$ on film.

Joe DiMaggio

Section of original subject reproduced here is part of an enlarged print. The enlargement was made from a negative of .6 magnification made by using 50mm El-Nikkor lens on camera body with M-ring for extension. The eye, 7mm in the original, appeared 4.25mm on the film.

On film, the detail of the eye occupied approximately one-half of the image dimension. The original is approximately 7mm while the film copy was not quite 18mm wide, representing approximately 2.5× magnification. The 50mm El-Nikkor lens was used on bellows PB-4 with a 125mm extension.

With a 190mm extension of the 50mm El-Nikkor lens on the bellows PB-4, the eye detail occupies approximately 5/6 of the long film dimension. Note how the details hold up crisply, breaking apart only to the extent that the paper texture and inking begin to come apart under high magnification. The detail on film represented a 25× magnification of the original subject.

ticularly when color films are being used. Fluorescence will be found satisfactory for black-and-white photography but not for color.

Ringlights may be used for small or large areas, depending on output of the unit. Test exposures should be made to ascertain uniformity of light distribution.

Indirect lighting may be used to distribute light uniformly (due to longer travel of light from source as well as to diffusion of light by dual reflection). Lights may be positioned outside the lens viewing angle, pointing to reflector boards which, in turn, must redirect light to the subject target.

Control of surface reflections. Two types of surface reflections must be controlled, other than those caused by poor placement of lighting sources: (1) reflections from high spots of surface irregularities, and (2) reflections from nearby objects picked up on the subject surface.

The slight tooth or pebbling of a paper surface will reflect tiny catchlights, which, cumulatively, show up as hot spots or exposure burns on the copy film. More pronounced catchlights are formed by curved surfaces because the copy is not lying absolutely flat. None of these reflections can be prevented by repositioning lights. Attempting to do so merely results in a shifting (but not an elimination) of the reflections.

The use of a polarizing filter over the camera lens will help subdue *some* of the reflections. The filter is rotated on the lens mount until the least reflection is observed. If polarizing filters are used over both lens and light sources, reflections will be cancelled out as though by magic. Moreover, the reflective range from highlight to blacks is increased, yielding better tonal gradations and deeper blacks. Oil paintings can be copied without high spots of brush marks burning up. Copying can be done through glass. Cracks, scratches, creases, and wrinkles become invisible or are minimized, provided they are also illuminated uniformly. For another tech-

nique of avoiding glass reflections, see instructions for use of the 35mm or 28mm PC-Nikkors.

Reflections may be caused by objects in the environment of the camera, such as shiny parts of the camera, tripod, lamp stands, and other instrumentation. A light shirt or other reflecting surface can spill light onto the subject to be picked up by the lens. Such environmental reflections are overcome by shielding. The area surrounding the subject is draped, masked, or painted dead black. If necessary, a black board is interposed between the camera and subject, with a hole in the board through which the lens can protrude. If the subject is dark, a white board may be used instead.

A strip of shiny material at the edge of a copy area can be used as a check on whether undesirable reflections or hot spots will be picked up. The photographer must observe the reflection either through the viewing apparatus of the camera or by viewing the subject from a point in line with the lens axis.

Raised surfaces (low reliefs). To show the texture or depth of a fabric, tapestry, painting, raised letters, engraving, or other three-dimensional surface, use oblique angle lighting for the main source. The angle formed by the light beam and the subject varies with the height of the texture or raised surface. A fine fabric would need a narrower angle than a heavy, bulky fabric. An oil painting with heavy strokes calls for a broader angle. The same pertains to raised letters placed over a solid or print background where only a little edge shadow is needed to suggest depth. Hence, the length or sweep of the shadow will govern the angle of the main light.

Use fill lighting to soften shadows and provide balanced illumination. Experiment with crossed light beams—each illuminating the far end of the subject— to balance the lighting, while affording desired shadow forms.

For additional suggestions, see Chapter 3, on "Coins, Medals, Reliefs."

Copying Black-and-White Line Originals

In general, expose and develop for high contrast separation of lines from background and from each other. Fine lines should not fill in.

Printed, typewritten, or handwritten material on both sides of white paper. No filter. White sheet or card behind to strengthen contrast. Typewritten originals prepared for copying should be typed with a clean ribbon or unused carbon paper, with a back-up sheet of carbon paper to make reverse print on underside of original. For copying, use white sheet in back.

Printed, typewritten, or handwritten material on colored paper, one side. Filter of same color as paper. Black back-up sheet if material is on both sides, as with bank checks; otherwise, white back-up.

Blueprints. Panatomic-X film with red filter to convert blue to black with white lines remaining.

Copying Colored Line Originals, Black-and-White Film (Continuous Tone)

Colored printing on white paper. To darken color, use complementary filter. If more than one color, matching filter can be used (or not) to eliminate undesired color.

Colored printing on colored paper. To lighten print color or background, use a filter of the same color as print or background, as desired.

Treat multicolored line originals as continuous tone subjects.

Various color and paper combinations. To build up contrast by increasing exposure of background (lightening it on positive print), use filters recommended.

Continuous-Tone Black-and-White Subjects and Films

Pencil writing and drawings, charcoal and black crayon sketches, etchings. No filter unless needed to control background. Develop continuous film for desired contrast/tonal range.

Halftones. Finest screen materials usually need continuous-tone films, developed for suitable contrast. Technically, a halftone is a line subject (consisting of black-and-white dots). Coarse screens can be treated as line-copying subjects.

Photographs. It is usually best to copy originals that do not have extremes of sharp white and dead black, if a choice is available. Glossy originals are preferable, to avoid picking up paper-grain patterns. Copy negatives should be exposed, developed, and printed for detail rendition in both highlights and shadows.

Combined line and continuous tone. Something must give in copying, but least of all the smoothness of tonal ranges. While continuous-tone film is used, expose and develop for contrast, preferably Panatomic-X film, which is inherently contrasty.

Colored Originals, Continuous Tone

Multicolored line originals, maps, colored charts. Use Kodachrome 25 or Kodachrome 40, Professional (Type A) for brilliance and contrast. Ektachrome 64, Ektachrome 50 Professional (Tungsten), or other film of your choice, depending on desired color and tonal emphasis, relative to subject characteristics.

Paintings. See above; see also lighting of raised surface originals.

Faded, Illegible, and Questionable Documents

Old, yellowed ink, faded prints, and photographs. Use blue Kodak C5 filter. Make best copy of original before attempting to alter it physically.

Creased, wrinkled, scratched surfaces. See lighting section, reflection control.

Yellowed paper. Deep yellow filter, Kodak G15.

Stained prints and documents. Use a darker filter of same color as stain; e.g., blue or red ink on paper, use blue or red filter.

Charred documents, forgeries, altered documents, concealed paintings. Kodak Infrared Film with Kodak 25A filter. See *Kodak Data Booklet—Infrared and Ultraviolet Photography.*

Invisible writing, bleached documents, faded ink. Use ultraviolet light in darkroom to fluoresce subject; panchromatic film, Kodak 2A filter. See *Kodak Data Booklet—Infrared and Ultraviolet Photography.*

Legibility Standards

Captions, reading matter, and statistical charts prepared for slide copying and projection must be readable at given viewing distances. Size guidances are to be found in two Kodak pamphlets available free from the Sales Service Division, Eastman Kodak Co., Rochester, New York, 14650. Ask for Kodak Pamphlet No. S-4, *Legibility Standards for Projected Material* and Kodak Pamphlet No. S-12, *Artwork Size Standards for Projected Visuals.*

Restrictions on Photocopying

Some types of documents, securities, and currency may not legally be copied. The following chart is a short guide as to what may or may not be copied.

Official documents not to be copied. Classified materials marked restricted, confidential, secret, or higher.

Government identification cards, passes, or insignia.

Certificates of citizenship, naturalization; immigration papers.

Selective service registration cards.

Automobile registrations and driver's permits.

Certificates of adjusted compensation for United States veterans.

Passports.

Financial papers not to be copied. Paper money in any form issued by the United States or any other country.

Bills, checks, or drafts upon the United States.

United States bonds and coupons (but United States Savings Bonds may be copied for use in promotion and sale).

Federal Reserve and United States Treasury Notes.

Silver and gold certificates; certificates of deposit; certificates of indebtedness.

Postal money orders, but customer's receipt may be copied.

Stamps, other than postage stamps (as below) and other than cancelled Internal Revenue Stamps copied as part of a legal document for legal purposes.

Postage stamps which may be copied for philatelic purposes only.

United States stamps, color or black-and-white, uncancelled, provided they are reproduced less than three-quarters or more than one and one-half times in linear dimension.

United States and foreign stamps, color, cancelled, exact size.

Foreign postage stamps in black-and-white, regardless of size, cancelled or uncancelled.

Foreign postage stamps in color if obsolete for postage.

Copyrighted materials that may or may not be copied. Commercial studios generally refuse to reproduce copyrighted material for fear of infringing on legal rights. The situation is confused and at times ridiculous. Some people hold that you cannot photocopy but do not object to copying by hand or with a typewriter. The restrictions seem to be honored more in the breach than in the observance. Some office copying machines are designed specifically to facilitate copying of books, journals, and magazines. Such machines are often found in libraries for coin operation by the library user.

The general rule is that you may copy materials for research or scholarly purposes. This is considered "fair use." Copying for display in a book or other publication *may* be fair use, provided such display is for review purposes, but you may need specific legal guidance in each case. When you reproduce copyrighted material, you must also reproduce or cite the original notice of copyright.

CHAPTER 3

Three-Dimensional Closeups

This chapter covers the photography of small, three-dimensional subjects. The problems include control of depth of field, apparent perspective distortion, shadows, background separation, and management of light sources. The subjects present lighting problems due to limited working space and the need for small lighting sources.

Also covered are the applications of close-up techniques to some typical kinds of subject matter.

Most of the problems covered here pertain to opaque, three-dimensional, front-lighted subjects, although side-, back-, and rim-lighting are also covered.

OPTICAL PROBLEMS

Lens Selection

The three key needs to consider when selecting a lens for three-dimensional closeups are: (1) to achieve sharpness in depth; (2) to overcome apparent perspective distortions in which near objects loom more prominently than objects or portions of them farther away; and (3) to afford adequate area for placement of lights.

Recommended camera-mount lenses are the 85mm, 105mm, 135mm, and 200mm focal lengths. The 105mm and 135mm lenses in short mount for bellows focusing are especially recommended.

For the same image size, longer lenses can be used at correspondingly greater working distances. Relative size of objects can thereby be shown, thus minimizing or overcoming apparent perspective distortion.

At the smallest lens apertures longer focal length lenses may offer more critical sharpness than lenses of shorter focal lengths at the same apertures due to the avoidance of diffraction effects. Equivalent f/numbers of longer lenses have wider physical lens openings than do shorter lenses. Accordingly, diffraction, which results from use of the smallest f/numbers with short lenses, may not be found at all or may be found to the same extent with the same f/numbers on longer lenses.

Shorter focal length lenses may be used when foreground dominance is desired and when diminished depth is not important.

When shorter focal lengths are used, typically the 50mm or 55mm, and it is desired that size relationships be main-

Francisco Hidalgo

"Way Out" effect achieved through use of 50mm f/1.4 lens at full aperture with the M tube for additional extension. Shallow depth of field yields single plane of sharpness while eye reflections are thrown wildly out of focus. Oh! Of course! It's a cat.

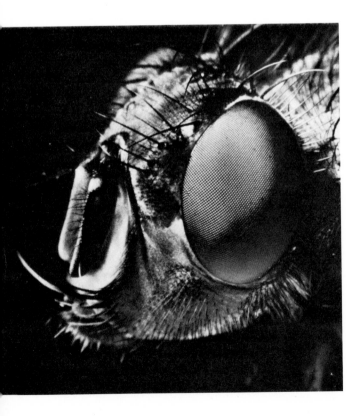

Francisco Hidalgo

Micro-Nikkor lens at full extension yielded this eye of the fly further magnified in the darkroom. 1/60 sec., f/32, Kodak Plus-X.

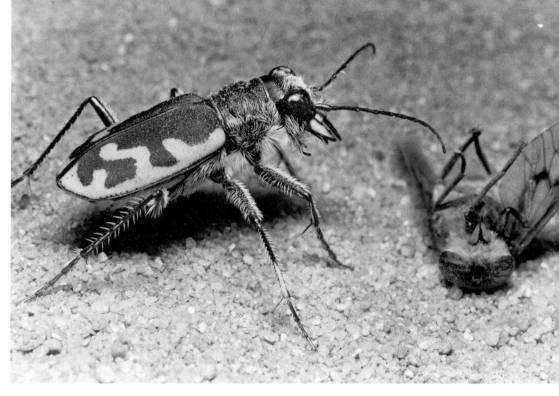

Larry West

The photograph of the tiger beetle with his prey—a fly—was made with the 55mm *f*/3.5 Micro-Nikkor at *f*/32. Electronic flash hand-held off camera at high position while focusing was achieved by moving entire camera assembly to and fro. Kodak Panatomic-X.

Larry West

The jewel weed leaves presented an interesting pattern in soft existing light. 55mm *f*/3.5 Micro-Nikkor.

Alfred Gregory

When small objects are focused upon at close range, backgrounds and foregrounds fall out of focus, sometimes producing either contributory or conflicting patterns which must be observed by depressing the depth-of-field preview button. Butterfly caught with 105mm f/2.5 lens and short extension tube. Kodak Tri-X, f/5.6, 1/125 sec.

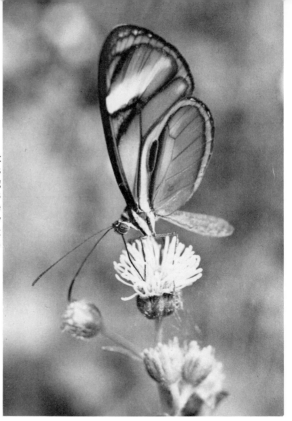

Tom Carroll

The tele-lenses, sometimes in conjunction with an extension tube or a close-up lens attachment are not to be overlooked in making closeups which sometimes can be quite dramatic. A common use of the tele-closeup is in retaining correct object proportions. This doorknob shot with the 105mm f/2.5. A short focal length lens would have distorted the roundness of the doorknob. Stopping the lens down brought the background into soft focus so that it would not compete wth the sharp isolation of the main object.

tained in depth, from front to rear, it may be necessary to back away from the subject, even though less magnification is achieved. Further magnification can then be obtained through darkroom manipulation, although this is not a preferred alternative.

Refer to lens data sheets and to tables in Chapter 2 for image area, depth of field, and working distances (subject-to-lens). Also see the guidelines on close-up attachment lenses.

Critical Focus and Sharpness

Critical sharpness from a purely optical standpoint is to be found only for a single plane at a focused distance. From a viewing standpoint, adequate sharpness may be achieved for subject areas beyond and in front of the plane of critical focus, although the greater the magnification, the lesser is the discernible depth of field.

As a practical matter, extended depth of field may not be necessary, provided the photographically important subject area coincides with the point of sharp focus. Beyond it, objects can soften into a blur without detracting from an overall visual impression of sharpness.

With most lenses, the zone of critical sharpness is usually found in the center of the image field. Edge softness is increased through use of close-up lenses and through focusing lenses at closer working distances than those for which they are normally intended. Overall sharpness with general-purposes lenses is increased, as previously discussed, by stopping down to about $f/8$ or $f/11$. Re-

member, however, that this need not be done when the center area only is of photographic importance, as when a small object is viewed against a solid background or against the sky (as with a flower.)

Magnification and Subject Movement

Subject movement affects image sharpness through image displacement at the focal plane. The greater the magnification, the greater will be the discernible image displacement. Control is exercised by using the fastest possible shutter speed consistent with lighting and depth-of-field requirements.

Side movements of the subject in parallel with the image plane (film) yield the greatest potential for image displacement. While the object may remain in focus, the moving image may cause a blurring of object edges and details— usually seen as overlapping edges and contour lines.

Movements toward or away from the lens also may cause blur of two kinds: (1) movement of the object out of the area of critical focus, especially if recorded at fast shutter speeds, and (2) softening of image contours if recorded during slow or time exposures.

Blur due to sideways image displacement is minimized or overcome by using shorter exposure times. The preferred way to accomplish this is with an electronic flash or other light sources. Slower films, which yield more clearly defined edge sharpness (acutance), are preferred when details are to be displayed.

CAMERA AND SUBJECT SUPPORTS

When photographing nature, you become acutely sensitive to the interplay between environment and equipment. In addition to subject movement, you note minute equipment displacements which, at the least, affect composition and framing. Gravitational shifts and the effects of pressure on camera controls and panhead controls may cause image displacement.

The same problems are encountered indoors. A complicating factor is the need to cope with environmental shock or vibration, which may be transmitted to both camera and subject during prolonged exposure. The environmental hazard stems from building and floor vibrations, motors starting and stopping, doors opening and closing, and other human, physical, and natural activity in and out of the building, including wind and thunderstorms. Wind is one of the more unmanageable hazards in outdoor close-up work.

For critical work, vibration tolerance can be no more than one-half the circle of confusion (1/60mm). Assuming the latter to be 1/750 inch (1/30mm), vibration can be no more than 1/1500 inch without causing a softening of image details.

The use of the cable release and the self-timer will minimize impact of finger pressure on the camera, especially at slow shutter speeds. The mirror can be locked up in advance of shutter release for tripod-mounted setups to minimize mechanical movement within the camera.

Overcoming Environmental Movement

In extreme close-up work, one way to minimize movement is to integrate camera support and subject support through physical connection. Thus, when the camera is mounted on an upright column (as with the Nikon Repro-Copy Outfits) for vertical photography of an object on a baseboard, both camera and subject tend to be influenced simultaneously by external forces. The top of the upright is likely to move laterally under outside stimuli, even though the base holds firm. Nevertheless, some of the independent movements of the camera and subject are minimized.

Greater rigidity in a vertical system is afforded with the Nikon Multiphot, which integrates a stand, light source, copy stage, and camera support.

For horizontal setups, one can devise a photographic stage that supports both camera and subject. Considering a low center of gravity for the two, image movement is minimized. At least both camera and subject tend to move in parallel in response to environmental force. This does not take into account, however, the independent force exerted upon the camera when the shutter-release button is pressed. The use of a cable release and a slow squeezing action will tend to minimize this motion.

Other precautions are to tape tripods to the floor; to work at minimum heights above the floor; and to put firm rubber shock absorbers—neither too hard nor too soft—under camera and subject supports. A bubble level on the camera and on the subject stage will reveal vibrations and offer clues as to readiness for exposure.

Some equipment shock and vibration may occur when the shutter-release button is depressed and the camera mechanism is activated. For really short exposures, the vibration or movement hazard is minimized. The more sensitive exposure problem is the intermediate one in which the camera mechanism shock occupies a relatively large span of exposure time. A longer exposure—all other things being equal—would decrease shock time and lengthen undisturbed exposure time.

Miscellaneous Camera Supports

The first rule for a tripod is that it must be sturdy. The greater the height at which it is used above its own base, the sturdier it must be. A regular tripod might be used at the edge of a table with the camera raised above and over the edge. Small tabletop tripods and clamping devices are available. The photographer on the go might carry with him clamping devices that attach to table edges, backs of chairs, tree trunks, fences, and any other rigid support. Such devices have $\frac{1}{4}''$–20 threads to go into the tripod socket of the camera.

Ball-and-socket heads and pan-tilt heads such as are used in motion-picture photography will be found invaluable in making lateral and vertical adjustments in the position of the camera on any tripod or other camera support. These devices can be found in any well-stocked camera store.

For outdoor photography, a Nikon pistol grip with finger control of a cable release will be very useful, especially in making nature closeups with bellows or long lenses. Such an arrangement may also be useful indoors, for example, in medical photography.

Subject Supports

A subject support must hold the subject rigidly in position while remaining out of camera view. At close range the latter is attainable with the aid of shallow depth of field, which throws objects out of focus when they lie beyond the area of critical view.

Some rather unsophisticated bits of hardware may be used to hold objects in place, including "double stick" plastic tape, pins, wires, price-ticket holders, modeling clay, laboratory tongs, and anything else that might stem from ingenious or desperate imagination.

Laboratory jacks can be used to raise or lower objects, bearing in mind that adjustments must be fine and smooth. The entire subject stage can also be mounted on a rack-and-pinion slide to move it closer and farther away from the lens.

Glass sheets are used in vertical photography when the subject is suspended over a background that will be out of focus. This is particularly important when reflection spots on black backgrounds need to be eliminated. The background is put into a different plane of focus, sufficiently far away so that reflections and catchlights are practically diffused out of existence. When the object is resting on a glass plate, it is usually well to mask the plate up to the subject field.

Instead of using a glass plate, an alternative approach is to suspend the subject on a wire over the horizontal background that may be black, grey, or white, depending upon the desired contrast with the subject, or colored for various tonal effects.

LIGHTS AND REFLECTORS

Lighting sources in close-up photography must be scaled in size in relation to the subjects to be illuminated. Ordinary light sources put too much light outside of the target area, some of which is wasted and some of which may be reflected back onto the subject. From an operational standpoint, the limited working space between lens and subject also calls for small and efficient lighting sources. These are discussed below. One should keep in mind the previous suggestions regarding choice of lenses: focal lengths that afford adequate working distance when used with appropriate close-up accessories should be favored.

Electronic Flash

Electronic flash is an ideal lighting source for outdoor hand-held photography of flowers, insects, and other small objects. It assures consistency of color temperature regardless of changes in daylight characteristics caused by time of day or cloud cover. In theory, under good daylight conditions one could use sturdy tripods, but they are not practicable when following insects or trying to overcome movements of flora due to wind. Electronic flash is instantaneous and capable of freezing ordinary movement. Combinations of electronic-flash units or of flash and reflectors may be used. The operational problem is to cope with background darkening due to rapid fall-off of light intensity at close distances.

When working indoors with flash, it may be convenient to substitute low-level continuous lighting sources for predetermination of shadow and highlight patterns, lighting ratios, and exposure. When lamp outputs are standardized, camera readings or independent meter readings can be converted by formula to appropriate lens settings based on output ratios of the two light sources.

At close range, the ordinary guide number concept is no longer applicable, because of inefficient reflectors and light output not falling on the subject effectively. Hence, trial-and-error exposures should be made with the particular flash unit under varying conditions.

Bare-bulb flash may be used effectively at close range, although the shape of the lamp source may be a factor in the selection in view of highlight patterns, as described below. Ordinarily expendable flashbulbs may be used, provided the flash reflector is collapsed, removed, or covered with dead black material. Exposure tests must be made.

A typical arrangement for using electronic flash is to extend the unit away from the camera body so as to achieve a 45-degree angle of illumination for the main lighting source. With practice, this can be a hand-held arrangement.

A small flash unit attached to the front of a lens mounted on a bellows unit, preferably one of the short-mount lenses, affords automatic exposure compensation as working distance from subject is varied. It is a matter of balancing the positive and negative applications of the inverse square law: as the draw of the bellows is increased, light falling on the image plane is decreased, but this is offset by the greater brilliance of the light falling on the subject at closer working distances. A clamping arrangement for this is shown in the accompanying photographs. This automatic feature is operative only in standardized or pretested situations from which exposure guides are derived.

Such a flash may serve as a primary light source, while one or more additional units, at greater working distances, serve as fill-in or secondary sources.

Ring Flash

Ring flash produces shadowless surface illumination. Accordingly, it has specific applications for deeply recessed areas or cavities, particularly in dental and surgical photography. This is quite satisfactory with color films, but it yields rather flat effects with black-and-white films. Ringlights are also useful in minimizing shadows of grouped objects.

It is important to find just the right working distance relative to width and depth of a cavity in order to avoid casting shadows within an opening. This involves balancing the situation with factors of image size and lens focal length. For this, the Medical-Nikkor with its built-in ringlight is ideal; its 200mm focal length together with supplementary close-up lenses that vary working distances and object size afford maximum flexibility.

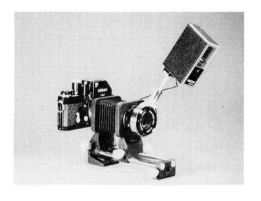

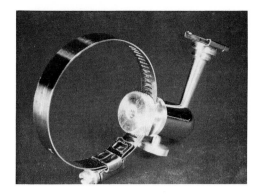

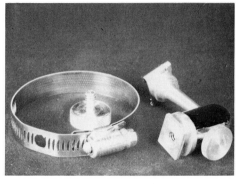

The flash combined with bellows was developed by Nikon School instructors James Arnett and John D. Slack from an item published by *Modern Photography* (November 1970).

The idea is that a flash mounted at the front of the lens used in close-up work will provide automatic exposure compensation as the distance from the subject is changed. The more intense illumination at closer distances is offset automatically by a loss of light falling on the film due to a decrease in relative aperture of the lens due to greater extension (and vice versa). A simple hose clamp and bounce flash attachment sufficed. An alternative since developed by Novoflex makes it possible to screw an adapter ring into the lens filter mount and then to attach to this ring a flash holder. This technique works within the range of 8" to 2½'.

Ideally, as with the ringlight units for the Nikon Speedlight, there should be provision for reducing or dampening light output. Otherwise, there may be problems in controlling unmanageably high flash guide numbers. If light output cannot be controlled at the power source, neutral density filters can be used over the lens (or colored filters with black-and-white films). Theoretically, there may be some loss of even illumination at close range due to the gap between the round flashtube ends where they lead to terminals, but in practice this may be overlooked.

When modeled or shaded effects in depth are desired, ring flash can be modified or supplemented. Lighting output may be altered in volume and in direction by selective coverage of the ring opaque material. Thus, if one-third of the flashtube were covered with black tape, there would be some shadowing or texturing along that area. Tape should

not be left on the circular lamp because it may be difficult to remove after repeated flashing, which will dry up the adhesive. An alternative is to apply opaque water-soluble paint that can be washed off easily.

When the ringlight is extremely close to an object, even distribution may be lost, for the circle of light may cause some shadowing or darkening toward the center of the image area.

An interesting edge-lighting effect may be achieved by putting a ringlight extension under a translucent sheet that supports the subject which then must be separately front-lighted. The ringlight would have to be plugged into a flash, which itself is an extension on a main triggering flash, either by wire or slave extension.

The use of ringlights is described additionally below, particularly with regard to reflection and highlight patterns. Ringlight attachments for the Nikon

A "trip down the bellows" to show relative size and depth of field at each picture-taking position. Subject is a Starr-Edwards aortic valve in a pathology specimen of the heart. Lens is 135mm f/3.5 Nikkor-Q Auto on bellows. Electronic flash with two lamp outlets, each with guide no. 140 for Kodak Plus-X Pan rated ASA 125. Lamps at 90-degree opposition with key light directly above subject. The fill light was disregarded in exposure calculations. If the two lamps were closer together, a slightly higher guide number would have had to be used to account for overlapping exposure. Electronic-flash pulse illumination yields maximum depth of field and prevents both movement and heat buildup, which occurs with continuous lighting. The following table shows the constant relative aperture

and the changing effective apertures with progressive 1/3-stop bellows extension. It also shows the closer positioning of the lamps to compensate for loss of light transmission due to increases in effective aperture size. Photos and technique by Stephen M. Shapiro, director, Medical Illustration Division, Albany Medical College.

PICTURE	A	B	C	D	E	F
Relative aperture	22	22	22	22	22	22
Effective aperture	36	40	45	50	58	64
Key light	47"	42"	37"	34"	29"	26"
Full light	66"	59"	52"	45"	41"	36"

Speedlight may also be mounted away from the lens for side-lighting effects. Many other techniques are possible, such as using the ringlight at the top of a translucent cone or tent covering the subject for diffuse, even illumination. Use of the 200mm $f/5.6$ Medical-Nikkor Auto lens is covered in Chapter 1.

Flashbulbs

Flashbulbs should not be overlooked, particularly when one or more units are used occasionally. Their light output is very high, and they are relatively inexpensive. The lamp pattern is round and concentrated, a matter of importance in highlight control, as discussed below.

Continuous Lighting Sources

The uses of continuous lighting sources are: (1) preliminary light-and-shade modeling of the subject, (2) determining accurate exposure readings through meter readings when using these sources, and (3) providing infinite capability in selectively shaping the quality and intensity of the light delivered to the subject. The chief disadvantage of the continuous source is that high outputs drive too much heat while low outputs call for prolonged exposures. The latter are not suitable for most live subjects in any event, but prolonged (time) exposures are made at the risk of softening image lines and contours due to cumulative vibrations as discussed above.

As a general requirement, lighting sources should have small reflectors and small lamps. Convenient items are the small, high-intensity lights commonly sold for household, office, and laboratory use. Some have flexible arms or uprights; others bend and swivel in almost any direction. Their color temperature outputs are *usually* suitable for Kodachrome 40, Type A, but tests would have to be made to ascertain more precisely the color balance for particular lamps. Units that have two or more output levels will emit light of correspondingly different color temperatures. For black-and-white photography these units are ideal.

Also useful are microscope lamps, pre-focused flashlight bulbs (which need intermediate transformers), slide projectors, spotlights, and snoots placed over larger lamps.

Regulating transformers and hi-lo switches permit control over intensity of light output. This affords flexibility in illumination and also minimizes heat build-up while setting up.

Light beams can be shaped by putting cut-out cards in front of the lamps. Card deflectors can be attached to lamp reflectors to guide light directionally.

If concentrated light is to be beamed on a subject for a prolonged period of time, it may be necessary to place a heat filter between the lamp and the subject. Floodlights generate excessive heat, making it difficult to work, and they may warp, wilt, or shrivel some subjects.

A ring fluorescent lamp circling the lens can be used for shadowless photography. It can also be used at the top or base of a photographic tent or light box. This source in color photography must be matched by suitable filtration.

Light sources can be mixed in black-and-white photography, but they must be matched for color temperature when using color films. Even the reflecting surfaces must be chosen for their color neutrality unless specifically desired effects are to be achieved.

Differences in both lamp type and lamp life should be avoided when multiple lamps are used, for differences in color temperature can result. Ideally, the lamps should be fresh or should have had approximately the same usage.

For long exposures, the technique of "painting" with light can be used. A lamp is held out of range of the camera lens and is moved in such a manner so that the light is distributed over the surface of the subject as desired. Of course, this technique also can be used with elec-

Stephen M. Shapiro

Depth of field in this series of a heart valve was controlled through manipulation of lights and lens apertures. Distance of object from camera and lens was held constant. Same lighting setup was used as in previous articles, but flash was at quarter power with guide no. 70. Image magnification was 0.6×. The procedure was to predetermine the field size and then to select the lens aperture that would yield the desired depth of field. The distance of the key lamp was then determined by dividing the lamp guide number by the effective aperture (not the nominal or relative aperture). The figure obtained, expressed in decimals of a foot, is multiplied by 12 to obtain lamp distance in inches. Exposure data follows:

PICTURE	A	B	C
Relative aperture	22	11	5.6
Effective aperture	40	20	10
Key lamp distance	21"	42"	84"

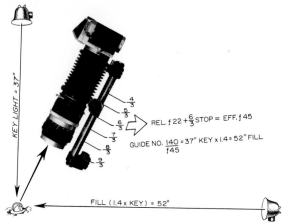

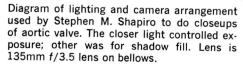

KEY LIGHT = 37"

$\frac{4}{3}$
$\frac{5}{3}$
$\frac{6}{3}$
$\frac{7}{3}$
$\frac{8}{3}$
$\frac{9}{3}$

REL. $f\,22 + \frac{6}{3}$ STOP = EFF. $f\,45$

GUIDE NO. $\frac{140}{f\,45}$ = 37" KEY x 1.4 = 52" FILL

FILL (1.4 x KEY) = 52"

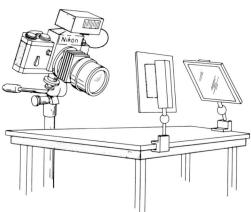

Diagram of lighting and camera arrangement used by Stephen M. Shapiro to do closeups of aortic valve. The closer light controlled exposure; other was for shadow fill. Lens is 135mm f/3.5 lens on bellows.

Homemade lighting stage using flash as main source for brilliant illumination and short exposures. Flash is aimed toward center of opposing reflector while side reflector picks up additional light for side fill. Lighting from rear provides depth. In this setup, form of subject is brought out through illumination of rear and sides with just enough light hitting front to fill in shadows. If necessary, additional front fill-in can be provided.

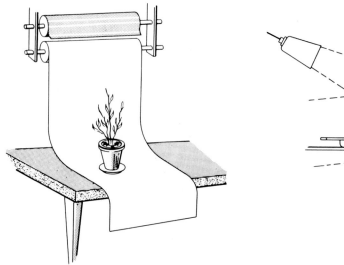

To eliminate detail from background, particularly the edge of the table, a large sheet is suspended from a wall or upright so that what otherwise would be a corner is formed into a continuous curved area. This is called a seamless background. One of many variations is to erect a large reflector board in front of the subject with the camera pointing down through a hole in the board. A light shined toward the board is aimed to deflect light back on the subject without shining directly into the lens.

tronic flash. In both cases, the shutter speed must be very low.

For black-and-white photography, critical sharpness effects can be heightened through use of monochromatic light. Use a Kodak 58 or 62 filter over the light source. This will minimize chromatic aberrations by cutting out much of the spectral components that come to a focus at slightly different distances from the lens.

Reflectors

Reflectors serve to pick up light from any source and to redirect it toward the subject. Reflectors can be highly directional or diffuse, depending upon desired effects.

Very small reflectors can be used to place limited amounts of light where desired. Highly polished surfaces, such as mirrors, throw concentrated beams of light approximating the size of the reflector. Shaving mirrors or magnifying mirrors can be used to reflect converging beams of light whose diameter is governed by distance from the subject.

Small purse mirrors can be attached to other supports for convenient placement. A machinist's mirror can be used in the same way. While more expensive, these mirrors are also much more professional, mounted on swivel-ball sockets, attached to long handles, and mounted on magnetic bases.

Mirrors and other polished reflecting surfaces can be masked or covered with cut-away paper designs in order to throw irregularly shaped beams of light.

Aluminum foil can be used to make reflector boards. The aluminum foil will throw a neutral reflection of cold character. Gold foil throws a warmer light, which might be preferable in color photography. Some foil is procurable with an imprinted surface stippling such as material used for wrapping packages. Reflector boards can be curved, of small size, and mounted on putty, price-ticket holders, and spring clips. They can be placed around the small object wherever it is necessary to fill in light.

Background boards or reflectors can be used for transillumination of translucent objects or for rim-lighting of opaque objects. Light is bounced off the background reflector so that it continues in the direction of the subject. The background can be vertical or horizontal. It could be a light box.

Reflectors can also be used to bounce light from the rear of a subject onto its front. A white card or other reflecting surface is mounted over the lens so that only the lens front protrudes. The light is then carefully directed so it does not strike the lens but instead is picked up by the reflector board and redirected to the front of the object. The effect is one of diffuse front illumination. Curving the reflecting board in relation to the lighting source may be helpful to avoid having light hit the lens surface directly.

Highlights Control

With three-dimensional objects, lighting must be designed to bring out form and depth while avoiding both unsightly shadows and highlights. Surface characteristics also must be considered. Thus, a textured surface, not very shiny, needs strong, undiffused lighting. On the other hand, shiny metal surfaces build up strong, distracting, detail-blocking highlights when illuminated with direct, undiffused light sources. Skillful use of light and shade may make up for lack of sharpness in depth.

Some general rules may be stated concerning highlights:

1. Shiny surfaces will reflect discernible light patterns similar to the shape of the lamp. A point-source light will be reflected as an intense highlight center. A ringlight will be reflected as a doughnut-shaped highlight. These patterns will be seen most sharply on eyes and other curved shiny surfaces.

2. The size of the reflection of the lamp will be governed by the size of the lamp and its distance from the subject. Stated otherwise, the greater the distance and the smaller the lamp, the smaller will be the highlight. (This is of particular importance when photographing irregular shiny surfaces that produce specular highlights.)

3. The shape of the reflecting surface will reproduce or modify the shape of the light source. Thus, a long curved metallic surface would reflect a light source as a long curved line. The round pattern of a ringlight would also be shape-converted to the form of the reflecting surface.

4. When a small lamp is covered with diffusing material, thus broadening its surface, the effect is as though a larger lamp were being used both for highlight and shadow control.

Various approaches are useful for the control, but not total elimination, of highlights. An optical approach is to use polarizing filters either to screen the light source, the camera lens, or both. Polarizing filters are useful in subduing highlights on shiny objects other than metal ones. Also, the light source must be at a particular angle. Achieving reflection control is accomplished by trial-and-error rotation of the filter on the lens mount and movement of the camera for the best angle. At the light source, polarizing screens may also be used independently of or together with filters in front of the camera lens. Polarizing filters reduce the amount of light reaching the lens and therefore require that longer exposures be made.

Irregular surfaces reflect light from sources at many different angles to subject surfaces. Rotating the polarizing filter may eliminate some highlights but may not eliminate others. The aim, therefore, is to achieve the best overall reflection-free effect.

Shiny objects under strong, direct illumination yield brilliant highlights that wash out subject detail. With diffused illumination, the highlights are broadened, thereby permitting more detail to come through.

Sometimes shiny surfaces need to be treated with dulling sprays in order to cut down on highlighting and blocking. You also can use putty, modeling clay, powders, and soft gum erasers to cut down on shiny reflections. To bring out embossed detail or the texture of metal surfaces, paint may be rubbed in and then wiped off. Blackening materials may be used, but not on objects that could become irreparably damaged.

Shadow Control

The size and relative sharpness of a shadow are governed by lamp size and distance from a subject. This pertains to both shadows falling on a background surface and shadows falling on the subject due to light being intercepted by protruding or raised surfaces. The latter pertains to mainly side or oblique lighting of individual objects as well as groups of objects positioned in depth.

For a shadow to be apparent it must have a contrasting background reasonably close to the subject. If it is very close, as when a butterfly is pinned to a board, the only shadow that may be observed will be a relatively thin one along the side opposite a single source of illumination. Additional illumination or reflectors may fill in such shadows. If the board is very dark or black, no shadow may be discernible.

If the subject is removed sufficiently from the background, no shadow will be seen even with frontal lighting, due to the diminution of light intensity (and hence loss of shadow contrast). Most commonly this is seen when subjects are flash-illuminated in large halls or outdoors.

When the lighting is slightly or moderately off-axis, relative to the line of

sight from lens to subject, the projected shadow of an object can often be arranged to fall outside the field of view of the lens. Residual shadow patterns on a vertical or horizontal background can be removed through use of background lights.

The principles governing shadow behavior may be stated in summary as follows:

1. The closer a lamp is to a subject, the bigger will be the shadow; the more distant the lamp, the smaller the shadow.

2. The greater the lamp size relative to a subject, the bigger will be the shadow; the smaller the lamp, the smaller the shadow at the same distance.

3. A larger lamp at some greater distance from the subject will cast a shadow of the same size as a smaller lamp at a closer distance.

4. When two or more objects fall within the path of light of a single light source, the object closest to the lamp will cast the biggest shadow even though it may be of identical size to the other(s). If shadows are desired, but if relative size of shadows is to be controlled, the distance of the main light from the closest foreground object should be increased, subject to adequate illumination from an exposure standpoint.

When shadows cannot be managed easily because of mutual interference by two or more objects, various bounce-lighting techniques can be used. As these techniques become more sophisticated, they approach the general nature of a light box or tent, as described below.

Textured surfaces call for sharp, oblique lighting in order to bring out surface detail. Ordinarily, a single light source may be used with fill, if needed, by using reflectors or supplementary lighting. Diffuse lighting is not suited to such subjects. A ringlight is also unsuitable unless it has directional control, but the latter would be suitable for very small subjects.

Light Boxes and Tents

A light box or tent is an enclosure, usually made of translucent material, within which the subject is placed. The enclosure has an opening at one end to which the lens is directed or, in some cases, through which it is placed. The light is directed onto the sides of the light box from outside of it. Hence, the illumination is very diffuse. Even though the light is scattered around, it can be made directional by throwing more light on one side than on another. The light is directed against the side of the tent in whatever amount or direction desired.

Light tents can be very simple and also very sophisticated. A white plastic bottle cut in half around its circumference and with its neck removed to afford access for the lens is one of the simplest of all tents. Half an empty eggshell or the bowl of a frosted light bulb with one side cut away can serve as a light box when photographing tiny objects within them. A cone can be made to fit around an object if a hole is cut in the top through which the lens will do its seeing and photographing.

Light tents can also be opaque where a dark ground is desired, with illumination coming from below for special effects. Circular fluorescent lamps have been used around paper cones to provide uniform distribution of diffuse illumination.

Backgrounds

One of the problems of the vertical background is to overcome the dividing line where the supporting surface and the background come together. A common technique is to use seamless paper or plastic, depending on the texture desired. A continuous sheet of material is suspended to form the background and continues underneath the subject. No joint is seen between the vertical back-

OPAL GLASS

WOOD PAINTED WHITE OR COVERED WITH CRUMPLED FOIL

Use of light box for shadowless photography.

Overhead view of rim-lighting setup.

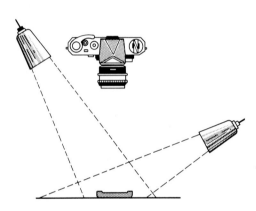

Raised surfaces require main light to skim surface at sharp angle. Opacity of shadow is controlled by fill-in light of lesser intensity.

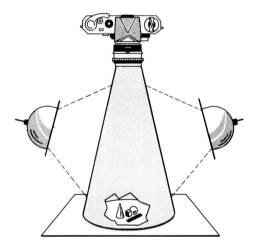

Cone made of paper or parchment with light driven into it from outside serves as shadow-defeating light box.

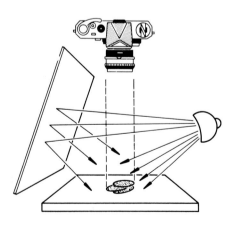

Single light is used here to illuminate small object on one side as principal light source while reflector board fills in other side.

Painting by light is done with shutter open through use either of electronic flash, fired manually as many times as desired and at varying distances for modelling effects, or with continuous light source.

Small reflectors for throwing light into restricted areas include magnifying mirrors, curved pieces of cardboard covered with crumpled foil or painted with aluminum, and hand mirrors or other highly reflective surfaces, perhaps held in place by ticket holders.

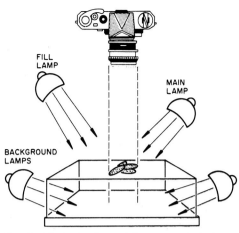

Small object on glass plate suspended above background throws latter out of focus. Special effects can be achieved with colored papers, patterns, illustrated backgrounds, and the like with height of glass varied to achieve desired focusing effects with background.

ground and the horizontal table surface because the sheet of material forms a gentle curve at what otherwise would be a right angle. The subject must be away from the background sufficiently to diffuse out highlights or catchlights. Peaks of curvature of the background should be smoothed out as much as possible in order to minimize highlights.

Contriving backgrounds also calls for ingenuity. Backgrounds are used to substitute blank tonal mass for distracting detail. An 18 percent grey reflectance card can serve as a neutral background. Complementary colors can be used for dynamic effect. A scene or an abstraction or other detail might be introduced on a background for a desired effect. When working at close range, the background is likely to be suggestive—even ghostlike.

Background tone or contrast may be varied through selection of materials or lighting or both. The texture itself may be selected for particular effects, including flat-surfaced cards, fabrics, painted surfaces, etc. On the other hand, highly polished surfaces that have no texture

might be desired, but these present a reflection problem. Opal glass, colored glass, and black glass have all been used as backgrounds. A rear-illuminated, slide-viewing surface offers a useful background.

Thus far, this discussion has concerned itself with essentially flat or single-plane backgrounds although these might also be curved, for example, when a flower is being isolated from other objects in its environment. Another problem of the background is the inclusion of other objects in depth. Since these are likely to fall out of focus, unexpected—even bizarre—effects might be achieved. In particular, attention must be given to unsightly highlight and color effects that are grossly out of focus. For example, bright points or spots of color may appear most distracting when they become globs of color that soften at the edges, seemingly attached to nothing. Aside from removing or relocating the objects, control might also include their utilization for desired effects, even to fill blank spaces to balance out other areas.

119

SOME TYPICAL CLOSE-UP PROBLEM AREAS

Ingenuity must reign in close-up photography. Small technological advances continue to make important contributions to lighting treatment. Through-the-lens metering has replaced the mathematics of exposure calculation for lens extensions beyond normal focusing range. Nevertheless, three-dimensional close-up photography will always be a challenge because of individual problems of lighting arrangements, perspective, texture and shadow rendition, background treatment, and control of environmental conditions in addition to control of the object itself.

In this concluding part of the chapter, four different categories of close-up subjects will be discussed briefly in order to bring into view a variety of problems and techniques that can best be conveyed in terms of tangible situations. These are: (1) small insect and animal life, (2) flowers, (3) coins, medals, reliefs, etc., and (4) tabletop photography.

Small Insects and Animals

Whenever possible, small insects and animals should be photographed alive. When photographed in a dead state, they lose realism. The practiced eye will observe drooping antennas, shrunken abdomens, and disoriented legs.

Sometimes photographic setups must be made in the field under natural conditions, usually at a low angle of view. The waist-level or right-angle finder should then be substituted.

Most field work will be done with a 200mm or 135mm lens and electronic flash. A long focal length lens is needed in order not to frighten the subject away.

Natural backgrounds reveal the creature in its living habitat. Either by working at the right time of day for an appropriate light angle or by using flash and reflectors, side-lighting should be used to bring out background texture, such as the bark of a tree, soil structure,

and so forth. Because insects and animals tend to take on protective coloration, which serves as natural camouflage, their separation from backgrounds may be difficult to achieve other than through shadows and shading achieved through lighting.

Whether in the field or in the studio, the most difficult problem is to bring the creature within a predetermined zone of sharpness or to be able to follow movements rapidly while focusing critically—the latter probably being more than one should expect in many situations. The photographer should study the habits of his quarry. Then, having prefocused and having predetermined exposure, he must have the infinite patience of a naturalist who waits for the subject to cross a given point near a hole in the ground or other place of entry or emergence. Living creatures often react less to presence than to movement. Fine focusing is achieved by moving the entire apparatus forward or backward rather than by mechanical adjustment of focusing controls.

Indoors, under studio conditions, one problem is to slow the movement of the creature in order to keep it within a zone of sharpness. Another is to protect the creature from heat and brilliant light glare. A low-level light is preferable for lighting arrangements prior to the moment of actual exposure. For this purpose, a hi-lo switching arrangement might be used. An alternative is to use a stand-in subject under actual lighting conditions and then, after having dimmed the lights, substitute the actual subject. Another approach is to use a combination of flash and reflectors, using exposure data accumulated through previous trials.

Slowing down the creature through the use of chemicals is not recommended, since behavior and physical appearance might thereby become unnatural. Cold-blooded animals (no mammals or birds)

can be stored in a refrigerator in order to slow down their biological processes. Insects can be placed under petri dishes, the camera can be readied, and the inverted dish removed just before the moment of exposure. Reptiles and flying insects must be kept within a glass cage with two front panels, the first of which should be removable so that picture taking is done through the second, smudge-free glass panel. If necessary, the front and rear panels of the glass cage can be placed close together in order to restrict depth of movement from a focusing standpoint. The same technique can be used in aquaria in order to keep water creatures within a manageable zone of sharpness.

Of course, living creatures are often photographed against neutral backgrounds, but then only part of the photographic story can be told. Realism is lost. If practical, natural background materials should be brought into the studio.

Small props such as floral twigs can be held in a machinist's vise. A colored paper background can be selected for subject contrast but beware of the subject casting a shadow on a too-close background. Electronic flash is preferred for crispness of image as an advantage of short exposures. The subject can be light-modeled with two flash lamps, while a third should be used on the background.

Most scientific photography for research purposes is done in the laboratory, usually with dead creatures. Lens selection and lighting will be governed by dimensional characteristics and desired magnification of subjects. The Micro-Nikkor 55mm, 105mm, and 200mm lenses may be used conveniently. The 50mm $f/2$ or $f/1.8$ lenses or any of the El-Nikkor enlarging lenses with bellows are also recommended.

Flowers

When photographing individual flowers or small clusters of flowers, the photographer must cope with background, confusion of adjacent foliage and floral displays, conflicting shadows, lighting direction, depth of field, and wind.

The best lighting for outdoor floral photography is a bright sun screened by a thin overcast, which effectively does away with harsh shadows. Such a light is bright enough to give form to the flowers and to assure that colors are well saturated. Better object separation is achieved when the source of light is at about a 45-degree angle to the subject, but for scientific purposes, color temperature will then be somewhat on the warmer side, thereby interfering with color fidelity. In most cases, however, this is not a problem, especially where aesthetics is the aim.

For texture and shape use soft or hazy side-lighting. This emphasizes roundness and relief as well. Early morning light is best, for flowers are also at their best then, but some color compensation may be needed. Side-lighting is also dramatic.

For translucence, use overhead or back-lighting as appropriate. Colors of petals are rendered in deeper saturation.

Reflectors can be used to fill shadows or to alter highlight patterns.

Wind shields of clear plastic can be placed at the sides or rear or both but should be at a sufficient distance to be thrown out of focus.

Sky colors, as backgrounds, will range from grey to blue at midday, depending on cloud cover characteristics. Early morning and later afternoon skies will be on the red side, subject to cloud-factor alterations.

Under natural lighting, the fastest color films are advantageous when working very close, in view of the wind and image displacement problem.

Backgrounds may be simplified by shooting carefully. A simple solution sometimes is to shoot from a low angle against the sky. For this purpose, the waist-level or right-angle finder is more advantageous. The low shooting angle

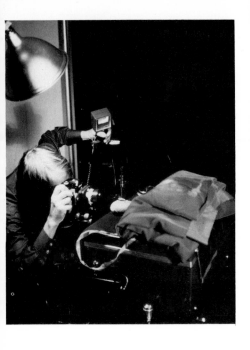

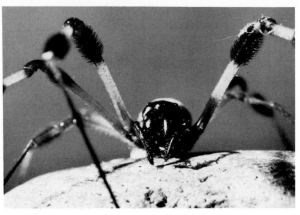

Dave Rummell **John D. Slack**

Spider was posed in setup shown in small picture on right. Floodlight overlooking entire area provided light for focusing and preview of depth of field. A second, slave-triggered strobe is over photographer John Slack's right shoulder. 35mm f/2, 1/30 sec., Kodachrome II (type A).

John D. Slack

Shallow depth of field is apparent in upper photo of front of spider whose diameter is about 6mm (¼"). Lower picture shows increase in sharpness by raising camera for angular overhead view. John Slack used 45mm f/2.8 GN Auto Nikkor reversed with BR-2 Ring on PB-4 Bellows with approximately 130mm extension, Kodachrome-X original, f/11, 1/60 sec., two flash units, setup similar to that shown here.

John D. Slack

The M tube was used for auto-diaphragm extension of the 85mm f/1.8 lens (used at f/4, 1/500 sec.) to obtain image magnification at a safe distance from the poisonous water moccasin in the Everglades. Kodachrome II.

Al Satterwhite

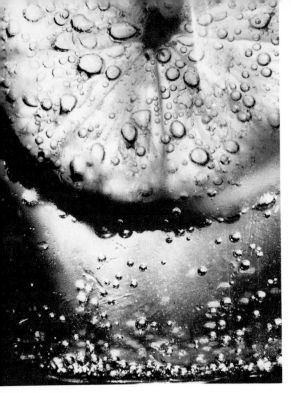

Ken Biggs

Lemon slice in glass of carbonated beverage illuminated from rear with electronic flash. Micro-Nikkor lens. Lemon slice had to be clipped to side of glass to keep it from floating to top.

Ancient coins. Another example of usefulness of 55mm f/3.5 Micro-Nikkor Auto at full extension with frontal views of objects not presenting perspective problems. Image ratio 1:2, lens set at f/16. Oblique lighting gives accent to coin markings and brings out surface texture.

is quite common, in fact, in flower photography.

Distractions should be removed with a pair of scissors or a toenail clipper. There might be other flowers in the same plane or there might be out-of-focus flowers that show up as conflicting color blobs in the foreground or background. Surrounding foliage (if inappropriate to be cut away) can be tied up with string to remove it from the field of view. Artificial backgrounds in suitable contrasting colors—cloth, stiff paper, or cardboards—can be used, provided the lighting is such (bright overcast, for example) as not to cause harsh shadows.

The background should be at a sufficient distance from the flower to cause any material texture to be completely out of focus. With long exposures, not often feasible outdoors, the background can be moved during exposure in order to further diffuse its patternings.

Long-stemmed flowers are particularly susceptible to wind-induced movement. It may be possible to limit movement by anchoring the stem to a sturdy support outside of the field of view.

To overcome problems of wind and daylight variations, flash is a preferred lighting medium. It permits the use of small apertures for maximum depth of field when needed. In the range of 10 to 20 inches, with small flashbulbs, apertures of $f/16$ and $f/22$ can be used with Kodachrome 25, Ektachrome 64, and other similarly rated films. At a distance of 30 inches, apertures of $f/11$ and $f/16$ can generally be used. When shooting toward the sky, it will be rendered darker, due to the greater brilliance of the light directed on the subject. Backgrounds can be rendered darker due to fall-off in intensity of light.

A hand spray gun is a useful piece of equipment. Tiny droplets of water on flower petals act as little lenses that reflect light to form little highlight centers.

Considering the need for portability, ideal equipment would include the use of the Micro-Nikkor by itself; close-up attachment lenses combined with moderate telephoto lenses; and E2 rings or bellows attachment combined with appropriate lenses. Close-up attachment lenses are quite useful in flower photography since one is working mainly with the center of the field in most cases. Hence, minor image quality fall-off at the edges is not a problem. The Medical-Nikkor is ideal for flower photography.

Lenses should ordinarily be used at their widest apertures both to shorten exposure times and to diffuse the background.

For good composition strive for simplicity. Don't include too many flowers. Avoid straight vertical lines as well as crossing stems. Good placement and balance are desirable, but symmetry is not likely to be pleasing.

Coins, Medals, Reliefs, and Such

In coin and medal photography, the subject is in very shallow relief. In effect, the problem is one of revealing texture in the form of minute image details. The ideal light is a single source set at an angle of 20 to 30 degrees from the upper left. A reflecting surface should be used to fill-in shadows. If highlights are objectionable, putty or other dulling materials can be used, provided the coins are not of "mint" quality. The latter should not be subjected to any form of soil, including the acid deposited by fingers in ordinary handling. Old coins that are tarnished, eroded, and otherwise discolored may need to be cleaned up before being photographed.

If highlights are objectionable and the coins cannot have their surfaces treated, the lighting source itself should be diffused. A frosted lamp can be used—one of the small mushroom bulbs—or a small high-intensity lamp can be used with a diffusing screen placed in front, sufficiently away from it so that it doesn't burn. Wooden or metal clips can be used to hold the screen in front of the lamp. The vertical copy stand will be most convenient since it provides a stable base. If

individual coins are to be photographed, they can be separated from the base as background by putting them on small pedestals—spools, pieces of doweling—of smaller diameter than the coin. Groups of coins can be separated from the base as background by being arranged on a piece of plate glass supported several inches above the baseboard.

Ringlights are not recommended. They bring out the sheen of coin surfaces, but because they are shadowless, they do not render image details and contours sharply.

Whenever possible, a ruler scale should be included in the photographic area even if it is to be excluded in prints. Thereby, actual size can be reestablished if necessary.

Tabletop Photography

The term *tabletop photography* has been in use for many years to describe small-scale setups of objects and scenes that may be variously realistic, humorous, or fantastic. Realistic tabletops are supposed to convey to the observer the impression that life-size pictures were taken. Accordingly, accuracy of detail is very important. So is the angle of view, which must correspond as closely as possible to what may be expected in real life. Waist-level and right-angle viewing aids are essential. When humorous, symbolic, or fantastic scenes are created, details need be less accurate or faithful, but a low picture-taking viewpoint is usually quite important.

In this interesting area of photography, of importance to professionals as well as indoor hobbyists, materials might come out of a toy store, hardware department, stationery shop, or notions counter. The variety of materials includes colored papers, pipe cleaners, putty, buttons, beads, cellophane tape, match sticks, pins, clips, rubber bands, modeling clay, wire, cellophane, plaster of Paris, salt, flour, and so on.

Working distance and optical effect will govern lens selection. To avoid undue foreground prominence or apparent

perspective distortion, the 135mm and 200mm lenses are preferable. If necessary, working distances can be reduced somewhat by using the No. 0 close-up attachment lens.

The more closely the objects in a scene are placed near each other, the easier it will be to keep objects in focus. Nevertheless, equal object sharpness will be difficult to achieve at close working distance. This is not too difficult a problem as long as the most important objects are brought in sharply. Those objects that round out the scene but that will be slightly out of focus can include some whose details need only be suggestive, while the more sharply delineated objects should be as faithful in detail as required for the particular purpose of presentation. Some of the more distant objects, which need only be suggestive, such as mountain tops, can be in the form of paper cutouts mounted on the base.

In designing the set, the colors of objects should be chosen with regard to how they will reproduce both monochromatically and in color. Monochromatic renditions should be adequately contrasted tonally. Color relationships can be planned to make up for loss of sharpness of background objects on color film. Out-of-focus catchlights and color blobs should be discovered and moved out of the field of view.

Lighting conditions must simulate those of actual outdoor or indoor conditions, as appropriate. If outdoor, the bright overcast can be simulated through bounce lighting. Bright sunlight can be simulated by using a single, concentrated point source of illumination. Indoor lighting is more difficult to simulate because of the variety of indoor lighting arrangements, but this may be an advantage. In general, bounce lighting from a surface above the set is most likely to replicate indoor conditions. The original source of lighting must be held low and reflected from a flat surface held above the set.

Index